MICHAEL FREEMAN
THE PHOTOGRAPHER'S [EYE]

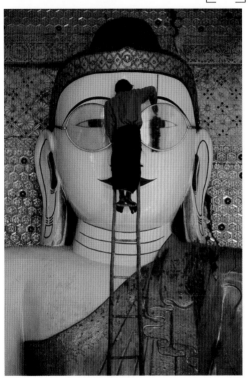

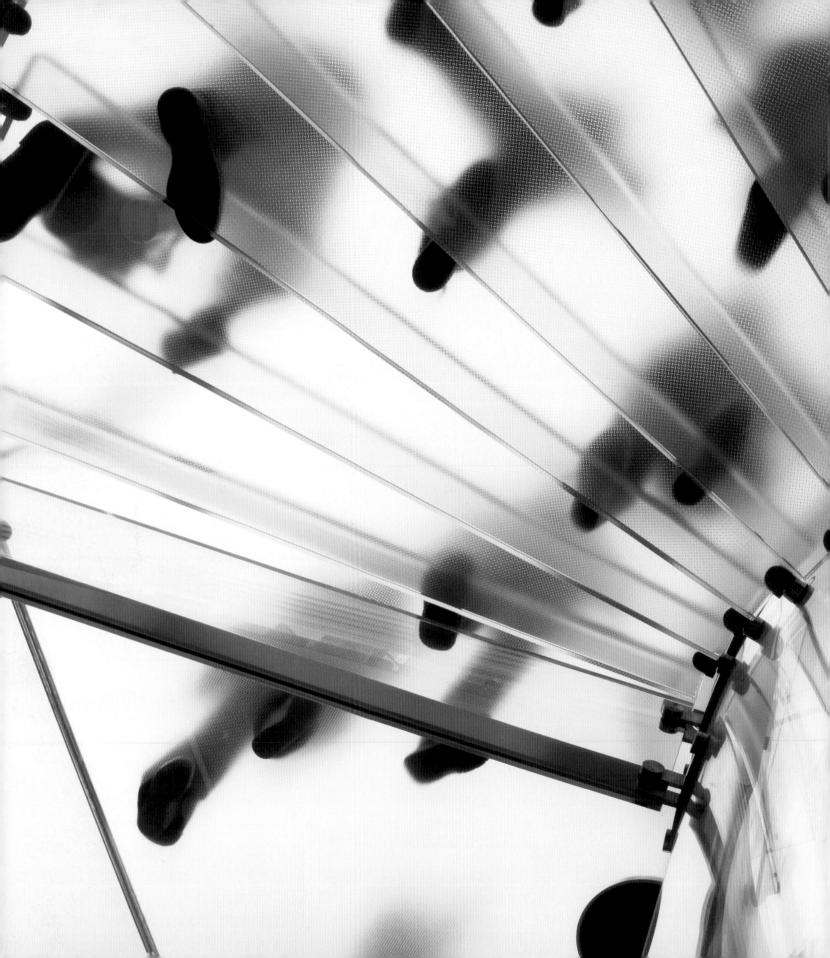

MICHAEL FREEMAN
THE PHOTOGRAPHER'S EYE
Composition and Design for Better Digital Photos

ILEX

First published in the UK in 2007 by
ILEX
210 High Street
Lewes, East Sussex
BN7 2NS
www.ilex-press.com

Publisher: Alastair Campbell
Creative Director: Peter Bridgewater
Associate Publisher: Robin Pearson
Editorial Director: Tom Mugridge
Editor: Adam Juniper
Art Director: Julie Weir
Designer: Simon Goggin
Design Assistant: Kate Haynes

British Library Cataloguing-in-Publication Data
A catalogue record for this book is available from
the British Library

ISBN 10: 1-905814-04-6
ISBN 13: 978-1-905814-04-6

For more information on this title, and some useful links, navigate to:
www.web-linked.com/seshuk

Printed and bound in China

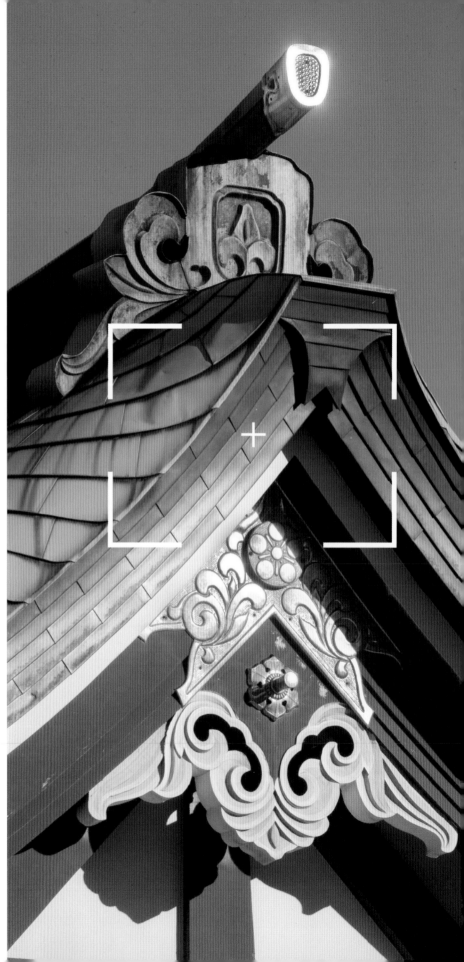

CONTENTS

INTRODUCTION

" …how you build a picture, what a picture consists of, how shapes are related to each other, how spaces are filled, how the whole thing must have a kind of unity." PAUL STRAND

Philosophical, lyrical, sometimes obscure commentaries on how photographs are made and what they mean are thick on the ground, usually by non-photographers. Not that there is anything at all wrong with the perceptive outsider's view; indeed, the distance of this kind of objectivity brings new, valuable insights. Roland Barthes even held his non-understanding of photographic processes ("I could not join the troupe of those…who deal with Photography-according-to-the-Photographer") as an advantage in investigating the subject ("I resolved to start my inquiry with no more than a few photographs, the ones I was sure existed for me. Nothing to do with a corpus…").

This book, however, is intended to be different, to explore the actual process of taking photographs. I think I'd like to call it an insider's view, though that smacks of hubris, because I'm drawing on the experience of photographers, myself included, at the time of shooting. A great deal goes on in the process of making an exposure that is not at all obvious to someone else seeing the result later. This will never prevent art critics and historians from supplying their own interpretations, which may be extremely interesting but not necessarily have anything to do with the circumstances and intentions of the photographer. What I will attempt to do here is to show how photographers compose their images, according to their intentions, moods, and abilities, and how the many skills of organizing an image in the viewfinder can be improved and shared.

The important decisions in photography, digital or otherwise, are those concerned with the image itself: the reasons for taking it, and the way it looks. The technology, of course, is

vital, but the best it can do is to help realize ideas and perception. Photographers have always had a complex and shifting relationship with their equipment. In part there is the fascination with the new, with gadgets, with bright, shiny toys. At the same time there is, at least among those who are reasonably self-confident, a belief that their innate ability overrides the mere mechanics of cameras. We need the equipment and yet are cautious, sometimes even dismissive about it.

One of the things that is clearly needed for successful photography is a proper balance in this conflict. Nevertheless, there have been very few attempts in publishing to deal comprehensively with composition in photography, as opposed to the technical issues. This is a rich and demanding subject, too often trivialized even when not ignored outright. Most people using a camera for the first time try to master the controls but ignore the ideas. They photograph intuitively, liking or disliking what they see without stopping to think why, and framing the view in the same way. Anyone who does it well is a natural photographer. But knowing in advance why some compositions or certain combinations of colors seem to work better than others, better equips any photographer.

One important reason why intuitive rather than informed photography is so common is that shooting is such an easy, immediate process. Whatever the level of thought and planning that goes into a photograph, from none to considerable, the image is created in an instant, as soon as the shutter release is pressed. This means that a picture can always be taken casually and without thought, and because it can, it often is. Johannes Itten, the great Bauhaus teacher in

Germany in the 1920s, talking about color in art, told his students: "If you, unknowing, are able to create masterpieces in color, then unknowledge is your way. But if you are unable to create masterpieces in color out of your unknowledge, then you ought to look for knowledge." This applies to art in general, including photography. In shooting, you can rely on natural ability or on a good knowledge of the principles of design. In other graphic arts, design is taught as a matter of course. In photography it has received less attention than it deserves, and here I set out to redress some of this lack.

A relatively new element is the rapid shift from film-based photography to digital, and this, at least in my opinion, has the potential to revitalize design. Because so much of the image workflow between shooting and printing is now placed on the computer in the hands of the photographer, most of us now spend much more time looking at and doing things to images. This alone encourages more study, more analysis of images and their qualities. Moreover, digital post-production, with all its many possible adjustments of brightness, contrast, and color, restores to photographers the control over the final image that was inherent in black-and-white film photography but extremely difficult in color. This comprehensive control inevitably affects composition, and the simple fact that so much can be done with an image in post-production increases the need to consider the image and its possibilities ever more carefully.

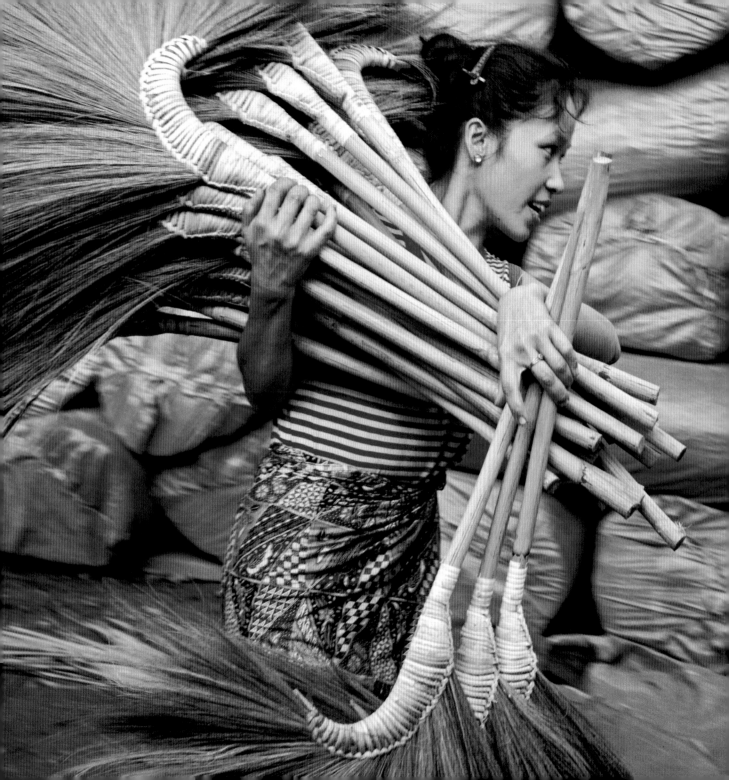

CHAPTER 1
THE IMAGE FRAME

Photographs are created within a spatial context, and that context is the viewfinder frame. This may be carried through unchanged to the final image, whether print or on-screen, or it may be cropped or extended. In whichever case, the borders of the image, nearly always a rectangle, exert strong influences on what is arranged inside them.

There is an important distinction, nevertheless, between composing photographs in the frame as they are intended to be, and planning ahead to either crop or extend the frame. Most 35mm film photography has been concerned with tight, final composition at the time of shooting, and at times this has led to a culture of demonstrating the fact by showing the rebates (the frame edges of the film) in the final print—a way of saying "hands off" once the shutter has been released. Square-format film, as we'll see on pages 13-17, is less amenable to comfortable composition, and is often used for later cropping. Large format film, such as 4x5-inch and 8x10-inch, is large enough to allow cropping without much loss of resolution in the final image, and is also often cropped, particularly in commercial work. Now digital photography adds its own twist to this, as stitching becomes more widely used for panoramas and over-sized images (see pages 18-19).

In traditional, shooting-to-the-final-composition photography, the frame plays a dynamic role, and arguably more so than in painting. The reason is that while a painting is built up from nothing, out of perception and imagination, the process of photography is one of selection from real scenes and events. Potential photographs exist in their entirety inside the frame every time the photographer raises the camera and looks through the viewfinder. Indeed, in very active, fast shooting, such as street photography, the frame is the stage on which the image evolves. Moving around a scene with the camera to the eye, the frame edges assume a considerable importance, as objects move into frame and immediately interact with them. The last chapter in this book, Process, deals with managing this constantly changing interaction between view and frame edges. It is complex, even when dealt with intuitively. If the subject is static, like a landscape, it is easy to spend enough time studying and evaluating the frame. With active subjects, however, there is not this period of grace. Decisions about composition, whatever they are, must often be taken in less time than it takes for them to be recognized as such.

Facility at using this frame depends on two things: knowing the principles of design, and the experience that comes from taking photographs regularly. The two combine to form a photographer's way of seeing things, a kind of frame vision that evaluates scenes from real life as potential images. What contributes to this frame vision is the subject of the first section of this volume.

FRAME DYNAMICS

The setting for the image is the picture frame. In photography, the format of this frame is fixed at the time of shooting, although it is always possible later to adjust the shape of the frame to the picture you have taken. Nevertheless, whatever opportunities exist for later changes (see pages 58-61), do not underestimate the influence of the viewfinder on composition. Most cameras offer a view of the world as a bright rectangle surrounded by blackness, and the presence of the frame is usually strongly felt. Even though experience may help you to ignore the dimensions of the viewfinder frame in order to shoot to a different format, intuition will work against this, encouraging you to make a design that feels satisfying at the time of shooting.

The most common picture area is the one shown at the top of this page: that of a horizontal frame in the proportions 3:2. Professionally, this is the most widely used camera format, and holding it horizontally is the easiest method. As an empty frame it has certain dynamic influences, as the diagram shows, although these tend to be felt only in very minimal and delicately toned images. More often, the dynamics of lines, shapes, and colors in the photograph take over completely.

Depending on the subject and on the treatment the photographer chooses, the edges of the frame can have a strong or weak influence on the image. The examples shown here are all ones in which the horizontal and vertical borders, and the corners, contribute strongly to the design of the photographs. They have been used as references for diagonal lines within the pictures, and the angles that have been created are important features.

What these photographs demonstrate is that the frame can be made to interact strongly with the lines of the image, but that this depends on the photographer's intention. If you choose to shoot more loosely, in a casual snapshot fashion, the frame will not seem so important. Compare the structural images on these two pages with less formally composed picture taken on a Calcutta street on page 165.

➤ THE EMPTY FRAME

Just the existence of a plain rectangular frame induces some reaction in the eye. This is one schema of how the eye might react (there are, of course, many). It begins in the middle, drifts up and left, then back down, and right, while at some point—either though peripheral vision or by flicking—registers the "sharp" corners. The dark surround seen through a camera viewfinder emphasizes corners and edges.

➤ ALIGNMENT

One simple device for originating an image that has prominent lines is to align one or two of them with the frame. In the case of this office block, the alignment of top edges avoids the untidiness of two corner areas of sky. Alignment like this emphasizes the geometry of an image.

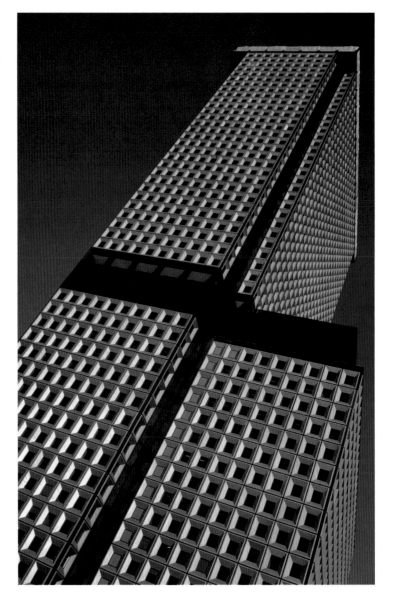

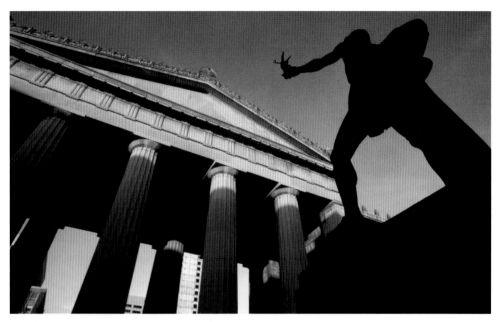

◄▲ DIAGONAL TENSION

The dynamic movement in this wide-angle photograph comes from the interplay of diagonals with the rectangular frame. Although the diagonal lines have an independent movement and direction, it is the reference standard of the frame edges that allows them to create tension in this picture.

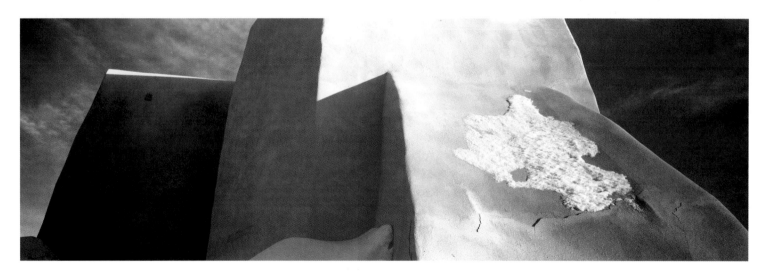

◄▲ INTERSECTING FOR ABSTRACTION

Breaking the normal rules, a panoramic frame is used here to exaggerate an abstract treatment of the back of an adobe church in New Mexico. A conventional approach would have been to show the top of this building and the lower buttressing down to the ground. The subject here, however, is not a literal version of the church, but the geometry and textures of the unusual planes. Squeezing the image at the top and bottom removes some of the realism, and compels the eye to consider the structure out of context.

FRAME SHAPE

The shape of the viewfinder frame (and LCD screen) has a huge influence on the form that the image takes. Despite the ease of cropping it later, there exists a powerful intuitive pressure at the time of shooting to compose right up to the edges of the frame. Indeed, it takes years of experience to ignore those parts of an image that are not being used, and some photographers never get used to this.

Most photography is composed to a few rigidly defined formats (aspect ratios), unlike in other graphic arts. Until digital photography, by far the most common format was 3:2—that of the standard 35mm camera, measuring 36x24mm—but now that the physical width of film is no longer a constraint, the majority of low- and middle-end cameras have adopted the less elongated, more "natural" 4:3 format that fits more comfortably on printing papers and monitor displays. The question of which aspect ratios are perceived as the most comfortable is a study in its own right, but in principle, there seems to be a tendency toward longer horizontally (the increasing popularity of wide-screen and letterbox formats for television), but less elongated for vertically composed images.

THE 3:2 FRAME

This is the classic 35mm frame, which has been transferred seamlessly to digital SLRs, creating in the process a sort of class distinction between professional and serious amateur photographers on the one hand, and everyone else on the other.

The reason for these proportions is a matter of historical accident; there are no compelling aesthetic reasons why it should be so. Indeed, more "natural" proportions would be less elongated, as evidenced by the bulk of the ways in which images are displayed—painting canvases, computer monitors, photographic printing paper, book and magazine formats, and so on. Part of the historical reason was that 35mm film was long considered too small for good enlargements, and the elongated shape gave more area. Nevertheless, its popularity demonstrates how easily our sense of intuitive composition adapts.

Overwhelmingly, this format is shot horizontally, and there are three reasons for this. The first is pure ergonomics. It is difficult to design a camera used at eye level so that it is just as easy to photograph vertically as horizontally, and few manufacturers have even bothered. SLRs are made to be used for horizontal pictures. Turning them on their side is just not as comfortable, and most photographers tend to avoid it. The second reason is more fundamental. Our binocular vision means that we see horizontally. There is no frame as such, as human vision involves paying attention to local detail and scanning a scene rapidly, rather than taking in a sharp overall view all at once. Our natural view of the world is in the form of a vague-edged, horizontal oval, and a standard horizontal film frame is a reasonable approximation. The final reason is that 3:2 proportions are often perceptually too elongated to work comfortably in portrait composition.

The net result is that a horizontal frame is natural and unremarkable. It influences the composition of an image, but not in an insistent, outstanding way. It conforms to the horizon, and so to most overall landscapes and general views. The horizontal component to the frame encourages a horizontal arrangement of elements, naturally enough. It is marginally more natural to place an image lower in the frame than higher—this tends to enhance the sensation of stability—but in any particular photograph there are likely to be many other influences. Placing a subject or horizon high in the frame produces a slight downward-looking, head-lowered sensation, which can have mildly negative associations.

For naturally vertical subjects, however, the elongation of a 2:3 frame is an advantage, and the human figure, standing, is the most commonly found vertical subject—a fortunate coincidence, as in most other respects the 2:3 proportions are rarely completely satisfactory.

▾ HUMAN VISION

Our natural view of the world is binocular and horizontal, so a horizontal picture format seems entirely normal. The edges of vision appear vague because our eyes focus sharply at only a small angle, and the surrounding image is progressively indistinct. Note, however, that this is not conventional blurring, as edges can be detected with peripheral vision. The limits of the view, here shown in gray, are also normally not perceived, just ignored.

ASPECT RATIO

This is the width-to-height ratio of an image or display. Here, for consistency, we assume the width is longer, unless referring to a specific vertical image. So, a standard SLR frame is 3:2, but composed vertically is 2:3.

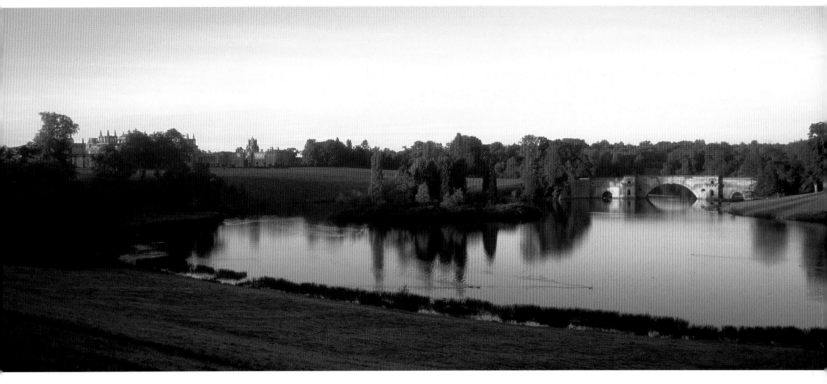

▲ PANORAMA
The correspondence of the horizon line and the format makes a horizontal frame natural for most long scenic views. This is the first sight for visitors of Blenheim Palace, Oxford, and its landscaped grounds, christened at the time it was built "the finest view in all of England." The length is necessary for this controlled scene, but depth is not.

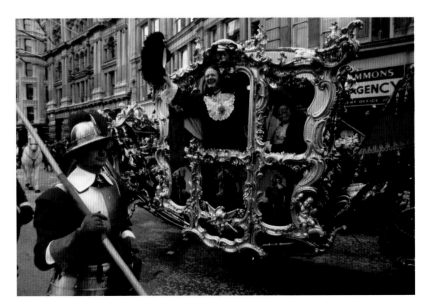

◄▲ THE STANDARD 3:2 FRAME
Its extra length when compared to the 4:3 frame of consumer cameras and most monitor displays makes this aspect ratio interesting to work in. There is always a sense of horizontality. In this photograph of the Lord Mayor's Show in the City of London, the basic structure depends on a balance between the soldier in the left foreground and the ornate coach behind, with a clear left-to-right vector and a distinct feeling of depth.

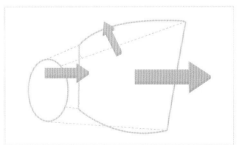

4:3 AND SIMILAR FRAMES

Traditionally, and once again with digital photography and on-screen presentations, these "fatter" frames are the most "natural" image formats. In other words, they are the least insistent and most accommodating to the eye. In the days when there was a rich variety of large-format film, formats included 5×4-inch, 10×8-inch, 14×11-inch, and 8½×6½-inch. There is now a reduced choice, but the proportions all work in much the same way, and equally for rollfilm formats, digital backs, and lower-end digital cameras.

In terms of composition, the frame dynamics impose less on the image, because there is less of a dominant direction than with 3:2. At the same time, that there is a distinction between height and width is important in helping the eye settle into the view, with the understanding that the view is horizontal or vertical. Compare this with the difficulties of a square format, which often suffers from lack of direction. As noted opposite, these proportions are very comfortable for most vertically composed images.

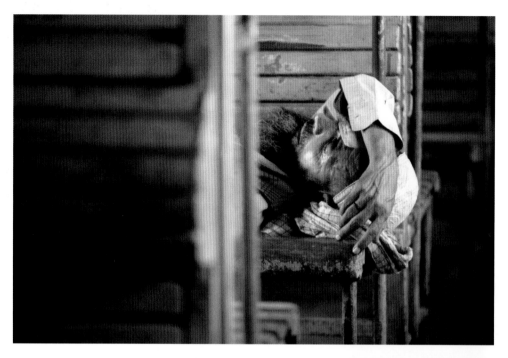

▲► SWITCHING ORIENTATION
In these photographs of a man sleeping on the Khyber railway, the natural balance occurs when his head is placed slightly low in the vertical shot, and to one side in the horizontal.

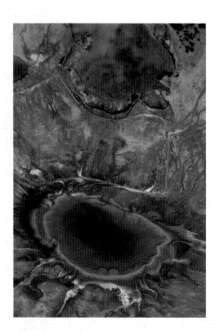

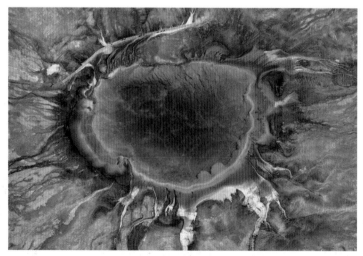

◄ SWITCHING ORIENTATION 2
Seen vertically from the air, the multi-hued Grand Prismatic Spring in Yellowstone National Park naturally fits a horizontal frame. Nevertheless, a vertical was also needed for possible full-page use. Switching to vertical meant placing the subject lower in the frame and finding another element (another spring) to fill the void above.

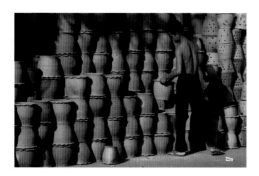

▲ VERTICAL SUBJECTS IN HORIZONTAL FRAMES

Although this format is not very well suited to vertical subjects like standing figures and tall buildings, inertia often encourages photographers to make it work as well as possible. One technique is to off-center the subject like this, so as to persuade the eye to move horizontally, across the frame.

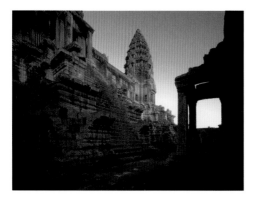

▲ AN UNINSISTENT FRAME

4:3, 5:4, and similar "fatter" frame shapes tend to dominate composition less than 3:2 or panoramas. There is usually more flexibility at the time of shooting. Indeed, this horizontal of Angkor Wat in Cambodia was eventually cropped in at the sides and used for a book cover.

SHOOTING VERTICALLY

As explained, there is a slight natural resistance to photographing vertically, even though print media actually favor this orientation because of the normal format of magazines and books (for this reason, professional photographers usually make an effort to shoot vertically as well as horizontally because of client demands). The naturalness of horizontal vision reinforces the eye's desire to scan from side to side, and a corresponding reluctance to scan up and down.

With a non-elongated subject, most people tend to place it below the center of the frame, and the more elongated the format, the lower, proportionately, the object goes. The natural tendency with a dominant single subject is to push the focus of attention downward, and demonstrates an inclination to avoid the upper part of a vertical frame. One explanation for this is that, as with horizontal frames, there is an assumption that the bottom of the picture is a base: a level surface on which other things can rest. This works unremarkably with 3:4 proportions, but the 2:3 proportions of an SLR frame are a little extreme, and this often leaves the upper part of the picture under-used.

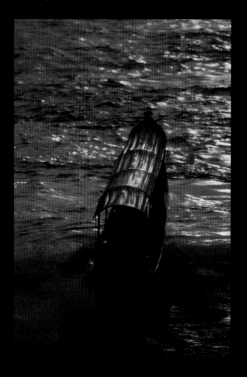

▲ LOW IN THE FRAME

The eye is naturally reluctant to scan up and down, and the bottom edge of a picture frame represents a base; thus gravity affects vertical composition. Subjects tend to be placed below the center, the more so with tall formats, as in this shot of a Bangkok river boat (the direction of movement also suggested a low placement).

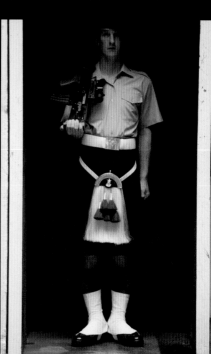

▲ STANDING FIGURE

The standing human figure is one of several classes of subject which suits a vertical format. Others include tall buildings, trees, many plants, bottles, and drinking glasses, doorways and archways.

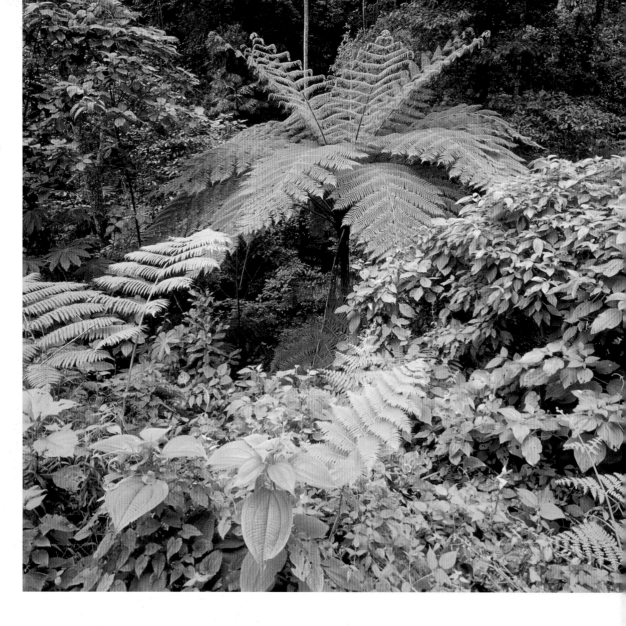

➤ **PATTERNS WITHOUT BIAS**
Patterns and other formless
arrangements fit well into a
square format because the frame
has no directional emphasis.
Under these circumstances, it
does not intrude on the image.

SQUARE

While all other photographic frames are rectangular, with varying proportions, one is fixed: the square. A few film cameras have this unusual format—unusual in that very few images lend themselves well to square composition. In general, it is the most difficult format to work with, and most design strategies for a square frame are concerned with escaping the tyranny of its perfect equilibrium.

We ought to look a little more closely at why most subjects are ill-suited to a square arrangement. In part, this has to do with the axis of the subject. Few shapes are so compact that they have no alignment. Most things are longer in one direction than in another, and it is natural to align the main axis of an image with the longer sides of a rectangular picture frame. Hence, most broad landscape views are generally handled as horizontal pictures, and most standing figures as verticals.

The square, however, has absolutely no bias. Its sides are in perfect 1:1 proportions, and its influence is a very precise and stable division of space. Here lies the second reason for the unsympathetic nature of square proportions: they impose a formal rigidity on the image. It is hard to escape the feeling of geometry when working with a square frame, and the symmetry of the sides and corners keeps reminding the eye of the center.

Occasionally a precise symmetrical image is interesting; it makes a change from the normally imprecise design of most photographs. However, a few such images quickly become a surfeit. It is fairly normal for photographers who work consistently with a square-format camera to imagine a vertical or horizontal direction to the picture, and to crop the resulting image later. Practically, this means composing fairly loosely in the viewfinder, to allow a certain amount of free space either at the sides or at the top and bottom.

SUBDIVIDING THE SQUARE

The equal dimensions of a square frame make it susceptible to symmetrical division, as these examples show. Vertical and horizontal lines enhance the square's stability; diagonals are more dynamic.

1. With its strongly implied center and equal sides, a square format takes very easily to a radial composition. Radial and other completely symmetrical subjects are particularly well-suited to the perfect equilibrium of the square. Their precision is complementary, but exact alignment is essential.

2. There is a precise relationship between the square and circle. Fitting one concentrically in the other emphasizes the sensation of focus and concentration on the center.

3. A natural subdivision is by vertical and horizontal lines, although the effect is extremely static.

4. A more dynamic, but still centered, subdivision is by means of diagonals and diamonds.

1

4

2

3

STITCHING AND EXTENDING

Digital stitching software has evolved into a widely used tool for creating images that are larger and wider. These are actually two separate functions. Shooting a scene with a longer focal length in overlapping frames is one technique for achieving higher resolution and so larger printed images—an equivalent of large-format photography. From the point of view of this book, however, the interest is in changing the shape of the final image. This tends to be panoramic, as long horizontal images have an enduring appeal for reasons we'll go into shortly, but there is also complete freedom, as the examples here show. What is often overlooked is the effect this stitching has on the process of shooting, because it demands anticipation of how the final image will look. There is no preview at the time, and this is a situation new to photography—that of having to imagine what the final image and frame shape will be. It gives stitched, extended images an unpredictability which can be refreshing.

Panoramas have a special place in photography. Even though proportions that exceed 2:1 seem to be extreme, for landscapes and other scenic views, they are actually very satisfying. To understand why, we have to look again at the way human vision works. We see by scanning, not by taking in a scene in a single, frozen instant. The eye's focus of attention roams around the view, usually very quickly, and the brain builds up the information. All of the standard photographic formats—and most painting formats, for that matter—are areas that can be absorbed in one rapid scanning sequence. The normal process of looking at the picture is to take in as much as possible in one prolonged glance, and then to return to details that seem interesting. A panorama, however, allows the eye to consider only a part of the image at a time, but this is by no means a disadvantage, because it replicates the way we look at any real scene. Apart from adding an element of realism to the picture, this slows down the viewing process, and, in theory at least, prolongs the interest of exploring

the image. All of this depends, however, on the photograph being reproduced fairly large and viewed from sufficiently close.

This virtue of the panorama—to draw the viewer in and present some of the image only to the peripheral vision—is regularly exploited in the cinema, where an elongated screen is normal. Special projection systems, such as Cinerama and IMAX, are premised on the realistic effect of wrapping the image around the viewer. Still panoramic images have a similar effect.

The frame can also be extended in post-production in other ways, by stretching (using warping, distortion, and other geometric software tools, and even by cloning). Certain images lend themselves to being extended in one or more directions—for instance, extending the sky upwards, or widening the background in a studio still-life. Magazine layouts often suggest this, although there are ethical considerations with this kind of manipulation, in that the final image is not necessarily as it was seen.

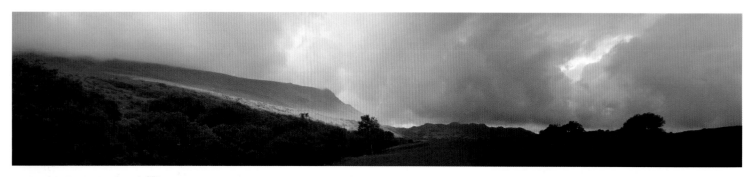

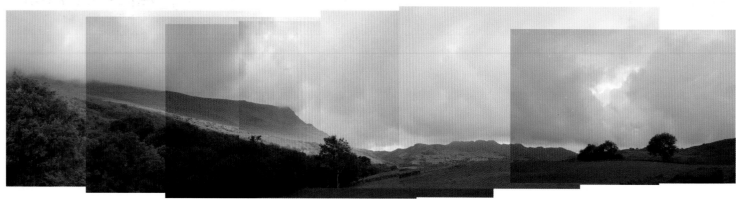

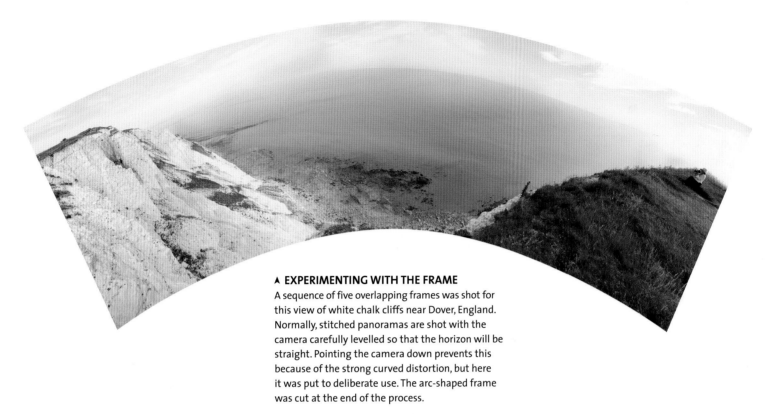

▲ EXPERIMENTING WITH THE FRAME
A sequence of five overlapping frames was shot for this view of white chalk cliffs near Dover, England. Normally, stitched panoramas are shot with the camera carefully levelled so that the horizon will be straight. Pointing the camera down prevents this because of the strong curved distortion, but here it was put to deliberate use. The arc-shaped frame was cut at the end of the process.

◄ 5:1 PANORAMA
In this stitched panoramic view, much of the sky and the foreground are removed, leaving the eye free to follow the rhythm of the horizon line and the interaction of cloud and mountain. Treated like this, a large number of natural landscapes fit very comfortably into stretched proportions. Eight overlapping horizontal images were shot.

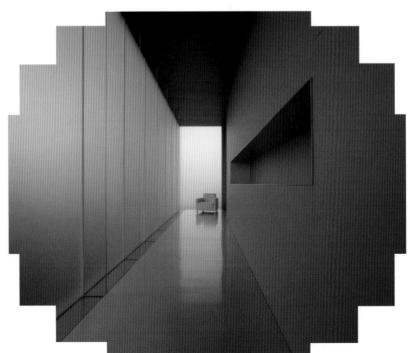

◄ STITCHING FOR CONTROL AND ENLARGEMENT
For a large-scale image and extra-wide coverage, a perspective-control shift lens was rotated, frame by frame, at full shift. Stitching these 13 images is, in a sense, the digital equivalent of large-format photography. Normally, this redented shape would be cropped, but here it has been left, not only to show the process but to be part of the form of the image.

CROPPING

Cropping is an editing skill that was highly developed during the days of black-and-white photography, lapsed somewhat in the color slide era, and is now revived fully as an integral part of preparing the final digital image. Even when the framing as shot is judged to be fine, technical adjustments such as lens distortion correction will demand it.

Cropping is one way of reworking the image well after it has been shot; an option for deferring design decisions, and even of exploring new ways of organizing an image. Unlike stitching, however, it reduces the size of the image, so demands a high resolution to begin with. In traditional enlarger printing, the enlarging easel itself acts as a cropping guide, but it may be easier to experiment first with L-shaped cropping masks on film (on a light box) or a contact sheet. With digital images (or scanned film), the process is infinitely easier and clearer, using software cropping tools.

It is important not to think of cropping as a design panacea or as an excuse for not being decisive at the time of shooting. The danger of having the opportunity to alter and manipulate a frame after it is shot is that it can lull you into imagining that you can perform a significant proportion of photography on the computer. Cropping introduces an interruption in the process of making a photograph, and most images benefit from continuity of vision.

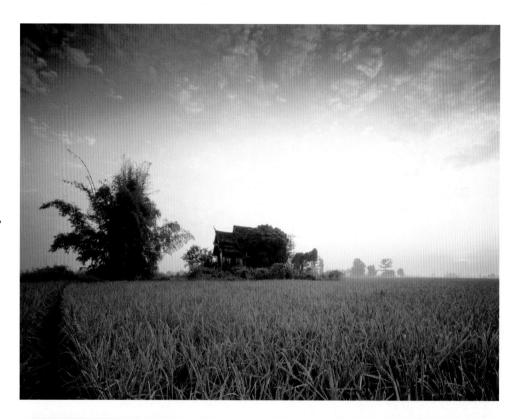

► NORTHERN THAI LANDSCAPE

For this Thai landscape, the several viable alternatives are shown together, superimposed on a black-and-white version of the image. The abandoned temple itself must remain the dominant element in the image—there is nothing else—and the choices are in the placement of the horizon line and in whether or not to include the clump of bamboo on the left. Placing the horizon low (purple and green frames) gives a more spacious, open feeling and emphasizes what is happening in the sky (sunrise and some threatening clouds). Raising the horizon line (red frame) draws attention to the rice in the field. A vertical crop (blue) also needs a significant area of rice to keep it anchored.

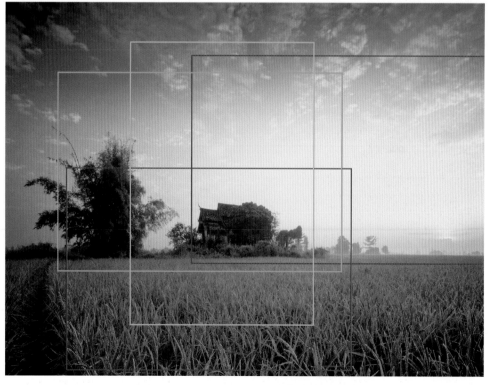

SCOTTISH LANDSCAPE

In the case of this misty landscape on the Isle of Skye, let's look at the kind of decisions involved. The original framing has clearly been chosen to make something of the rippled clouds at the top of the frame, and the horizon has been placed correspondingly low. This in itself reduces our options a little.

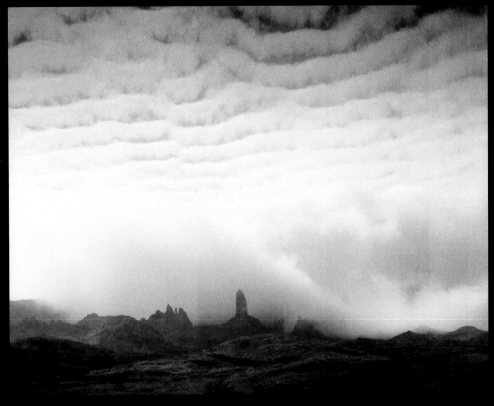

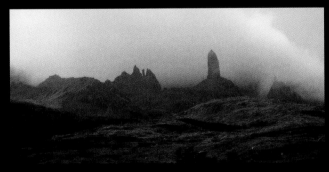

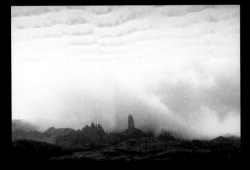

1. Perhaps the first, obvious crop is to ignore the high clouds and concentrate instead on the mist-shrouded qualities of the rocky pillars. Now, once we have dispensed with the clouds, there are no limits to how far down we can crop the top of the frame. In this instance, I have chosen to reverse the proportion of land to sky, and to take the opportunity to make a panorama. This is a viable alternative to the original picture, although it really needs to be considerably enlarged for the best possible effect.

2. Next, what if we try to crop in and still retain moderate horizontal proportions? Unfortunately, it seems that if there is to be any significant area of sky, it should go right to the existing top of the frame, simply in order to provide some tone and weight in that part of the picture. Cropping in at the sides does very little to enhance the importance of the pillars. The only reasonable option will be to crop the bottom, and go for a horizon line that almost coincides with the base of the picture.

3. Is a vertical crop possible? Given that an upright image has even more need of the tonal weight of the clouds, the best that we can do is to crop in at the sides. The choices are informed by selecting the most interesting shapes on the horizon.

FILLING THE FRAME

In order to be able to talk about the different graphic elements in composition, and to look at the way they interact, the first thing we must do is to isolate them, choosing the most basic situations for composing pictures. A little caution is needed here, because in practice there is usually a multitude of possibilities, and a single, isolated subject is something of a special case. The examples here may seem a little obvious, but at this stage we need clear, uncluttered examples.

The most basic of all photographic situations is one single, obvious subject in front of the camera, but even this presents two options. We have an immediate choice: whether to close right in so that it fills up the picture frame, or to pull back so that we can see something of its surroundings. What would influence the choice? One consideration is the information content of the picture. Obviously, the larger the subject is in the photograph, the more detail of it can be shown. If it is something unusual and interesting, this may be paramount; if very familiar, perhaps not. For example, if a wildlife photographer has tracked down a rare animal, we would reasonably expect to see as much of it as possible.

Another consideration is the relationship between the subject and its setting. Are the surroundings important, either to the content of the shot or to its design? In the studio, subjects are often set against neutral backgrounds; then the setting has nothing to tell the viewer, and its only value is for composition. Outside the studio, however, settings nearly always have some relevance. They can show scale (a climber on a rock-face) or something about the activity of the subject.

A third factor is the subjective relationship that the photographer wants to create between the viewer and the subject. If presence is important, and the subject needs to be imposing, then taking the viewer right up to it by filling the frame is a reasonable option. There are some mechanical matters involved, such as the ultimate size of the picture when displayed, the focal length of lens, and the scale of the subject

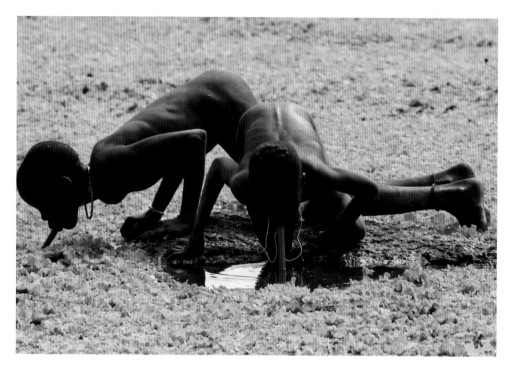

to begin with. Nevertheless, a big subject filling the frame of a big picture usually acquires force and impact. Moreover, as the examples here show, there can also be a satisfying precision in just matching subject to frame—particularly if the image has to be composed rapidly.

The shape of the subject in relation to the format of the frame clearly has an effect. In the sequence of the Hong Kong ferry on the right, the main picture shows a very satisfactory fit: the boat from this angle just reaches the edges all round. In the majority of single-subject pictures, however, the focus of attention does not fill the frame. The shape may not coincide with the format of the picture (cropping is always possible, but it is not necessarily elegant, and it may not suit the intended display method). Another possible risk with running the edges of the subject right up to the borders of the picture is that the eye may feel uncomfortable concentrating on points falling very near the edges of the picture. It often needs—or at least benefits from—a little free area around a subject to be able to move without feeling constricted.

▲ GUINEA WORM FILTERS

Two southern Sudanese boys using plastic filters to drink from a pond. Just fitting with little to spare, like this, usually means quick work with either feet or a zoom lens. In this case, there is room to spare at the top and bottom, but this usefully shows the uniform covering of duckweed, apparently limitless.

VIEWFINDER OR LCD?

Digital cameras offer two possibilities for active composition–looking *through* the viewfinder in the traditional way, or the newer method of looking *at* the two-dimensional LCD screen. The argument for the latter is that it eases the translation from a 3D scene to a 2D image. For active framing, this applies only to cameras without moving prism mechanisms (not SLRs). Even when using the viewfinder, the LCD offers a very useful review, not just of technical matters, but composition also.

VARYING THE SIZE IN THE FRAME

1. The success of this shot depends almost entirely on perfect timing as the ferry approaches the camera. Although it may not be immediately obvious, much of the design appeal of this photograph lies in the almost exact fit of the boat's shape to the 35mm frame. A little earlier, with more water showing around the edges, would have been more ordinary; a fraction later would have looked like a mistake. The ferry in this picture feels large; it has presence.

3. A different kind of context shot. More informative than attractive in its design, this shows us less about the ferry but more about where it is and what it does.

2. Pulling back gives a more typical subject-in-its-setting treatment. Successful because of the crisp lighting but more ordinary than the previous photograph, the setting in this case can be taken as read; we know the ferry must be on water, and because there is nothing unusual about it (heavy waves or interesting color), it adds little to the picture.

4. Over-filling the frame takes us into the structural details of a subject. Here, the lifebelts inform us that this is a boat, but the definition of the subject has altered: this picture is now concerned as much with the people as with the ferry.

PLACEMENT

In any construction involving one, obvious subject, other than filling the frame with it, there is always the decision of where to place it, remaining sensitive to the proportions of the space surrounding it. As soon as you allow free space around the subject, its position becomes an issue. It has to be placed, consciously, somewhere within the frame. Logically, it might seem that the natural position is right in the middle with equal space around, and indeed, there are many occasions when this holds true. If there are no other elements in the picture, why not?

One compelling reason why not is that it is very predictable—and, if repeated, boring. We are faced with a conflicting choice. On the one hand, there is a desire to do something interesting with the design and escape the bull's-eye method of framing a subject. On the other hand, placing the subject anywhere but in a natural position needs a reason. If you place a subject right in the corner of an otherwise empty frame, you need a justification, or the design becomes simply perverse. Eccentric composition can work extremely well, but as we will see later in the book, its success depends on there being some purpose behind it.

The importance of placement increases as the subject becomes smaller in the frame. In the photograph of the sentry on page 15, we are not really conscious that the figure is actually in any position in the frame. It is, in fact, centered but with not so much space around it as to be obvious. With the photograph of the water-bound hamlet here, we are made very aware of its position in the frame because it is obviously isolated and surrounded by ocean. Some off-centeredness is usually desirable simply in order to set up a relationship between the subject and its background. A position dead center is so stable as to have no dynamic tension at all. If slightly away from the middle, the subject tends to appear to be more in context. There are also considerations of harmony and balance, which we'll come to in the next chapter.

In practice, other elements do creep into most images, and even a slight secondary point of interest is usually enough to influence the placement of the subject. In the case of the stilted houses, we aware of the position of the sun above and left; there is an inferred relationship here, one that makes it natural to offset the houses slightly in the opposite direction.

Vectors can also influence an off-center position. For instance, if the subject is obviously in motion, and its direction is plain, then the natural tendency is to have it entering the frame rather than leaving it. I emphasize the word natural, however, because there may always be special reasons for doing things differently—and different usually gets more attention. In a more general sense, subjects that "face" in one direction (not necessarily literally) also often fit more comfortably so that they are offset, so that some of the direction they "see" is in the frame.

As a rule of thumb, when the setting is significant—that is, when it can actually contribute to the idea behind the picture—then it is worth considering this kind of composition, in which the subject occupies only a small area. In the case of the houses in the sea, the whole point of the picture is that people live in such unusual circumstances: surrounded by water. Closing in would miss the point. Unfortunately, moving further back would only reduce the size of the houses so much that they would be indecipherable, although it would show still more ocean.

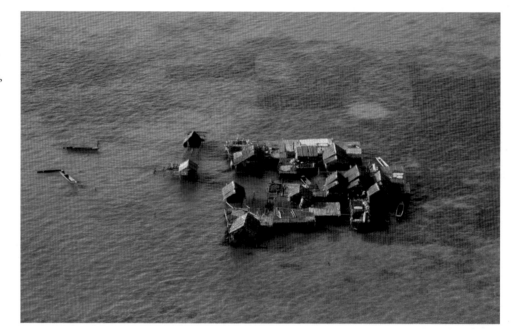

◄▲ OCEAN LIVING
The purpose of this aerial view of stilted houses built in the middle of the Sulu Sea in the Philippines is to draw attention to their unusual and isolated location. Off-centering the subject brings some life to the design, and encourages the eye to move from the houses towards the upper left corner of the frame.

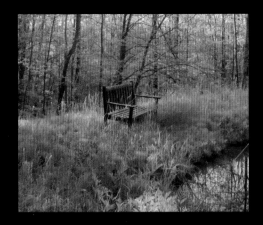

A BENCH IN THE GRASS

This is an exercise in placement. The overall view shows that the old bench is next to a pond and surrounded by green, although the foreground is more continuous than the background, where patches of sky can be seen. For this last reason, closing in meant keeping the bench near the top of the frame.

1. The first attempt was a tight fit, and the gaps marked with parallel blue lines are where the framing decision has to be made.

2. Pulling back offers two choices. In this, the diagonals of the bench are considered dominant, so the placement is offset against them, to the right.

3. Alternatively, the bench, waiting for someone to sit, can be thought of as "facing" right and down. To counter this, it is placed on the left.

4. Now a horizontal attempt. Here it definitely makes sense to consider its right-facing aspect, so it is placed at left, facing in.

5. Pulling back reveals the edge of the pond. This is now a second subject added to the image, and the framing attempts to balance the two.

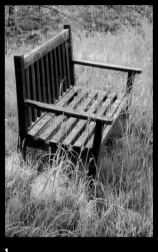

1

2

4

3

5

DIVIDING THE FRAME

Any image, of any kind, automatically creates a division of the picture frame. Something like a prominent horizon line does this very obviously, but even a small object against a bland background (a point, in other words) makes an implied division. Look at any of the pictures in this book which comprise a single small subject—shifting the position of the subject changes the areas into which the frame is divided.

There are, naturally, an infinite number of possible divisions, but the most interesting ones are those that bear a definable relationship to each other. Division is essentially a matter of proportion, and this has preoccupied artists in different periods of history. During the Renaissance, in particular, considerable attention was given to dividing the picture frame by geometry. This has interesting implications for photography, for while a painter creates the structure of a picture from nothing, a photographer usually has little such opportunity, so much less reason to worry about exact proportions. Nevertheless, different proportions evoke certain responses in the viewer, whether they were calculated exactly or not.

During the Renaissance, a number of painters realized that proportions of division based on simple numbers (like 1:1, 2:1, or 3:2) produced an essentially static division. By contrast, a dynamic division could be made by constructing more interesting ratios. The Golden Section, which was known to the Greeks, is the best known "harmonious" division. As outlined below, the Golden Section is based on pure geometry, and photographers almost never have either the need or the opportunity to construct it. Its importance lies in the fact that all the areas are integrally related; the ratio of the small section to the large one is the same as that of the large section to the complete frame. They are tied together, hence the idea that they give a sense of harmony.

The logic of this may not seem completely obvious at first, but it underlies more than just the subdivision of a picture frame. The argument is that there are objective physical principles that underlie harmony. In this case, they are geometric, and while we may not be aware of them in operation, they still produce a predictable effect. The subdivision of a standard 3:2 frame according to the Golden Section is shown opposite. Precision is not of major importance, as the photographs show.

The Golden Section is not the only way of making a harmonious division. It is not even the only method in which the ratios are integrally related. Another basis, also from the Renaissance, is the Fibonacci series—a sequence of numbers in which each is the sum of the previous two: 1, 2, 3, 5, 8, 13, and so on. In yet another method, the frame is subdivided according to the ratio of its own sides. There is, indeed, a massive variety of subdivisions that obey some internal principle, and they all have the potential to make workable and interesting images.

This is all very well for a painter or illustrator, but how can photography make sensible use of it? Certainly, no-one is going to use a calculator to plan the division of a photograph. Intuitive composition is the only practical approach for the majority of photographs. The most useful approach to dividing a frame into areas is to prime your eye by becoming familiar with the nuances of harmony in different proportions. If you know them well, intuitive composition will naturally become more finely tuned. As photographers, we may be able to ignore the geometry, but we can not ignore the fact that these proportions are fundamentally satisfying. Notice also that, by dividing the frame in both directions, an intersection is produced, and this makes a generally satisfying location for a point, or any other focus of attention. Compare this with the off-center placement of small subjects on pages 66-69.

GOLDEN SECTION PROPORTIONS

Two parts are said to be in the golden ratio if the whole (the sum of the two parts) is to the larger part as the larger part is to the smaller part. The calculation for this is:

$$\frac{a+b}{a} = \frac{a}{b}$$

where a is the larger part and b is the smaller part.

This ratio, denoted φ (phi), is an irrational number with the value

$$\varphi = \frac{1}{2}\left(1 + \sqrt{5}\right) \approx 1.618033989$$

In photography, this is analysis after the event; no photographer ever calculates this, but familiarity with these proportions makes it easy to reproduce them, more or less, in a composition instinctively.

GOLDEN RATIO FRAME

The frame on the left is in the ratio 1.618, or 144:89, which argues for its being aesthetically pleasing and balanced. For more on ratios and the principle of balance, see pages 40-43. For comparison, on the right is the standard 35mm (now digital SLR) frame in the ratio 3:2. They are by no means dissimilar.

INTEGRATED PROPORTIONS

In principle, any subdivision of the frame that is integrated internally produces a sense of harmonious balance. The first diagram below demonstrates a subdivision according to the Fibonacci series (see page 26). The second shows a geometric base using the frame's own sides. Most of the useful subdivisions are rectilinear, but diagonals can be used to create triangular spaces.

In the photograph to the right, the composition was of course intuitive, but the changing alignments very clearly suggested a rectilinear division. As the sequence shows, the initial scene was of just the horizon and distant boats, hence the experiments up and down. The arrival of the fisherman in a red rowing boat changed the dynamics, and the instant when both he and the boat were aligned vertically in the frame made the shot. A moment later, this all fell apart.

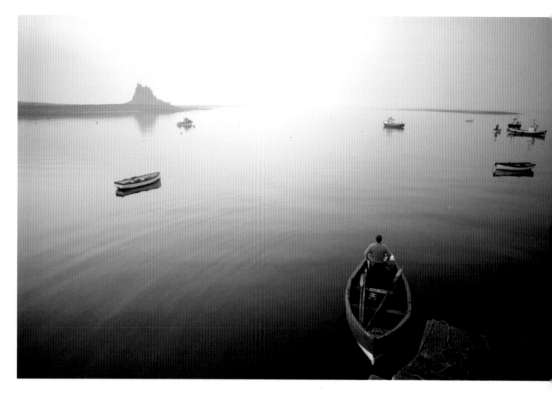

FIBONACCI DIVISIONS

BEFORE

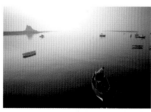 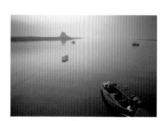

GEOMETRICAL (BASED ON SIDES)

AFTER

HORIZON

Probably the most common photographic situation in which the frame must be divided cleanly and precisely is the one that includes the horizon line. In landscapes of the type shown on these pages it becomes the dominant graphic element, the more so if there are no outstanding points of interest in the scene.

Plainly, if the line of the horizon is the only significant graphic element, placing it becomes a matter of some importance, and the simple case is when it is actually horizontal (no hilly contours). There is a natural tendency to place the line lower in the frame than higher, related to the association of the bottom of the picture frame with a base. We explore this later, on pages 40-43 (Balance), but a low placement for most things in principle gives a greater sense of stability. This apart, the question of the exact position remains open. One method is to use the linear relationships described on the preceding pages.

Another is to balance the tones or colors (see pages 118-121 for the principles of combining colors according to their relative brightness).

Yet another method is to divide the frame according to what you see as the intrinsic importance of the ground and sky. For instance, the foreground may be uninteresting, distracting, or in some other way unwanted, while the skyscape is dynamic, and this might argue for a very low horizon, almost to the edge of the frame. There are examples of this here and elsewhere in this book (cropping, as discussed on pages 20-21, is another opportunity to explore these considerations). In the shot of Lake Inle, the form of the clouds is definitely worth making part of the image, but the clouds are too delicate in tone simply to use a wider angle of lens and include more of the dark foreground. They can register properly only if the proportion of the ground is severely reduced so that it does not overwhelm the picture.

If, on the other hand, there is some distinct feature of interest in the foreground, this will encourage a higher position for the horizon. Indeed, if the sky has no graphic value and the foreground has plenty of interest, it may make more sense to reverse whatever subdivision you choose, and place the horizon much closer to the top of the frame.

There is, needless to say, no ideal position even for any one particular scene and angle of view. Given this, and the kind of decisions just mentioned, there may be good reasons for experimenting with different positions. There is little point, however, in simply starting low and moving progressively higher without considering the influences and reasons. As the pair of photographs shot in Monument Valley illustrates, different horizon positions can have equal validity, depending on the circumstances of the picture, and also on personal taste.

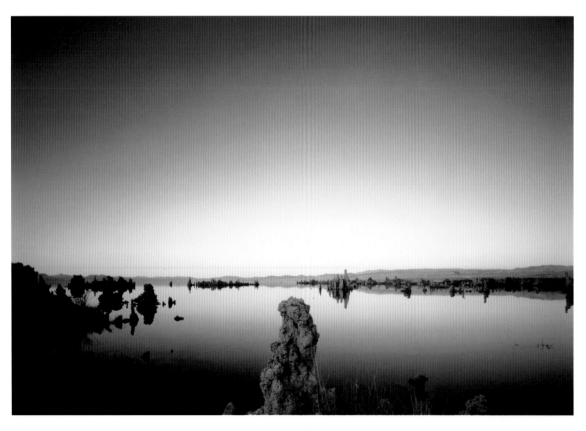

◄ A NATURAL, LOW POSITION
In this view of Mono Lake, California, the horizon is uninterrupted and the sky empty of clouds, which simplifies the factors affecting the placement. This position approximates to the Golden Section (see page 26).

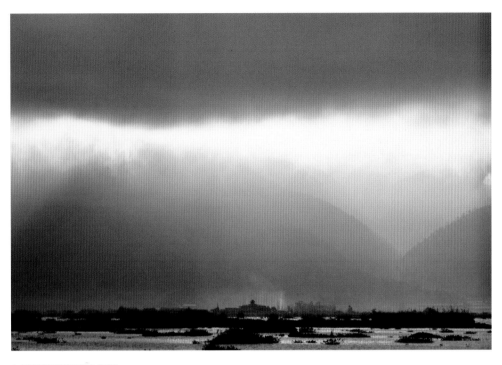

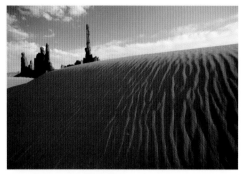

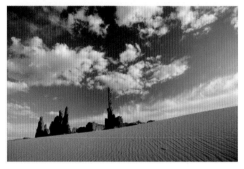

▲ FAVORING THE SKY
The atmospheric sky and mountains in this telephoto shot of Lake Inle in Burma justify a very low placement, and avoid what would be an out-of-focus foreground.

▲ A CHOICE OF HIGH OR LOW
The Totem Pole and Yei-Bichei Rocks in Monument Valley, seen from the foot of a sand dune. The texture of the dune seen in raking sunlight and the cloud pattern in the sky competed in interest, suggesting two equally valid alternative framings.

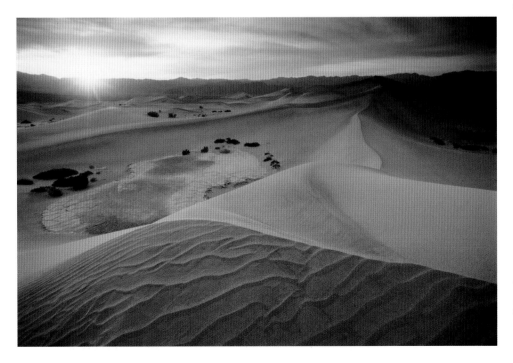

◄ NEGLECTING THE SKY
A wide-angle view of Death Valley sand dunes places the interest in the details of the ripples. The setting sun gives sufficient interest to the horizon without needing more sky in the composition.

FRAMES WITHIN FRAMES

One of the most predictably successful of all photographic design constructions is an internal frame. As with any established design formula, it contains real risks of overuse, and has the makings of a cliché, but these dangers are only evidence of the fact that it does work. It simply needs a little more care and imagination when it is being applied.

The appeal of frames within frames is partly to do with composition, but at a deeper level it relates to perception. Frames like those shown here and on the next few pages enhance the dimensionality of a photograph by emphasizing that the viewer is looking through from one plane to another. As we'll see at other points in this book, one of the recurrent issues in photography is what happens in converting a fully three-dimensional scene into a two-dimensional picture. It is more central to photography than to painting or illustration because of photography's essentially realistic roots. Frames within the picture have the effect of pulling the viewer through; in other words, they are a

kind of window. There is a relationship between the frame of the photograph and an initial step in which the viewer's attention is drawn inward (the corners are particularly important in this). Thereafter, there is an implied momentum forward through the frame. Walker Evans, for example, often made deliberate use of this device. As his biographer, Belinda Rathbone, writes, "That his photographs saw through windows and porches and around corners gave them a new dimension and power and even an aura of revelation."

Another part of the appeal is that by drawing a boundary around the principal image, an internal frame is evidence of organization. A measure of control has been imposed on the scene. Limits have been set, and the image held back from flowing over the edges. Some feelings of stability and even rigidity enter into this, and this type of photograph lacks the casual, freewheeling associations that you can see in, for example, classic journalistic or reportage photography. As a result, frames within frames appeal to a certain aspect

of our personalities. It is a fundamental part of human nature to want to impose control on the environment, and this has an immediate corollary in placing a structure on images. It feels satisfying to see that the elements of a picture have been defined and placed under a kind of control.

On a purely graphic level, frames focus the attention of the viewer because they establish a diminishing direction from the outer picture frame. The internal frame draws the eye in by one step, particularly if it is similar in shape to the picture format. This momentum is then easily continued further into the picture. Another important design opportunity to note is the shape relationship between the two frames. As we saw when we looked at the dynamics of the basic frame, the angles and shapes that are set up between the boundary of the picture and lines inside the image are important. This is especially so with a continuous edge inside the picture. The graphic relationship between the two frames is strongest when the gap between them is narrow.

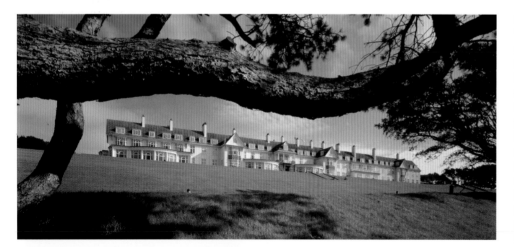

◄ ▲ ENHANCING PERSPECTIVE
From a low and exact camera position (one with little latitude for movement), the natural frame formed by the tree in the foreground helps to strengthen a composition in which the eye is led under the branch and up the lawn toward the building.

► MANHATTAN BRIDGE
This pair of related photographs, taken a short distance apart, of the Empire State Building and the Manhattan Bridge in New York, shows how the frame-within-frame technique can alter the dynamics of the image. In the first photograph, the viewpoint was chosen so that the image of the building butts right up to the edge of the bridge's tower. The principal dynamic here is the correspondence of shapes, encouraging the eye to move between the two, as shown in the first diagram. From a viewpoint slightly to the right, the building can be made to fit neatly into the bridge tower's central arch. Now the eye is directed inward toward the building, in three steps, as shown by the arrows in the second diagram. Once again, the internal frame structures the images more formally.

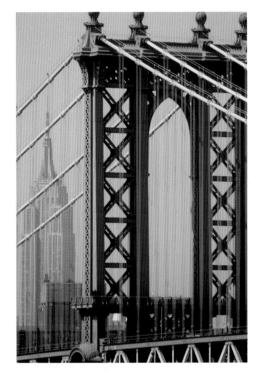

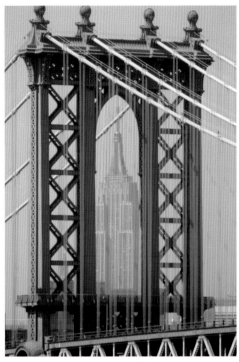

▲ INTRODUCING MOVEMENT

Much of the success of using internal frames is due to finding the right correspondence of shape, followed by a combination of camera position and focal length to make the match. In this case, the undulation of the heavy silhouetted branch in the foreground creates a rotating vector to enliven the image.

CHAPTER 2:
DESIGN BASICS

Composition is essentially organization, the ordering of all the possible graphic elements inside the frame. This is basic design, and photography has the same fundamental needs in this respect as any other graphic art. The danger is the same also—that detailing a technique on paper can lead to it being read as a dogmatic set of rules. It is especially important to treat basic design as a form of inquiry, an attitude of mind, and a summary of the resources available. It is not a quick fix.

There is a useful analogy with language. Using the frame, which we have just looked at, as the context or setting, design basics form the grammar, the graphic elements in the next chapter are the vocabulary, and the process, in the last chapter, is the syntax—the way in which the forms in photography are put together, ultimately defining its nature.

The principles of design in photography are, to an extent, different from those in painting and illustration. For the most part there is no particular value in making these comparisons, but it is important to understand that there are objective principles of design; that is, they exist independently of individual taste. They explain why certain photographs create the impressions they do, and why particular ways of organizing the image have predictable effects.

The two most fundamental principles are contrast and balance. Contrast stresses the differences between graphic elements in a picture, whether it is contrast of tone, color, form, or whatever. Two contrasting elements reinforce each other. Balance is intimately related to contrast; it is the active relationship between opposing elements. If the balance (between blocks of color, for example) is resolved, there is a sense of equilibrium in the image. If unresolved, the image seems out of balance, and a visual tension remains.

Both extremes, and all varieties of balance in between, have their uses in photography. The eye seeks harmony, although this does not make it a rule of composition. Denying the eye perfect balance can make a more interesting image, and help to provoke the response the photographer wants. Effective composition is not committed to producing gentle images in familiar proportions. It is usually visually satisfying, but ultimately good design is functional. It begins with the photographer having a clear idea of the potential for a picture, and of what the effect of the image should be.

Finally, design has to work within limits: what its audience already knows about photographs. This audience may know nothing of design techniques, but it has an understanding of the conventions, based on familiarity from seeing countless images. Sharp focus, for instance, is understood to mark the points of interest and attention. Certain ways of composing an image are considered normal, so that there are assumed standards; the photograph can meet these or challenge them, according to the photographer's intention.

CONTRAST

The most fundamental overhaul of design theory in the 20th century took place in Germany in the 1920s and its focus was the Bauhaus. Founded in 1919 in Dessau, this school of art, design, and architecture was a major influence because of its experimental, questioning approach to the principles of design. Johannes Itten ran the Basic Course at the Bauhaus. His theory of composition was rooted in one simple concept: contrasts. Contrast between light and dark (chiaroscuro), between shapes, colors, and even sensations, was the basis for composing an image. One of the first exercises that Itten set the Bauhaus students was to discover and illustrate the different possibilities of contrast. These included, among many others, large/small, long/short, smooth/rough, transparent/opaque, and so on. These were intended as art exercises, but they translate very comfortably into photography.

Itten's intention was "to awaken a vital feeling for the subject through a personal observation," and his exercise was a vehicle for plunging in and exploring the nature of design. Here is an adaptation of his exercises for photography.

The project is in two parts. The first is rather easier—producing pairs of photographs that contrast with each other. The easiest way to do this is to make a selection from pictures you've already taken, choosing those that best show a certain contrast. More demanding but more valuable is to go out and look for images that illustrate a pre-planned type of contrast—executing shots to order.

The second part of the project is to combine the two poles of the contrast in one photograph, an exercise that calls for a bit more imagination. There are no restrictions to the kind of contrast, and it can be to do with form (bright/dark, blurred/sharp) or with any aspect of content. For example, it could be contrast in a concept, such as continuous/intermittent, or something non-visual, like loud/quiet. The list in the box below is from Itten's original Bauhaus exercise.

A passionate educator, Itten wanted his students to approach these contrasts from three directions; "they had to experience them with their senses, objectivize them intellectually, and realize them synthetically." That is, each student had first to try to get a feeling for each contrast without immediately thinking of it as an image, then list the ways of putting this sensation across, and finally make a picture. For example, for "much/little," one first impression might be of a large group of things with one of them standing out because it is in some way different. On the other hand, it could be treated as a group of things with an identical object standing a little apart, and so isolated. These are just two approaches out of several alternatives.

ITTEN'S CONTRASTS	
Point / line	Area / line
Plane / volume	Area / body
Large / small	Line / body
High / low	Smooth / rough
Long / short	Hard / soft
Broad / narrow	Still / moving
Thick / thin	Light / heavy
Light / dark	Transparent / opaque
Black / white	Continuous / intermittent
Much / little	Liquid / solid
Straight / curved	Sweet / sour
Pointed / blunt	Strong / weak
Horizontal / vertical	Loud / soft
Diagonal / circular	

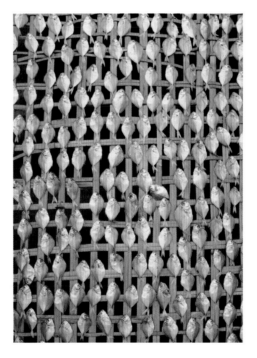

MANY
To maximize the impression of quantity, this shot of drying fish was composed right to the edges of the rack, but not beyond, so that the fish appear to extend beyond the frame edges.

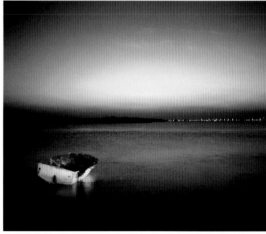

ONE
To emphasize the isolation of this abandoned boat, a wide-angle lens increases the perspective, separating it from the distant shore. The composition helps by eliminating from the view other extraneous points of attention.

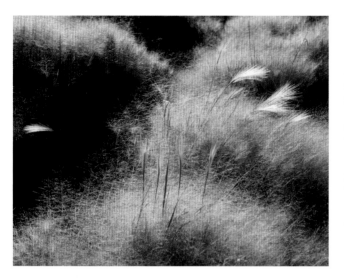

SOFT
The very fine texture of this marsh grass near Mono Lake, California, is made to appear even more delicate by choosing a viewpoint against the sun.

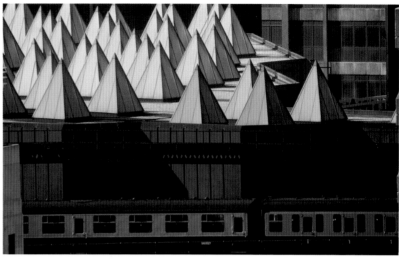

HARD
The dull lighting, drab urban setting, and foreshortening effect of a telephoto lens all contribute to the spiky, aggressive quality of these architectural roof pyramids.

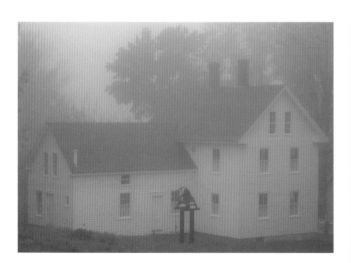

FLAT
The low contrast in this view of a Shaker village in Maine is due entirely to the quality of lighting: early morning fog.

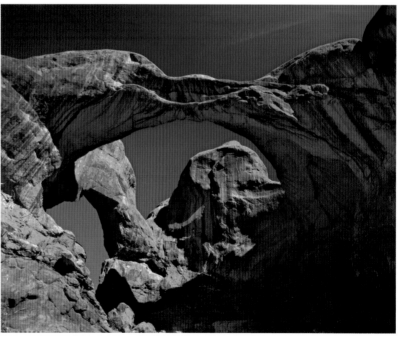

CONTRASTY
The highest-contrast lighting effect is produced by a high sun in clear weather and unpolluted air. The strong relief of these rock arches creates deep, unrelieved shadow.

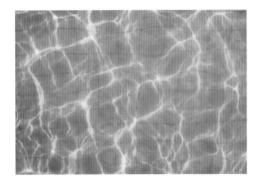

LIQUID

Water and other liquids have no intrinsic shape, so one common method of representing them is as droplets or falling streams against a non-liquid background. Here, however, the wave patterns of sunlight convey the effect in a swimming pool, making it possible to shoot nothing but water.

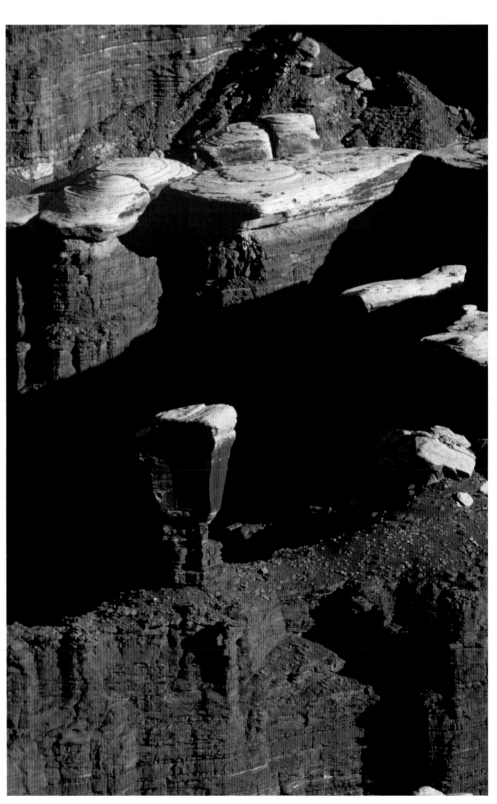

SOLID

Hard lighting and rough, dry texture give the impression of rocky solidity. A telephoto lens compresses the view of these canyons into a wall-like structure, filling the frame.

SOFT/HARD
A flamingo's pink feather fallen onto cracked, baked mud in Mexico's Rio lagartos reserve in Yucatan.

SOLID/LIQUID
Combining the two contrasts shown opposite in one, this still-life shows a steel superconducting device in its cooling bath of liquid nitrogen, bubbling in the higher temperature of the studio.

DELICATE/BRASH
Cherry blossom week in Japan is a holiday occasion for viewing the delicate pink flowers. Here, however, they are seen against garish hoardings in Tokyo. The contrast is even more poignant in Japanese, as the characters read "Really Cheap!"

GESTALT PERCEPTION

Gestalt psychology was founded in Austria and Germany in the early 20th century, and while some of its ideas (such as that objects seen form similarly shaped traces in the brain) have long been abandoned, it has had an important revival in its approach to visual recognition.

Modern Gestalt theory takes a holistic approach to perception, on the basic principle that the whole is greater than the sum of its parts, and that in viewing an entire scene or image, the mind takes a sudden leap from recognizing the individual elements to understanding the scene in its entirety. These two concepts—appreciating the greater meaning of the entire image and grasping it suddenly and intuitively—may at first seem at odds with what is known about how we look at images. (The principle that we build up a picture from a series of rapid eye movements to points of interest is explored more thoroughly on pages 80-81.) However, in reality, Gestalt theory has adapted to experimental research, and, despite its sometimes vague assertions, offers some valid explanations about the complex process of perception. Its importance for photography lies mainly in its laws of organization, which underpin most of the principles of composing images, particularly in this and the next chapter.

The word "Gestalt" has no perfect English translation, but refers to the way in which something has been *gestellt*, that is, "placed" or "put together," with obvious relevance to composition. As a way of understanding perception, it offers an alternative to the atomistic, iterative way in which computers and digital imaging work, step-by-step, and stresses the value of insight. Another principle from Gestalt is "optimization," favoring clarity and simplicity. Allied to this is the concept of *pragnanz* (precision), which states that when understanding takes place as a whole ("grasping the image"), it involves minimal effort.

The Gestalt laws of organization, listed in the box, go a long way toward explaining the ways in which graphic elements in photographs, such as potential lines, points, shapes, and vectors, are "completed" in viewers' minds and understood to animate and give balance to an image. One of the most important and easy-to-grasp laws is that of Closure, usually illustrated by the well-known Kanizsa triangle (illustrated opposite). We can see this principle time and again in photography, where certain parts of a composition suggest a shape, and this perceived shape then helps to give structure to the image. In other words, an implied shape tends to strengthen a composition. It helps the viewer make sense of it. Triangles are among the most potent of "closure-induced" shapes in photography, but the example illustrated opposite is the somewhat more unusual one of a double circle.

As we'll see in more detail when we come to the process of shooting (in Chapter 6), creating and reading a photograph heavily involves the principle of making sense of a scene or an image, of taking the visual input and attempting to fit it to some hypothesis that explains the way it looks. Gestalt theory introduces the idea of regrouping and restructuring the visual elements so that they make sense as an entire image—also known as the "phi-phenomenon." However, whereas Gestalt theory is used in instructional design—for example, to eliminate confusion and speed up recognition (diagrams, keyboards, plans, and so on)— in photography it can play an equally valuable opposite role.

As we'll see when we come to Chapter 6, Intent, there are many advantages in slowing down the way people view a photograph, so as to deliver a surprise or to involve them more deeply in the image (Gombrich's "beholder's share", page 140). For example, the principle of Emergence (see box) is valuable in explaining how, in a sudden moment, the mind comprehends something in a photograph that was visually "hidden" (pages 144-145, Delay, go into this in more detail). Normally, in presenting information, making the viewer's mind work harder is not considered a good thing, but in photography and other arts it becomes part of the reward for viewing.

▲ KANISZA TRIANGLE
The most well-known demonstration of closure is this, designed by Italian psychologist Gaetano Kanisza, in which the only shapes are three circles with wedges cut out of them, yet the eye sees a triangle.

GESTALT LAWS AND PRINCIPLES

THE GESTALT LAWS OF PERCEPTUAL ORGANIZATION:

1. Law of Proximity. Visual elements are grouped in the mind according to how close they are to each other.
2. Law of Similarity. Elements that are similar in some way, by form or content, tend to be grouped.
3. Law of Closure. Elements roughly arranged together are seen to complete an outline shape. The mind seeks completeness.
4. Law of Simplicity. The mind tends towards visual explanations that are simple; simple lines, curves, and shapes are preferred, as is symmetry and balance.
5. Law of Common Fate. Grouped elements are assumed to move together and behave as one.
6. Law of Good Continuation. Similar to the above, this states that the mind tends to continue shapes and lines beyond their ending points.
7. Law of Segregation. In order for a figure to be perceived, it must stand out from its background. Figure-ground images (see page 48) exploit the uncertainty of deciding which is the figure and which is the background, for creative interest.

Grouping plays a large part in Gestalt thinking, and this is known as "chunking."

GESTALT PRINCIPLES INCLUDE:

1. Emergence. Parts of an image that do not contain sufficient information to explain them suddenly pop out as a result of looking long enough and finally grasping the sense.
2. Reification. The mind fills in a shape or area due to inadequate visual input. This includes closure (above).
3. Multistability. In some instances, when there are insufficient depth clues, objects can be seen to invert spontaneously. This has been exploited more in art (M. C. Escher, Salvador Dali) than in photography.
4. Invariance. Objects can be recognized regardless of orientation, rotation, aspect, scale, or other factors.

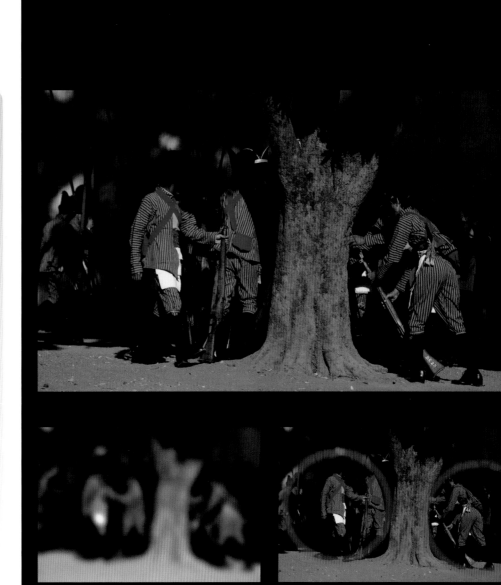

1

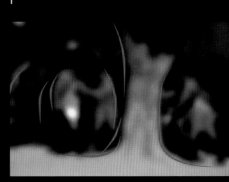

2

3

▲ ➤ CLOSURE TO CIRCLES

The Gestalt Law of Closure governs many of the compositional techniques that help give structure to images. In this photograph of ceremonial guards at the annual Garebeg ceremony at the palace of Yogyakarta, Java, the eye sees two approximate circles left and right, and this helps order the image. Yet these are entirely notional. In [1], applying a median filter to simplify the view, the shapes stand out more. In [2], the actual curved sections are marked, and can be seen to be very far from completed circles, yet as highlighted in [3], the implied circles work to concentrate the attention on the uniformed soldiers inside them. This is essentially the mechanism demonstrated on pages 84-93 (which cover the theme of shapes).

BALANCE

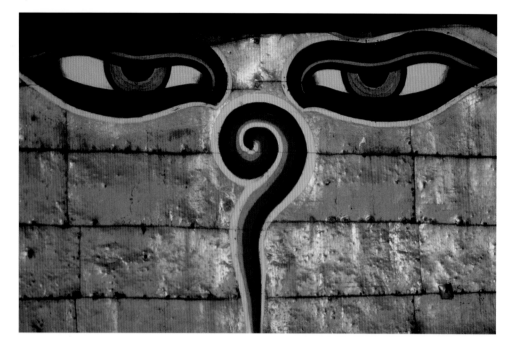

At the heart of composition lies the concept of balance. Balance is the resolution of tension, opposing forces that are matched to provide equilibrium and a sense of harmony. It is a fundamental principle of visual perception that the eye seeks to balance one force with another. Balance is harmony, resolution, a condition that intuitively seems aesthetically pleasing. In this context, balance can refer to any of the graphic elements in a picture (in Chapter 3 we will review each of these in turn).

If we consider two strong points in a picture, for example, the center of the frame becomes a reference against which we see their position. If one diagonal line in another image creates a strong sense of movement in one direction, the eye is aware of the need for an opposite sense of movement. In color relationships, successive and simultaneous contrasts demonstrate that the eye will seek to provide its own complementary hues.

When talking about the balance of forces in a picture, the usual analogies tend to be ones drawn from the physical world: gravity, levers, weights, and fulcrums. These are quite reasonable analogies to use, because the eye and mind have a real, objective response to balance that works in a very similar way to the laws of mechanics. We can develop the physical analogies more literally by thinking of an image as a surface balanced at one point, rather like a weighing scale. If we add anything to one side of the image—that is, off-center—it becomes unbalanced, and we feel the need to correct this. It does not matter whether we are talking about masses of tone, color, an arrangement of points, or whatever. The aim is to find the visual "center of gravity."

Considered in this way, there are two distinct kinds of balance. One is symmetrical or static; the other is dynamic. In symmetrical balance, the arrangement of forces is centered—everything falls equally away from the middle of the picture. We can create this by placing the subject of a photograph right in the middle of the frame. In our weighing-scale analogy, it sits right over the fulcrum, the point of balance. Another way of achieving the same static balance is to place two equal weights on either side of the center, at equal distances. Adding a dimension to this, several graphic elements equally arranged around the center have the same effect.

The second kind of visual balance opposes weights and forces that are unequal, and in doing so enlivens the image. On the weighing scale, a large object can be balanced by a small one, as long as the latter is placed far enough away from the fulcrum. Similarly, a small graphic element can successfully oppose a dominant one, as long as it is placed toward the edge of the frame. Mutual opposition is the mechanism by which most balance is achieved. It is, of course, a type of contrast (see Contrast, on pages 34-37).

These are the ground rules of visual balance, but they need to be treated with some caution. All we have done so far is to describe the way the balance works in simple circumstances. In many pictures, a variety of elements interact, and the question of balance can only be resolved intuitively, according to what feels right. The weighing scale analogy is fine as far as it goes— to explain the fundamentals—but I would certainly not recommend actually using it as an aid to composition.

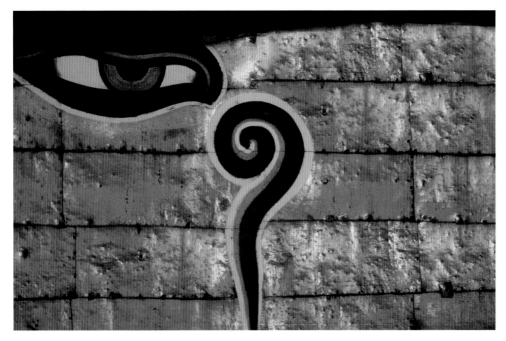

Using the analogy of a weighing scale, think of a picture as balanced at its center. In this close-up of the eyes on the Buddhist stupa at Swayambunath in Nepal, the simple arrangement is symmetrical. The arrangement is balanced exactly over the fulcrum; the forces are evenly balanced. However, if we remove one element, done here digitally for the exercise, the visual center of gravity is shifted to the left, and the balance is upset. The natural tendency would be to shift the view to the left.

Apart from this, a more crucial consideration is whether or not balance is even desirable. Certainly, the eye and brain need equilibrium, but providing it is not necessarily the job of art or photography. Georges Seurat, the neo-Impressionist painter, claimed that "Art is harmony," but as Itten pointed out, he was mistaking a means of art for its end. If we accepted a definition of good photography as the creation of images that produce a calm, satisfying sensation, the results would be very dull indeed. An expressive picture is by no means always harmonious, as you can see time and again throughout this book. We will keep returning to this issue, and it underlines many design decisions, not just in an obvious way—where to place the center of interest, for example—but in the sense of how much tension or harmony to create. Ultimately, the choice is a personal one, and not determined by the view or the subject.

In composing the image, the poles are symmetry and eccentricity. Symmetry is a special, perfect case of balance, not necessarily satisfying, and very rigid. In the natural run of views that a photographer is likely to come across, it is not particularly common. You would have to specialize in a group of things that embody symmetrical principles, such as architecture or seashells, to make much use of it. For this reason, it can be appealing if used occasionally. On the subject of a mirrored composition in Sequoia National Park, the landscape photographer Galen Rowell wrote, "When I photographed Big Bird

RATIOS, HARMONY, AND BALANCE

The belief that there are naturally ideal proportions goes back to the Pythagoreans, whose thought was dominated by mathematics, yet was also mystical. A core belief was that reality was numerically ordered. In arguing the creation of the universe, Stobaeus wrote: "Things that were alike and of the same kind had no need of harmony, but those that were unlike and not of the same kind and of unequal order—it was necessary for such things to have been locked together by harmony, if they are to be held together in an ordered universe." In music, for example, a scale that produces harmonic (pleasing) sounds must have pitches that are in a consistent ratio. The idea of natural harmony can be extended to other fields, such as visual proportions. The Greek Aristides (530-468 BC) wrote about painting that, "we shall find that it does nothing without the help of numbers and proportions: it is through numbers that it hunts for the proportionate measures of bodies and mixtures of colors, and from these it gives the pictures their beauty." Nevertheless, at many times in the history of art there has been conflict between those who sought inspiration from mathematical, harmonic order and those who found it dry, sterile, and stifling to the imagination—the painter William Blake, for example. (See also pages 118-121.)

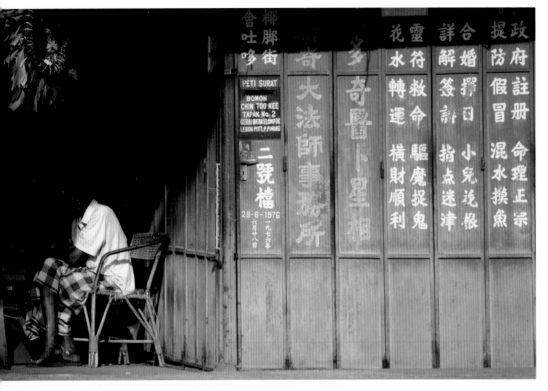

◄ DYNAMIC BALANCE
Dynamic equilibrium opposes two unequal subjects or areas. Just as a small weight can balance a larger mass by being placed further from the fulcrum, large and small elements in an image can be balanced by placing them carefully in the frame. Note here that the content of the upper right area—Chinese characters—increases its visual importance (see pages 98-99 for more on visual weight).

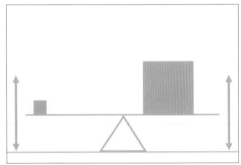

Lake with a fine reflective surface on the water, I intuitively broke traditional rules of composition and split my image 50-50 to strengthen the patterns and emphasize the similarity between the two halves of my image." To succeed, symmetrical composition must be absolutely precise. Few images look sloppier than an almost symmetrical view that did not quite make it.

We ought now to consider how tension actually works in an unbalanced composition. The mechanics are considerably more subtle than the balancing-scale analogy can show. While the eye and brain search for balance, it would be wrong to assume that it is satisfying to have it handed on a plate. Interest in any image is in direct proportion to the amount of work the viewer has to do, and too perfect a balance leaves less for the eye to work at. Hence, dynamic balance tends to be more interesting than static balance. Not only this, but in the absence of equilibrium, the eye tries

to produce it independently. In color theory, this is the process involved in successive and simultaneous contrast (see pages 118-121).

This can be seen in action in any eccentrically composed picture. In the photograph of a farmer in a rice field on page 69, according to the weighing-scale analogy the equilibrium is completely upset, yet the image is not at all uncomfortable in appearance. What happens is that the eye and brain want to find something closer to the center to balance the figure in the top-right corner, and so keep coming back to the lower-left center of the frame. Of course, the only thing there is the mass of rice, so that the setting in fact gains extra attention. The green stalks of rice would be less dominant if the figure were centrally placed. As it is, it would be difficult to say whether the photograph is of a worker in a rice field or of a rice field with, incidentally, a figure working in it. This process of trying to compensate for an obvious asymmetry in an image is what creates

visual tension, and it can be very useful indeed in making a picture more dynamic. It can help draw attention to an area of a scene that would normally be too bland to be noticed.

A second factor involved in eccentrically composed images is that of logic. The more extreme the asymmetry, the more the viewer expects a reason for it. Theoretically, at least, someone looking at such an image will be more prepared to examine it carefully for the justification. Be warned, however, that eccentric composition can as easily be seen as contrived.

Finally, all considerations of balance must take into account the sheer graphic complexity of many images. In order to study the design of photographs, we are doing our best in this book to isolate each of the graphic elements we look at. Many of the examples, such as the rice field picture, are deliberately uncomplicated. In reality, most photographs contain several layers of graphic effect.

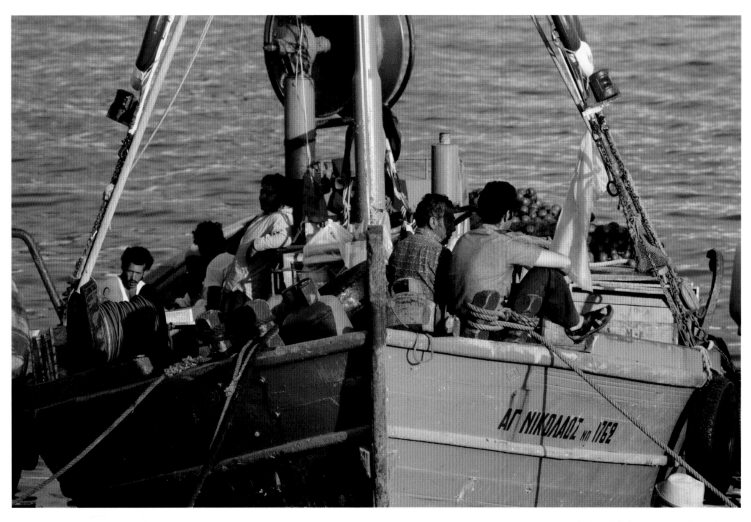

▲ BILATERAL SYMMETRY

Certain classes of subject are naturally symmetrical around one axis, as with this Greek fishing boat seen from the front. Architecture also often falls into this category, as do head-on views of many living things (such as a human face). Precision is particularly important with a symmetrical composition, because the smallest misalignment will stand out immediately and may simply look like a failure.

BALANCE AND GRAVITY

There is a natural tendency to apply our experience of gravity to images and image frames. As we'll see in Chapter 3, verticals express a gravitational pull downwards, while horizontal bases provide a supporting flatness. This is probably why the placement of a dominant element in a frame tends to be lower, particularly with a vertical frame (see page 26). As the painter and teacher Maurice De Sausmarez wrote about a vertical above a horizontal: "The two together produce a deeply satisfying resolved feeling, perhaps because together they symbolize the human experience of absolute balance, of standing erect on level ground."

DYNAMIC TENSION

We have already seen how certain of the basic graphic elements have more energy than others: diagonals, for instance. Some design constructions are also more dynamic; rhythm creates momentum and activity, and eccentric placement of objects induces tension as the eye attempts to create its own balance. However, rather than think of an image as balanced or unbalanced, we can consider it in terms of its dynamic tension. This is essentially making use of the energy inherent in various structures, and using it to keep the eye alert and moving outward from the center of the picture. It is the opposite of the static character of formal compositions.

Some caution is necessary, simply because introducing dynamic tension into a picture seems such an easy and immediate way of attracting attention. Just as the use of rich, vibrant colors is instantly effective in an individual photograph but can become mannered if used constantly, so this kind of activation can also become wearing after a while. As with any design technique that

is strong and obvious when first seen, it tends to lack staying power. Its effect is usually spent very quickly, and the eye moves on to the next image.

The techniques for achieving dynamic tension are, however, fairly straightforward, as the examples here show. While not trying to reduce it to a formula, the ideal combination is a variety of diagonals in different directions, opposed lines, and any structural device that leads the eye outward, preferably in competing directions. This argues against, for example, using circular enclosing structures, and suggests that good use can be made of a powerful standby, eye-lines (see pages 82-83).

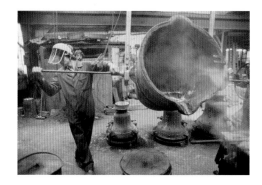

➤ ▲ BELL FOUNDRY
Eye-lines and the direction in which things appear to face are responsible here for the diverging lines of view. The man faces left, and the line of his stance contributes to this. The hopper full of molten metal faces forward and to the right. The two pull against each other visually.

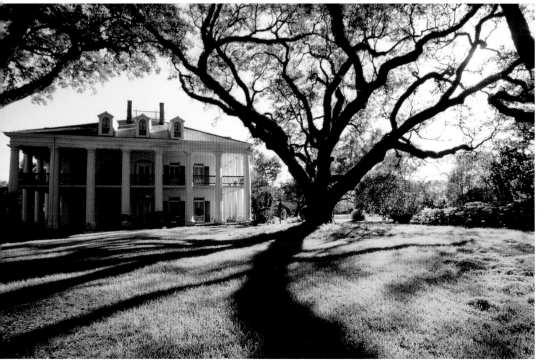

◄ ▼ OAK ALLEY PLANTATION
Diverging lines and movement are the key to dynamic tension. Here, the branches of a tree and its strong curving shadow have powerful outward movement, exaggerated by the 20 mm efl (equivalent focal length) wide-angle lens. The distortion and placement of the building make it seem to move left, out of frame.

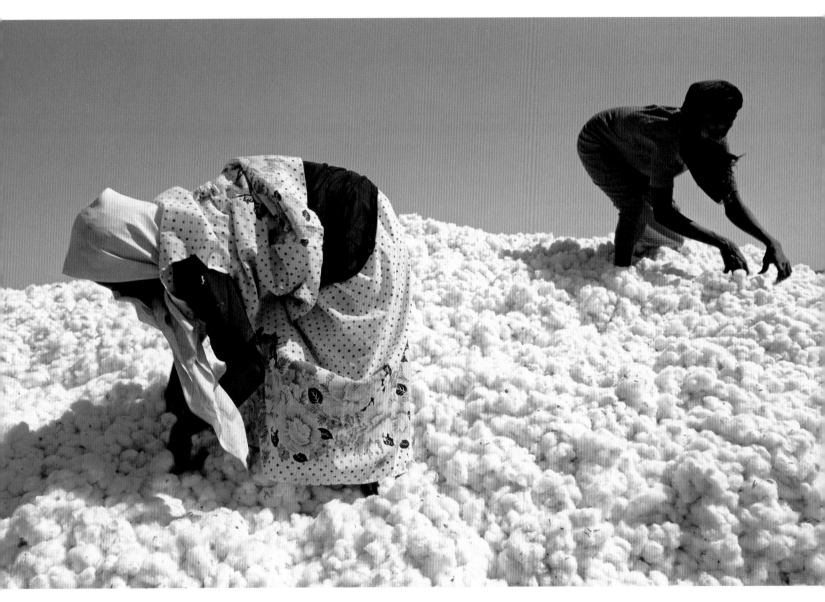

◄ ▲ HILL OF COTTON

Sorting and tramping down freshly picked cotton south of Khartoum, two Sudanese women move deftly and gracefully. A wide-angle lens exaggerates the geometry of the image close to the edges of the frame, and from a sequence of shots the one chosen here has the most energy and movement—the lines and gestures pull the attention outward at both left and right.

FIGURE AND GROUND

We are conditioned to accepting the idea of a background. In other words, from our normal visual experience, we assume that in most scenes that is something that we look at (the subject), and there is a setting against which it stands or lies (the background). One stands forward, the other recedes. One is important, and the reason for taking a photograph; the other is just there because something has to occupy the rest of the frame. As we saw, this is an essential principle of Gestalt theory.

In most picture situations, that is essentially true. We select something as the purpose of the image, and it is more often than not a discrete object or group of objects. It may be a person, a still-life, a group of buildings, a part of something. What is behind the focus of interest is the background, and in many well-designed and satisfying images, it complements the subject. Often, we already know what the subject is before the photography begins. The main point of interest has been decided on: a human figure, perhaps, or a horse, or a car. If it is possible to control the circumstances of the picture, the

next decision may well be to choose the background: that is, to decide which of the locally available settings will show off the subject to its best advantage. This occurs so often, as you can see from a casual glance at most of the pictures in this book, that it scarcely even merits mention.

There are, however, circumstances when the photographer can choose which of two components in a view is to be the figure and which is to be the ground against which the figure is seen. This opportunity occurs when there is some ambiguity in the image, and it helps to have a minimum of realistic detail. In this respect, photography is at an initial disadvantage to illustration, because it is hard to remove the inherent realism in a photograph. In particular, the viewer knows that the image is of something real, and so the eye searches for clues.

Some of the purest examples of ambiguous figure/ground relationships are in Japanese and Chinese calligraphy, in which the white spaces between the brush strokes are just as active and coherent as the black characters. When

the ambiguity is greatest, an alternation of perception occurs. At one moment the dark tones advance, at another they recede. Two interlinked images fluctuate backwards and forwards. The preconditions for this are fairly simple. There should be two tones in the image, and they should contrast as much as possible. The two areas should be as equal as possible. Finally, there should be limited clues in the content of the picture as to what is in front of what.

The point of importance here is not how to make illusory photographs, but how to use or remove ambiguity in the relationship between subject and background. The two examples shown here, both silhouettes, use the same technique as the calligraphy: the real background is lighter than the real subject, which tends to make it move forward; the areas are nearly equal; the shapes are not completely obvious at first glance. The shapes are, however, recognizable, even if only after a moment's study. The figure/ground ambiguity is used, not as an attempt to create and abstract illusion, but to add some optical tension and interest to the images.

◀ WINDOWS
The view across the courtyard of a Nubian house in northern Sudan is through two rammed-earth open window frames. In the harsh sunlight, the contrast between light and shade is extreme, and cropping the frame carefully so that the areas of light and dark are equal creates a figure-ground ambiguity—the more so because light is normally expected to stand forward from dark.

BURMESE MONK

In this sequence of shots closing in on the subject, the subject is a monk praying at the side of a Burmese stupa, silhouetted against the golden wall of a large pagoda. The sequence from left to right moves from straightforward and obvious towards some ambiguity, and the final crop is designed to make the light and dark areas equal in size. As the background is light, this creates a visual alternation, increasing its abstraction.

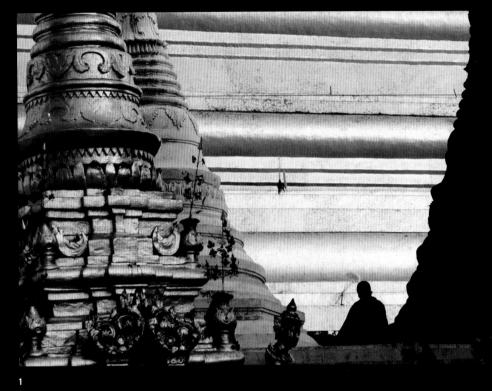

1

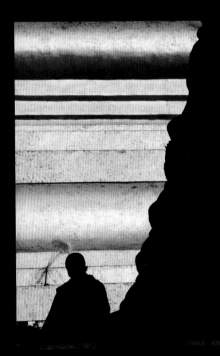

2

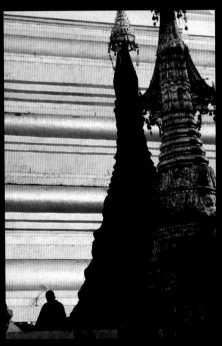

3

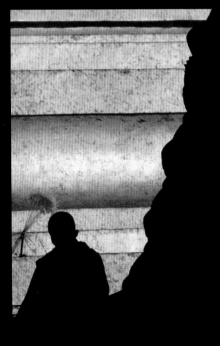

4

RHYTHM

When there are several similar elements in a scene, their arrangement may, under special conditions, set up a rhythmic visual structure. Repetition is a necessary ingredient, but this alone does not guarantee a sense of rhythm. There is an obvious musical analogy, and it makes considerable sense. Like the beat in a piece of music, the optical beat in a picture can vary from being completely regular to variations similar to, for instance, syncopation.

Rhythm in a picture needs time and the movement of the eye to be appreciated. The dimensions of the frame, therefore, set some limits, so that what can be seen is not much more than a rhythmical phrase. However, the eye and mind are naturally adept at extending what they see (the Gestalt Law of Good Continuation), and—in a photograph such as that of the row of soldiers on page 183— readily assume the continuation of the rhythm. In this way, a repeating flow of images is perceived as being longer than can actually be seen.

Rhythm is a feature of the way the eye scans the picture as much as of the repetition. It is strongest when each cycle in the beat encourages the eye to move (just as in the example to the right). The natural tendency of the eye to move from side to side (see pages 12-15) is particularly evident here, as rhythm needs direction and flow in order to come alive. The rhythmical movement is therefore usually up and down, as vertical rhythm is much less easily perceived. Rhythm produces considerable strength in an image, as it does in music. It has momentum, and because of this, a sense of continuation. Once the eye has recognized the repetition, the viewer assumes that the repetition will continue beyond the frame.

Rhythm is also a feature of repetitive action, and this has real practical significance in photographing work and similar activity. In the main picture opposite, of Indian farmers in the countryside near Madras winnowing rice, the potential soon became apparent. The first picture in the sequence is uninteresting but shows the situation. The individual action was to scoop rice into the basket and hold it high, tipping it gently

so that the breeze would separate the rice from the chaff. Each person worked independently, but inevitably two or more would be in the same position at the same time. It was then a matter of waiting for the moment in which three were in unison, and finding a viewpoint that would align them so that the rhythm has maximum graphic effect. These things are never certain—someone could simply stop work—but the possibility in a situation like this is high.

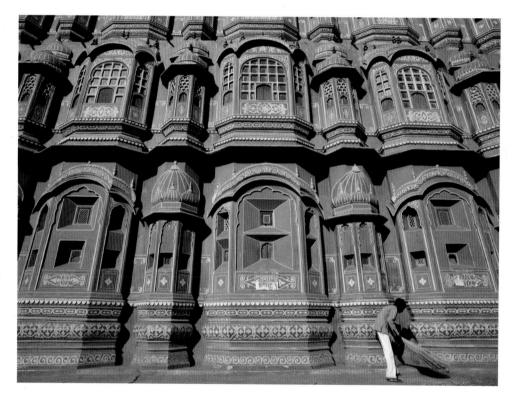

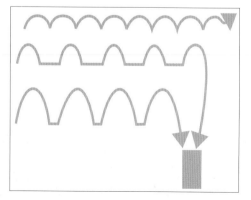

◄ ▲ RHYTHM AND STOP
When the rhythm is predictable, as in this palace façade in Jaipur, India, the repetition is frequently boring. In this case, an anomaly that interrupts the rhythm can make the image more dynamic. Here, a man sweeping provides the necessary break. Note that, as the eye naturally follows a rhythmical structure from left to right, it works better to place the figure on the far right, so that the eye has time to establish the rhythm.

THE DYNAMICS

In line, shot with a wide-angle lens, the action is graphically strongly directional, and for this reason the figures are placed left of center so that the direction is into frame. The stance of the woman closest the camera adds to the curved flow. Typical of such a situation, in which the basics are known but there is no control by the photographer, are the many distractions and small happenings that do not (of course) conform to what the photographer would like. This sequence shows things gradually getting closer to what the photographer had in mind.

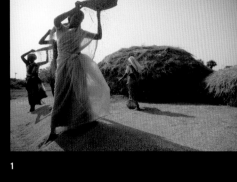

1

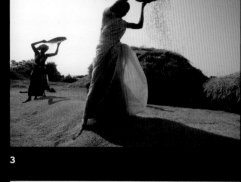

3

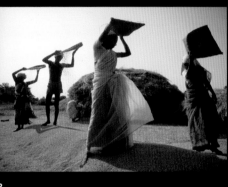

2

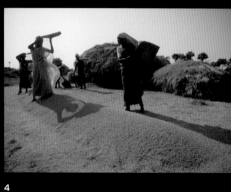

4

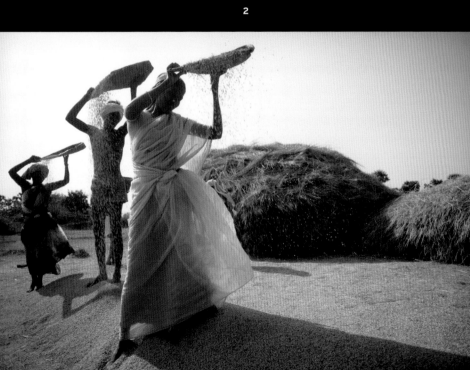

5

PATTERN, TEXTURE, MANY

Like rhythm, pattern is built on repetition, but unlike rhythm it is associated with area, not direction. A pattern does not encourage the eye to move in a particular way, but rather to roam across the surface of the picture. It has at least an element of homogeneity, and, as a result, something of a static nature.

The prime quality of a pattern is that it covers an area, thus the photographs that show the strongest pattern are those in which it extends right to the edges of the frame. Then, as with an edge-to-edge rhythm, the phenomenon of continuation occurs, and the eye assumes that the pattern extends beyond. The photograph of the bicycle saddles illustrates this. In other words, showing any border at all to the pattern establishes limits; if none can be seen, the image is take to be a part of a larger area.

At the same time, the larger the number of elements that can be seen in the picture, the more there is a sense of pattern than of a group of individual objects. This operates up to a quantity at which the individual elements become difficult to distinguish and so become more of a texture. In terms of the number of elements, the effective limits lie between about ten and several hundred, and a useful exercise when faced with a mass of similar objects is to start at a distance (or with a focal length) that takes in the entire group, making sure that they reach the frame edges, and then take successive photographs, closing in, ending with just four or five of the units. Within this sequence of images there will be one or two in which the pattern effect is strongest. Pattern, in other words, also depends on scale.

A pattern seen at a sufficiently large scale takes on the appearance of texture. Texture is the primary quality of a surface. The structure of an object is its form, whereas the structure of the material from which it is made is its texture. Like pattern, it is determined by scale. The texture of a piece of sandstone is the roughness of the individual compacted grains, a fraction of a millimeter across. Then think of the same sandstone as part of a cliff; the cliff face is now

the surface, and the texture is on a much larger scale, the cracks and ridges of the rock. Finally, think of a chain of mountains that contains this cliff face. A satellite picture shows even the largest mountains as wrinkles on the surface of the earth: its texture. This kind of repeating scale of texture is related to fractal geometry.

Texture is a quality of structure rather than of tone or color, and so appeals principally to the sense of touch. Even if we cannot physically reach out and touch it, its appearance works through this sensory channel. This explains why texture is revealed through lighting—at a small scale, only this throws up relief. Specifically, the direction and quality of the lighting are therefore important. Relief, and thus texture, appears strongest when the lighting is oblique, and when the light is hard rather than soft and diffuse. These conditions combine to create the sharpest shadows thrown by each element in the texture, whether it is the weave in a fabric, the wrinkles in leather, or the grain in wood. As a rule, the finer the texture, the more oblique and hard the lighting it needs to be seen clearly—except that

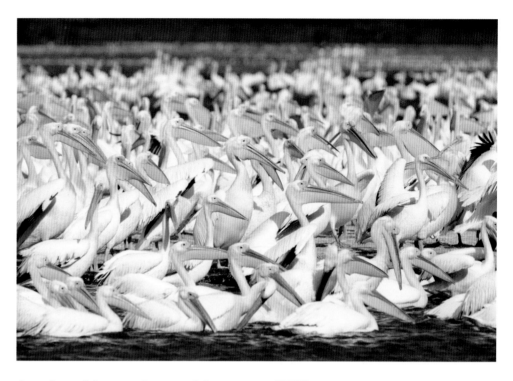

▲ MANY

The massing of subjects has its own appeal, both graphic and in the sense of wonder at sheer unexpected quantity. Filling, or nearly filling, the frame is more or less essential for this kind of image to work. In this case, even though the angle of view is low, a 600 mm telephoto lens compresses the mass.

the smoothest of all surfaces are reflective, such as polished metal, and texture is replaced by reflection (see page 124).

Related to pattern and texture, but with content playing a stronger role, is the idea of many, as in a crowd of people or a large shoal of fish. The appeal of huge numbers of similar things lies often in the surprise of seeing so many of them in one place and at one time. The view of the Kaaba in Mecca, seen from one of the minarets, for example, is said to take in at least a million people, and this fact is itself remarkable. Large numbers congregating usually constitutes an event. Framing to within the edges of the mass allows the eye to believe that it continues indefinitely.

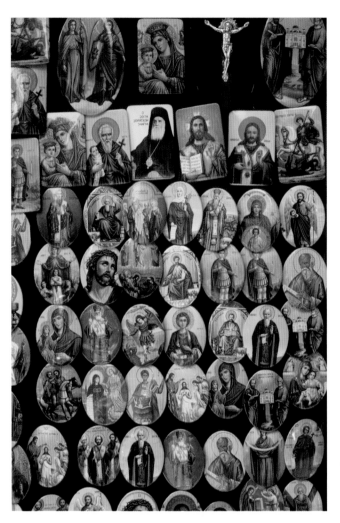

◄ REGULAR PATTERN
Ordered rows and other geometric arrangements of large numbers of things make regular patterns. The alignment in an example like this is not particularly attractive, and the interest of the photograph depends very much on the nature of the object: bottle tops would be less appealing than these small religious plaques. Note that the sense of pattern depends on scale and number; a crop would lose it.

◄ IRREGULAR PATTERN
To be irregular and yet still appear as a pattern, objects must still be grouped closely; the irregularity is not quite so disordered as it may seem. The effectiveness of a pattern also depends on how much area it covers. If the elements reach the borders of the frame all round, as in this photograph, the eye assumes that they continue beyond.

◄ BREAKING THE PATTERN
Patterns tend to be directionless, and so often make better backgrounds than subjects in themselves. In this example, however, the mass of pearls, freshly extracted at a Thai pearl farm, is the subject. To show quantity, they were arranged to reach beyond the four edges, but to make an image out of the arrangement, a contrasting visual element was included—a discoloured baroque pearl— which breaks the pattern in order to emphasize it.

▲ OBLIQUE DIRECT LIGHTING
The classic lighting condition for revealing texture at its strongest is at an active angle and with a direct, undiffused source. The sun in a clear sky is the hardest source available, and here, almost parallel to this wrought-iron grill, it makes texture dominate the image.

PERSPECTIVE AND DEPTH

One of the paradoxes of vision is that while the image projected onto the retina obeys the laws of optics and shows distant objects smaller than nearer ones, the brain, given sufficient clues, knows their proper size. And, in one view, the brain accepts both realities—distant objects that are small and full-scale at the same time. The same thing happens with linear perspective. The parallel sides of a road stretching away from us converge optically but at the same time are perceived as straight and parallel. The explanation for this is known as "constancy scaling" or "scale constancy," a little-understood perceptual mechanism that allows the mind to resolve the inconsistencies of depth. Its impact on photography is that the recorded image is purely optical, so that distant objects appear only small, and parallel lines do converge. As in painting, photography has to pursue various strategies to enhance or reduce the sense of depth, and images work within their own frame of reference, not that of normal perception.

Photography's constant relationship with real scenes makes the sense of depth in a picture always important, and this in turn influences the realism of the photograph. In its broadest sense, perspective is the appearance of objects in space, and their relationships to each other and the viewer. More usually, in photography it is used to describe the intensity of the impression of depth. The various types of perspective and other depth controls will be described in a moment, but before this we ought to consider how to use them, and why. Given the ability to make a difference to the perspective, under what conditions will it help the photograph to enhance, or to diminish, the sense of depth? A heightened sense of depth through strong perspective tends to improve the viewer's sense of being there in front of a real scene. It makes more of the representational qualities of the subject, and less of the graphic structure.

The following types of perspective contain the main variables that affect our sense of depth in a photograph. Which ones dominate depends on the situation, as does the influence that the photographer has over them.

LINEAR PERSPECTIVE

In two-dimensional imagery, this is, overall, the most prominent type of perspective effect. Linear perspective is characterized by converging lines. These lines are, in most scenes, actually parallel, like the edges of a road and the top and bottom of a wall, but if they recede from the camera, they appear to converge toward one or more vanishing points. If they continue in the image for a sufficient distance, they do actually meet at a real point. If the camera is level, and the view is a landscape, the horizontal lines will converge on the horizon. If the camera is pointed upward, the vertical lines, such as the sides of a building, will converge toward some unspecified part of the sky; visually, this is more difficult for most people to accept as a normal image.

WAYS OF STRENGTHENING PERSPECTIVE	WAYS OF WEAKENING PERSPECTIVE
Choose a viewpoint that shows a range of distance.	Alter the viewpoint so that different distances in the scene appear as unconnected planes; the fewer the better.
A wide-angle lens enhances linear perspective if used close to the nearest parts of the scene, and can show a large foreground-to-distance range.	A telephoto lens compresses these planes, reducing linear perspective, if used from a distance.
Place warm-hued subjects against cool-hued backgrounds.	Place cool-hued subjects against warm-hued backgrounds.
Use more direct, less diffused lighting.	Use frontal lighting, diffused and shadowless.
Use lighting or placement to keep bright tones in the foreground and dark tones behind.	Equalize or reverse the distribution of tones, so that light objects do not appear in the foreground.
Where applicable, include familiar-sized objects at different distances to give recognizable scale. Ideally, have similar objects.	Maximize the depth of field so that, ideally, the entire picture is sharply focused. With a view camera or tilt lens, use the movements to increase overall sharpness.
Allow the focus to become unsharp towards the distance.	Reduce atmospheric haze by using ultraviolet or polarizing filters.

➤ TILT LENS
Taken with a tilt lens, this image is sharp not only on the nearby cartographical texts, but also at the far side of the room. A tilt lens places the lens elements at an angle to the sensor, which in turn places the focal plane of the image at a correspondingly stronger angle from the camera's sensor chip.

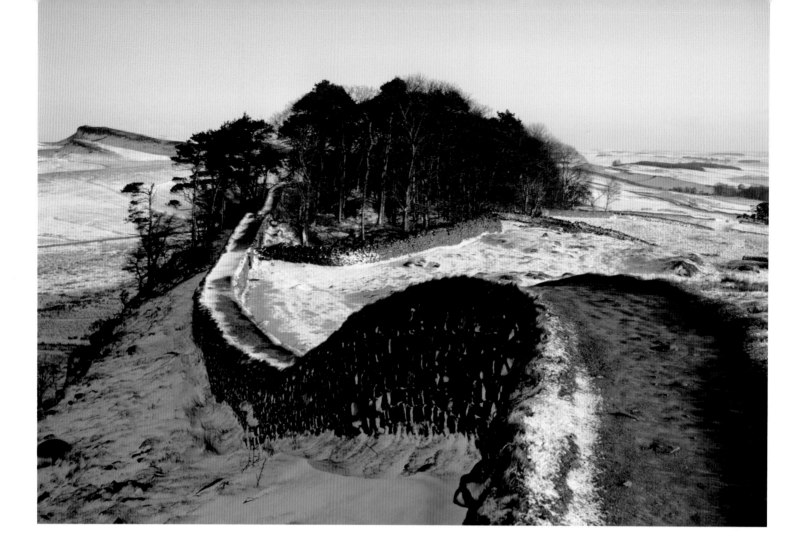

In the process of convergence, all or most of the lines become diagonal, and this, as we'll see on pages 76-77, induces visual tension and a sense of movement. The movement itself adds to the perception of depth, along lines that carry the eye into and out of the scene. By association, therefore, diagonal lines of all kinds contain a suggestion of depth, and this includes shadows which, if seen obliquely, can appear as lines. So a direct sun, particularly if low in the sky, will enhance perspective if the shadows it casts fall diagonally. Viewpoint determines the degree of convergence, and the more acute the angle of view to the surface, the greater this is— at least until the camera is close to ground level, at which point the convergence becomes extreme enough to disappear.

The focal length of lens is another important factor in linear perspective. Of two lenses aimed directly towards the vanishing point of a scene, the wide-angle lens will show more of the diagonals in the foreground, and these will tend to dominate the structure of the image more. Hence, wide-angle lenses have a propensity to enhance linear perspective, while telephoto lenses tend to flatten it.

DIMINISHING PERSPECTIVE

This is related to linear perspective, and is in fact a form of it. Imagine a row of identical trees lining a road. A view along the road would produce the familiar convergence in the line of trees, but individually they will appear to be successively smaller. This is diminishing perspective, and works most effectively with identical or similar objects at different distances.

For similar reasons, anything of recognizable size will give a standard of scale; in the

▲ LINEAR PERSPECTIVE

A 20 mm efl wide-angle lens and a viewpoint that shows the parallel lines of a wall (Hadrian's Wall in the north of England) receding directly from the camera provide classic conditions for strong linear perspective. The height of the camera above the wall determines the vertical distance visible in the photograph. This in turn determines the degree of convergence (see page 55).

appropriate place in the scene, it helps to establish perspective. Also associated with diminishing perspective are placement (things in the lower part of the picture are, through familiarity, assumed to be in the foreground) and overlap (if the outline of one object overlaps another, it is assumed to be the one in front).

▲ VERY LOW

▲ LOW

◄ **CONVERGENCE AND HEIGHT**
The angle of view to the surface that carries
the converging lines determines the strength
of the perspective effect. Too low fails to read
clearly; too high shows little convergence.

▲ MEDIUM

▲ HIGH

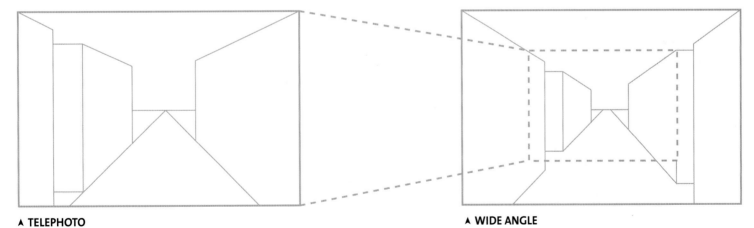

▲ TELEPHOTO

▲ WIDE ANGLE

▲ **CONVERGENCE AND FOCAL LENGTH**
The same viewpoint with lenses of different
focal lengths gives a more diagonal convergent
image from the wider-angle lens.

AERIAL PERSPECTIVE

Atmospheric haze acts as a filter, reducing the contrast in distant parts of a scene and lightening their tone. Our familiarity with this effect (pale horizons, for example), enables our eyes to use it as a clue to depth. Hazy, misty scenes appear deeper than they really are because of their strong aerial perspective. It can be enhanced by using backlighting, as in the example below, and by not using filters (such as those designed to cut ultraviolet radiation) that reduce haze. Telephoto lenses tend to show more aerial perspective than wide-angle lenses if used on different subjects, because they show less of nearby things that have little haze between them and the camera. Favoring the blue channel when using channel mixing to convert an RGB digital image to black and white also accentuates the effect.

TONAL PERSPECTIVE

Apart from the lightening effect that haze has on distant things, light tones appear to advance and dark tones recede. So, a light object against a dark background will normally stand forward, with a strong sense of depth. This can be controlled by placing subjects carefully, or by lighting. Doing the reverse, as we saw on pages 46-47, creates a figure-ground ambiguity.

COLOR PERSPECTIVE

Warm colors tend to advance perceptually and cool colors recede. Other factors apart, therefore, a red or orange subject against a green or blue background will have a sense of depth for purely optical reasons. Again, appropriate positioning can be used as a control. The more intense the colors, the stronger the effect, but if there is a difference in intensity, it should be in favour of the foreground.

➤ AERIAL PERSPECTIVE

Progressively lighter shadow tones indicate the effects of an increasing depth of atmospheric haze, and so establish depth. The effect appears strongly in back-lighting similar to this.

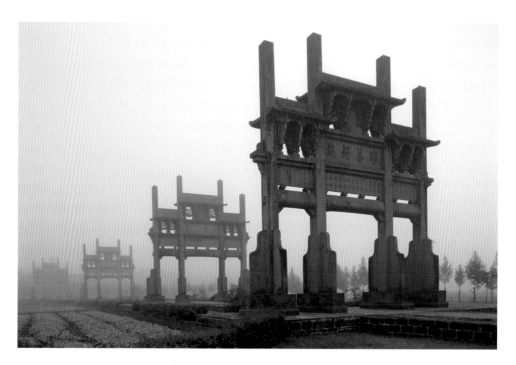

▲ DIMINISHING PERSPECTIVE

In this line of memorial arches in Anhui province, China, the eye assumes that they are identical. Their diminishing size establishes a strong sense of depth. There is also aerial perspective present because of the mist.

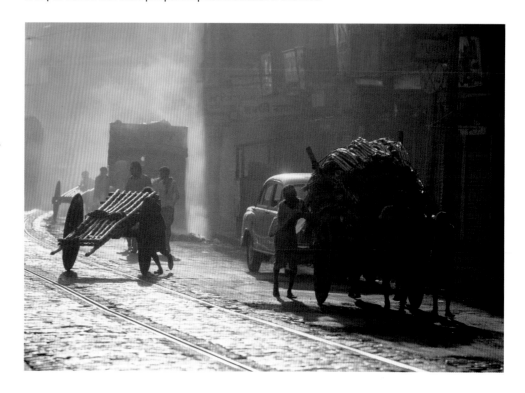

SHARPNESS

Good definition suggests closeness, and anything that creates a difference in sharpness in favor of the foreground will enhance the impression of depth. Atmospheric haze has something of this effect. The most powerful control, however, is focus. If there is a difference in sharpness across the image, through familiarity we take this as a depth clue—either that the foreground is out of focus, or the background, or both.

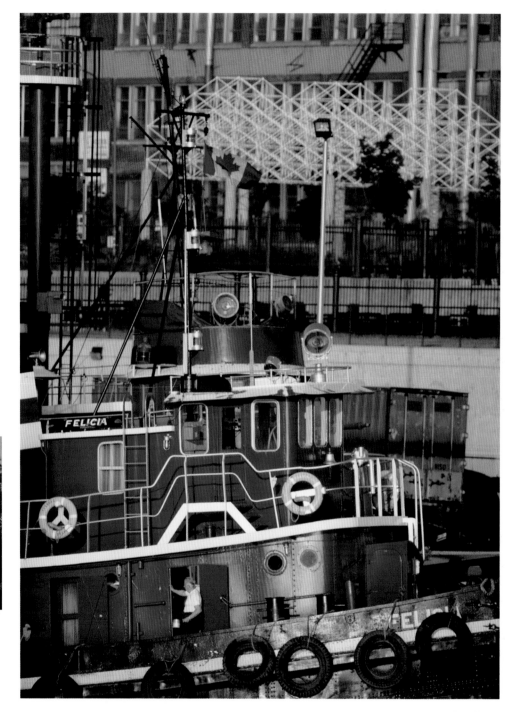

▲ SHARPNESS

Selective focus establishes depth by exploiting two perceptual triggers. One is attracting attention to the areas with most density of information (that is, focused). The other is our experience of looking at photographs, in which an out-of-focus area overlapping a sharp area is known to be in front. In addition, in this image of a hill-tribe village in northern Thailand, there is a psychological component—the sense of standing outside the community peering in.

▲ LACK OF AERIAL PERSPECTIVE

Frontal lighting and clear weather are the two conditions that reduce aerial perspective, as in this early morning dockside photograph. The tones and local contrast in the background and foreground, are very similar, and give little sense of depth.

VISUAL WEIGHT

So obvious as to be a truism is that we look most at what interests us. This means that as we start to look at anything, whether a real scene or an image, we bring to the task "stored knowledge" that we have accumulated from experience. Recent research in perception confirms this; Deutsch and Deutsch (1963) proposed "importance weightings" as a main factor in visual attention. This is crucial in deciding how photographs will be looked at, because in addition to the composition, certain kinds of content will do more than others to attract the eye. Of course, filtering out idiosyncrasy is difficult, to say the least, but there are some useful generalizations. Certain subjects will tend to attract people more than others, either because we have learned to expect more information from them or because they appeal to our emotions or desires.

The most common high-attractant subjects are the key parts of the human face, especially the eyes and mouth, almost certainly because this is where we derive most of our information for deciding how someone will react. In fact, research into the nervous system has shown that there are specific brain modules for recognizing faces, and others for recognizing hands—clear proof of how important these subjects are visually.

Another class of subject that attracts the eye with a high weighting is writing—again, something of obvious high-information value. In street photography, for example, signs and billboards have a tendency to divert attention, and the meaning of the words can add another level of interest—consider a word intended to shock, as is sometimes used in advertising. Even if the language is unknown to the viewer (for example, the image on page 42 for any non-Chinese speaker), it still appears to command attention. Ansel Adams, on the subject of a photograph of Chinese grave markers, wrote, "Inscriptions in a foreign language can have a direct aesthetic quality, unmodified by the imposition of meaning," but the very fact that they had any visual quality was because they represented a language.

As well as these "informational" subjects, there is an even wider and harder-to-define class that appeals to the emotions. These include sexual attraction (erotic and pornographic images), cuteness (baby animals and pets, for example), horror (scenes of death and violence), disgust, fashion, desirable goods, and novelty. Reactions in this class depend more on the individual interests of the viewer.

There is no way of accurately balancing all of these weightings, but on an intuitive level it is fairly easy, as long as the photographer is conscious of the various degrees of attraction. All of this content-based weighting also has to be set against the complex ways in which the form of the image—the graphic elements and colors—directs attention.

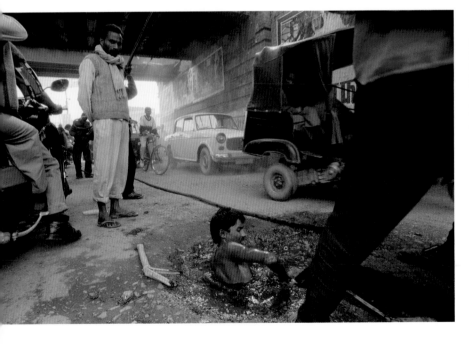

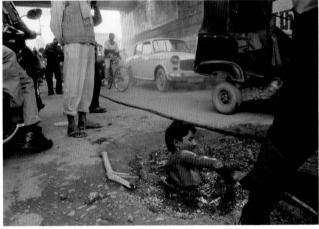

◄ ▲ BENARES STREET
In this Indian street scene, the clear focus of interest is the man doing what must be an extremely unpleasant and possibly dangerous job in the middle of the traffic. However, as happens all too often in India, any delay in shooting results in people staring at the camera, which was not what I wanted but was unavoidable, given the time it took to move into position. In the second version, the face of the onlooker has been cropped out, and whether or not this is an improvement to the overall image, it certainly demonstrates the difference in the way the eye naturally travels around the frame.

▲ FISH MARKET

A close-up of fish parts in a Kyoto market unexpectedly offers three "attractants" in one—an eye (admittedly separated from the fish, but nevertheless still an eye), writing, and a strong color patch. These three framings were taken naturally, with no intention of making an exercise. In the first, the eye is the undisputed focus, and placed slightly off-center. Pulling back and up, in the second frame, reveals one-and-a-half Japanese characters, and the attention is strongly diverted towards this corner. Pulling back even farther, and down, brings a piece of blue plastic into view, so that they eye travels between the three points of interest.

LOOKING AND INTEREST

How people look at images is of fundamental importance to painters, photographers, and anyone else who creates those images. The premise of this book is that the way you compose a photograph will influence the way in which someone else looks at it. While this is tacitly accepted throughout the visual arts, pinpointing the how and the why of visual attention has been hampered by lack of information. Traditionally, art and photography critics have used their own experience and empathy to divine what a viewer might or should get out of a picture, but it is only in the last few decades that this has been researched. Eye-tracking provides the experimental evidence for how people look at a scene or an image, and the groundbreaking study was by A. L. Yarbus in 1967. In looking at any scene or image, the eye scans it in fast jumps, moving from one point of interest to another. These movements of both eyes together are known as saccades. One reason for them is that only the central part of the retina, the fovea, has high resolution, and a succession of saccades allows the brain to assemble a total view in the short-term memory. The eye's saccadic movements can be tracked, and the so-called "scanpath" recorded. If then superimposed on the view—such as a photograph—it shows how and in what order a viewer scanned the image.

All of this happens so quickly (saccades last between 20 and 200 milliseconds) that most people are unaware of their pattern of looking. Research, however, shows that there are different types of looking, depending on what the viewer expects to get from the experience. There is spontaneous looking, in which the viewer is "just looking," without any particular thing in mind. The gaze pattern is influenced by such factors as novelty, complexity, and incongruity. In the case of a photograph, the eye is attracted to things that are of interest and to parts of the picture that contain information useful for making sense out of it. Visual weight, as we saw on the previous pages, plays an important role; this is because spontaneous looking is also influenced by "stored knowledge," which includes, among other things, knowing that eyes and lips tell a great deal about other people's moods and attitudes.

A second type of looking is task-relevant looking, in which the viewer sets out to look for something or gain specific information from an image or scene. In looking at a photograph, we can assume that the viewer is doing this by choice, and probably for some kind of pleasure or entertainment (or in the hope that the photograph will deliver this). This is an important starting condition. Next come the viewer's expectations. For instance, if he or she sees at first glance that there is something unusual or unexplained about the image, this is likely to cause a gaze pattern that is searching for information that will explain the circumstances. The classic study was by Yarbus in 1967, in which a picture of a visitor arriving in a living room was shown first without any instructions, and then with six different prior questions, including estimating the ages of the people in the image. The very different scanpaths showed how the task influenced the looking.

Other research in this area shows that most people tend to agree on what are the most informative parts of a picture, but that this is always tempered by individual experience (personal stored knowledge makes scanpaths idiosyncratic). Also, most painters and photographers believe that they can in some way control the way that other people view their work (this is, after all, the entire theme of this book), and research backs this up, in particular an experiment (Hansen & Støvring, 1988) in which an artist explained how he intended viewers to look at the work and subsequent eye-tracking proved him largely correct. Another experiment with interesting potential is that the scanpath that emerges at first viewing occupies about 30% of the viewing time, and that most viewers then repeat it—re-scanning the same way rather than using the time to explore other parts of the picture. In other words, most people decide quite quickly what they think is important and/or interesting in an image, and go on looking at those parts.

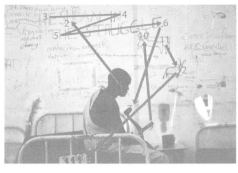

▲ ➤ INTENDED ORDER
In this photograph of a holding tent at a Red Cross hospital for combat injuries in the Sudan civil war, I wanted to show two things more or less equally. One was the injured soldier, an amputee, and the other was the rich history of graffiti that had accumulated over time. This graffiti contained one obvious slogan that removes the need for a caption, and drawings of animals, in particular cattle (many of the patients had been from cattle-rearing ethnic groups), and recalled cave paintings. Although the way in which the photograph would be viewed was not mapped out with any precision, I identified the key elements in my order of intention (outlined and numbered in the upper illustration). From this I had an approximate intended order of viewing, as indicated by the arrows on the lower illustration (this admittedly reconstructed for the purposes of this page).

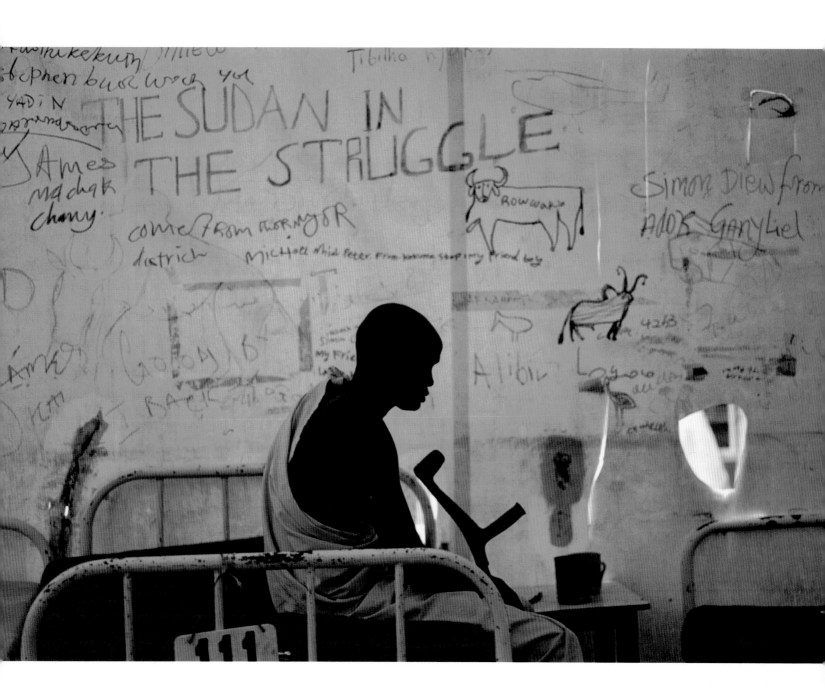

CONTENT, WEAK & STRONG

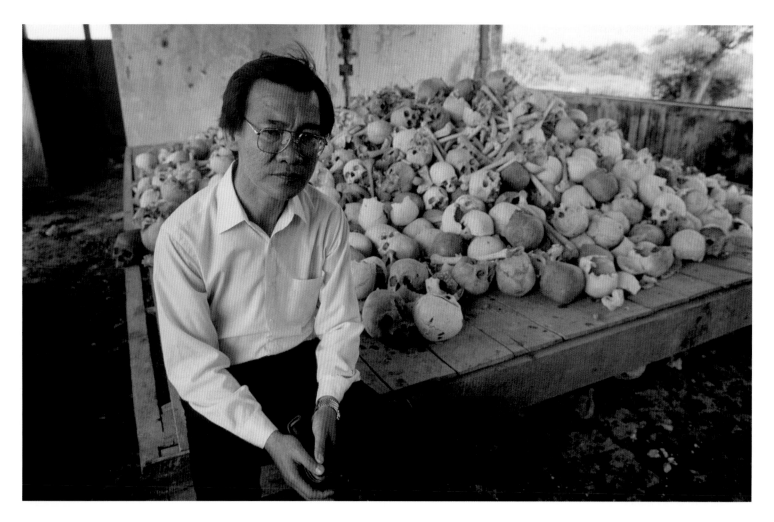

The relationship between the content and the geometry of a photograph, and the difficulty of separating them for analysis, has caused anguish, or at least sustained puzzlement, in more than a few writers. Roland Barthes, for example, considered photography more or less unclassifiable because it "always carries its referent with itself" and there is "no photograph without something or someone."

As a philosophical issue, this applies to the finished image and to reverse readings of photographs, but in the context of making a photograph, matters tend to be simplified by knowledge of the task at hand. At some point in the making of almost every photograph, the photographer knows what the subject should

be and is solving the problem of how best to make it into an image.

Content is the subject matter, both concrete (objects, people, scenes, and so on) and abstract (events, actions, concepts, and emotions). The role it plays in influencing the design is complex, because it has a specific attention value. Moreover, different classes of subject tend to direct the shooting method, largely for practical reasons. In news photography, the fact of an event is the crucial issue, at least for the editors. It is possible to shoot at a news event and treat it in a different way, perhaps looking for something more generic or symbolic, but this then is no longer true news photography. And if the facts rule the shooting, there is likely to be less opportunity or reason to experiment

with individual treatments. Strong content, in other words, tends to call for straight treatment—practical rather than unusual composition.

Perhaps at this point the following tale from British photographer George Rodger (1908-1995), a co-founder of Magnum, would not be out of place, even though fortunately most of us will never find ourselves in such an extreme situation. At the end of the Second World War, Rodger entered Belsen concentration camp with Allied troops. He later said, in an interview, "When I discovered that I could look at the horror of Belsen—4,000 dead and starving lying around—and think only of a nice photographic composition, I knew something had happened to me and it had to stop."

◄ RETURN TO THE KILLING FIELDS

I include this image because I thought, the evening of the day I shot it, of George Rodger's comment about Belsen. The occasion was the return to Cambodia for the first time for the protagonists of the film *The Killing Fields*—both Dith Pran, on whose experiences the film was based, and Haing Ngor, who played his role in the film, and received an Oscar for it. The content is not only dominant, but horrible. It raised moral issues for me and the writer, my friend Roger Warner. The purpose of the trip was to make a powerful story for an American television show, *Prime Time*, with our assignment for *The Sunday Times Magazine* secondary. What everyone wanted to do, particularly Dith Pran and Haing Ngor, was to remind as wide a public as possible of the genocide, which meant that everyone knew they had a job to do. Dith Pran, in particular, had been holding his emotions in check, which meant that the producer of the program was having difficulty conveying the personal horror of the situation. Roger and I knew of this untended old schoolhouse near Angkor where skulls and bones had been roughly deposited. It was obvious that the two men would be distraught if they visited here. We put it to them; they both accepted because they knew that the documentary and the picture story would be more effective as a result. It was not pleasant for anyone, but we all deemed it necessary. As you might imagine, any discussion of composition or technique would be distasteful. Yet, as any professional photographer will recognize, you always bring your skills and decisions to every shooting situation, and probably with more care and respect in a situation such as this.

▲ MAINLY FORM

The subject, hard to guess from this view, is the melting of gold ingots in a crucible. Seen from overhead, the graphics and colors were surprising and delightful—in other words, an opportunity to create a visually surprising image.

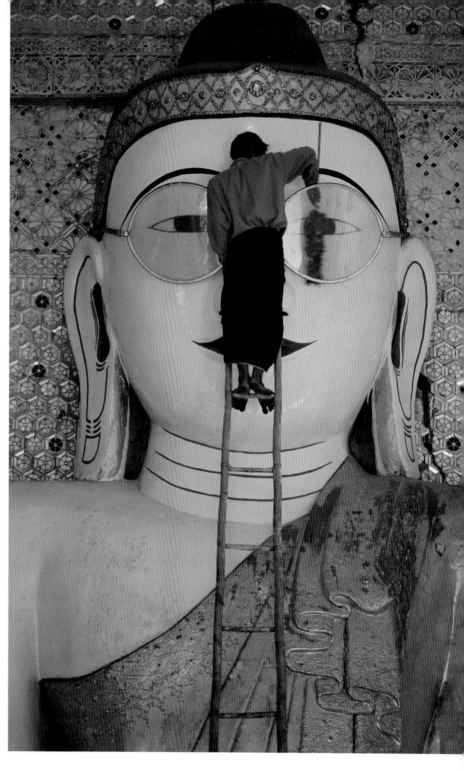

▲ MAINLY CONTENT

This image is very much about a fact—an object and an event—and almost the entire interest lies in what is happening, not in the camera angle or geometry. The caption reads: "The 'Buddha of the Golden Spectacles' in a small town near Pye, Burma. The Buddha is reputed to have powers to help eyesight problems, and this pair of giant spectacles was donated by a British colonial officer in thanks for a cure for his wife's difficulties. The spectacles are cleaned monthly."

CHAPTER 3:
GRAPHIC &
PHOTOGRAPHIC
ELEMENTS

The vocabulary of design is made up of what we can call graphic elements, the two-dimensional forms that appear inside the picture frame. In classic design theory, relating to painting and illustration, it is not so difficult to isolate these marks and forms on the paper from real subjects; the things that they might be used to represent. Painting and illustration offer no compulsion to be realistic, so that an abstract treatment of the basic elements is perfectly acceptable to the viewer.

In photography, however, this is not completely straightforward. We come back to its unique property, that its images are always taken directly from real things. The marks on a photographic print are never the same as those drawn by hand. They always represent something that existed. This by no means invalidates the idea of graphic elements, but it does make them more complex in the way they act.

The simplest elements of all are points, which tend to draw attention. An order higher than these are lines, which are valuable in directing and creating vectors. An order above these are shapes, which have the role of organizing the elements of an image and bringing structure. What we choose to identify in a photograph as a point, line, or shape often depends on how we ourselves choose to consider an image, and this can be influenced by the content and our understanding of and interest in it.

All three groups are intimately connected, because the simplest graphic elements tend to create more complex structures. A row of points implies a line, lines can define shapes, and so on. Thus shapes are intimately connected, both graphically and expressively, with lines. Rectangles are the product of horizontal and vertical lines, triangles are built from diagonals, and circles from curves. Although it might seem that there is an infinite number of shapes, there are only three basic ones: rectangle, triangle, and circle. All others, from trapezoids to ellipses, are variations on these, and as their importance in composition relies on their fundamental recognizability, there is no need to go beyond these three basic planar figures. Subtly formed shapes that are implied and understated are among the most useful of all; they help to order an image into a recognizable form and allow the eye the satisfaction of discovering them by making a little visual effort.

These are the classic elements in any graphic art, but for photography there are others, too—visual qualities from the process that are uniquely photographic. These purely photographic influences can sometimes be limitations (for example insufficient light for a motion-stopping shutter speed) and sometimes a kind of artifact (for example, flare). However, they can also be used deliberately to work for the image (for example, color blur from de-focus), and can be enjoyed as part of the syntax of photography.

A SINGLE POINT

The most basic element of all is the point. By definition, a point has to be a very small part of the total image, but to be significant it must contrast in some way with its setting—in tone or color, for example. The simplest form of a point in a photograph is an isolated object seen from a distance, against a relatively plain background, such as a boat on water, or a bird against the sky. There is no simpler design situation in photography than this: one element without significant shape, and a single background. The main consideration, then, is the matter of placement. Wherever the point is in the frame, it will be seen straight away. Placing it in a certain position is chiefly for the aesthetics of the picture, to give it whatever balance or interest is wanted, and perhaps paying heed to background.

Some of the issues involved in positioning the subject in the frame have already been covered on pages 24-25, and most of what was said applies here. To summarize: from a purely aesthetic point of view, placing a point right in the middle of the frame may be logical, but it is also static and uninteresting, and is rarely satisfactory. The choice then becomes how far off center to place the point, and in what direction? The more eccentric the position, the more it demands justification.

Free placement, however, is never guaranteed in photography, and the conditions are often such that you cannot arrange things exactly as you would like them, even with changes of lens or viewpoint. This is the case with the photograph of the rice farmer on pages 68-69, but the result is still not so bad. What it demonstrates is how much leeway exists in photographic composition. Also (and this is a personal judgment), it is usually better to err on the side of doing something unusual than to be predictable.

➤ EGRET
The tonal contrast between the white egret and its background make it a natural point. Notice that only a slight reason is needed to influence the direction of a point's location; in this case, the weak patch of sunlight is sufficient to place the egret toward the top left corner of the picture, to oppose it.

▼ PLACEMENT ZONES
Practically, there are three zones in a picture frame for placing a single, dominant point. However, the limits that are drawn here for convenience are not, in reality, precise. A point has two basic relationships with the frame. In one, there are implied forces that are in proportion to its distance from each corner and side. In the other, implied lines suggest a horizontal and vertical division of the frame.

▲ CENTRAL
Static, and usually dull.

▲ CLOSE TO THE EDGE
Markedly eccentric, needing some justification.

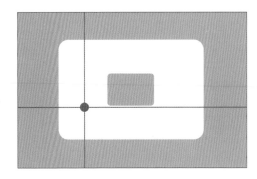

▲ SLIGHTLY OFF-CENTER
Moderately dynamic, without being extreme.

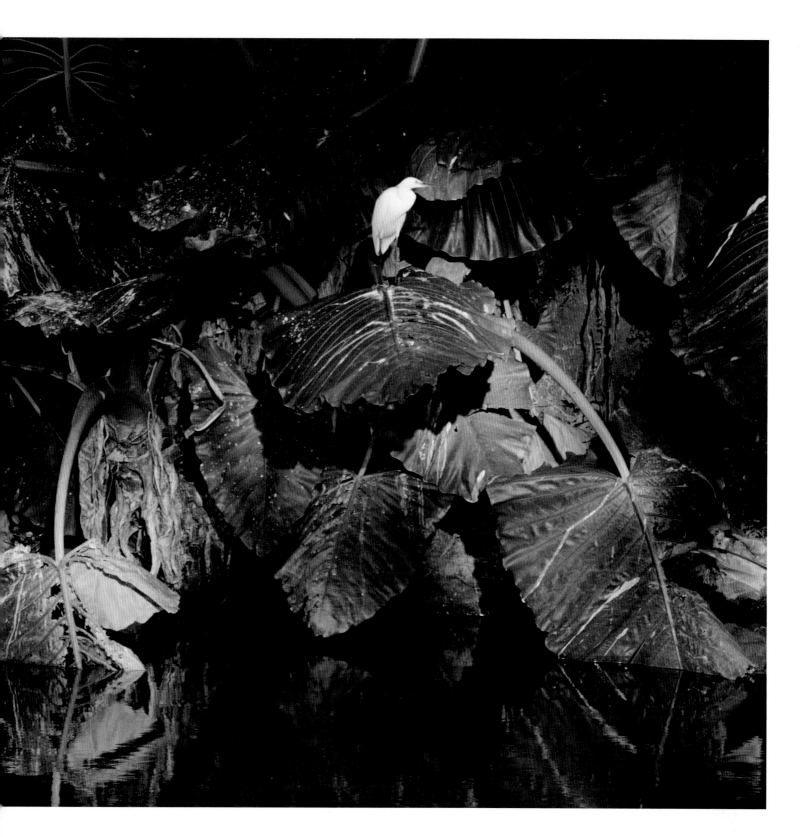

RICE FARMER

This sequence shows some of the practical issues involved in composing a photograph around a single point. The setting was a rice field in northern Thailand. The intention was to create just this kind of shot—one person surrounded by green right up to the frame edges—but because the viewpoint was only slightly elevated, there was little choice at the top of the frame. The first four frames were shot with a 180mm efl lens, and the results too eccentric in placement. Accordingly, the lens was switched to a 300mm efl, which allowed more room relatively at the top; every shot was framed as high as possible without leaving the rice field. Vertical variations were also tried, but the shot finally used on a magazine double-spread was number 5, the choice influenced by the farmer's action.

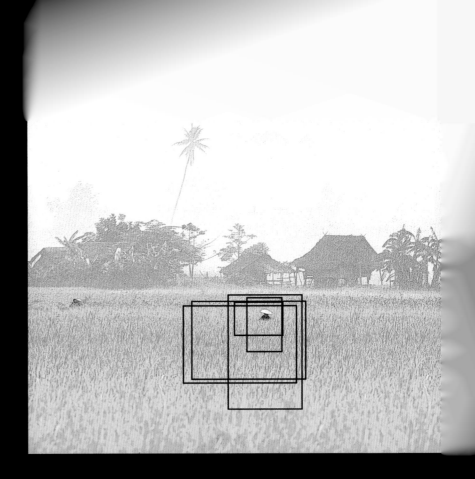

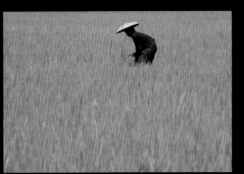

2

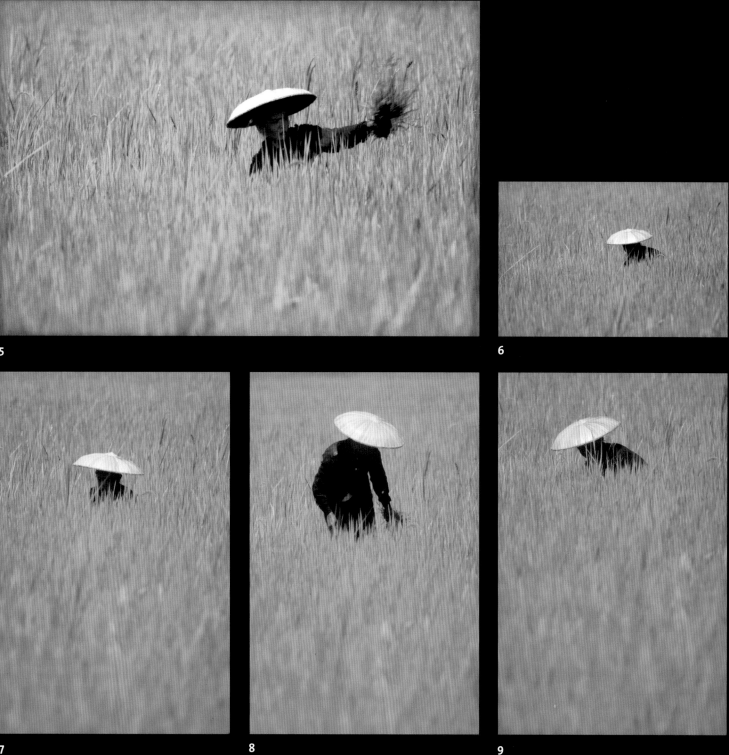

5

6

7

8

9

SEVERAL POINTS

As soon as even one more point is added, the simplicity is lost. Two dominant points in a frame create a dimension of distance, a measurement of part of the frame. The strength of the relationship between two points depends, naturally, on how dominant they are and on how receding the background is. The examples chosen here are quite strong in this respect, but in complex images, additional picture elements reduce two-point relationships.

The eye is induced to move from one point to another and back, so there is always an implied line connecting the points. This line is the most important dynamic in a two-point image; being a line, it has a relationship with the horizontals and verticals of the frame, and it also has direction. The direction of the line depends on a variety of factors, but it will tend to be from the stronger to the weaker point, and toward the point that is close to an edge.

Several points carry the sense of occupying the space between them, again by implication. In this way, they can unify the area. This effect, however, depends on their location and spacing, and with a group the eye has an almost irresistible tendency to create shapes from their arrangement (see Gestalt Viewing on page 36). These may serve to exclude other areas of the frame and so, in effect, break up the image.

When several objects need to be arranged for a photograph, the order and placement can become very demanding. How structured should the grouping be? Should there be an attempt at naturalness? If it is completely obvious that the image is of an arrangement, and not found, as is the case with the three examples on page 71 (jade, pearls, and resin-encased objects), too artful an arrangement may simply insult the viewer's intelligence. The American photographer Frederick Sommer had this to say about arranged versus found compositions (he was actually being asked if he had rearranged a group of carcasses): "Things come to our awareness in ways that are much more complex than we could arrange. Let me give you an example. We could take five pebbles, just a little bit larger than dice, of a somewhat irregular shape. We would find that we could continue throwing them endlessly, and will get interesting arrangements. Every throw of these stones would bring us a combination of relationships that we could not even approach by arranging them ourselves. In other words, the forces in nature are constantly at work for us."

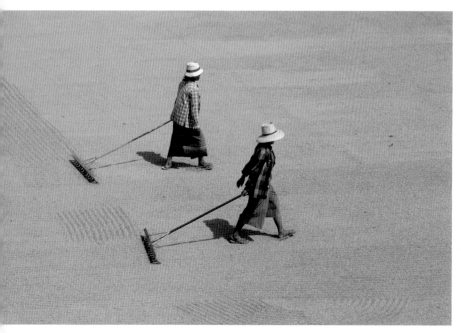

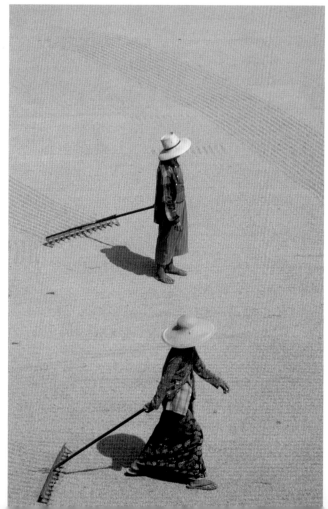

∧ ➤ RAKING RICE
Workers at a Thai rice mill cross and re-cross an open space covered with rice husks. From a rooftop vantage point, there was plenty of choice of timing and placement, and there is a case in favor of each. Note the different dynamics between horizontal and vertical formats.

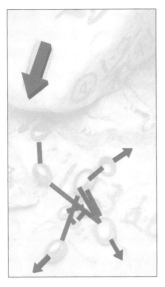

▲ GEM-QUALITY JADE

A set-up still-life arrangement, taken on location at a jade dealer's. The rough stones provided the background, one of them with a characteristic "window" ground out of its surface. This determined the area available for laying out the nine cabochons. One of the most eye-catching occasions in unplanned photography is the unexpected appearance of regular shapes and patterns, but studio photography often poses a reverse problem. It is clear that the stones have been arranged and not found. Yet the style of the image is loose, not geometric. Arranging nine virtually identical objects so that they did not lock together into an obvious shape took several minutes, and some thought was given to the vectors. The ground "window" initiated a movement into the group, and the final structure has lines of direction pulling outward, though not strongly, in three directions. Creating disorder that still remains cohesive is usually more difficult than establishing order.

▲ ORANGE PEARLS

Another still-life arrangement, this time of rare orange pearls. Here the key decision was to provide a background of polished black pebbles for textural and color contrast. The effect they had on the composition was to offer a limited number of gaps between them for placing the pearls. The final structure chosen was a kind of horseshoe curve.

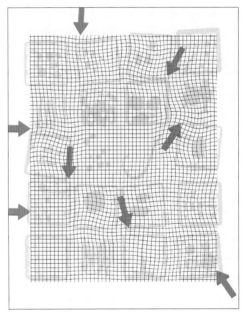

▲ SPECIMENS IN RESIN

For a story on archeometry, these fragments of Roman metal tools embedded in resin blocks suggested an ordered arrangement. Nevertheless, there are limits to the appeal of precision, and having first been placed in a highly regular pattern, several of them were then deliberately skewed, to avoid what would have been a rather anal composition.

HORIZONTAL LINES

Arrangements of several points, as we have just seen, produce the effect of being joined, which leads naturally to the next major group of elements in an image: lines. Whereas in illustration a line is often the first mark made, in photography it occurs less obviously and usually by implication. In this respect it is similar to the way we actually see the world, where most lines are in fact edges. Contrast plays the biggest role in defining lines visually; contrast between light and shade, between areas of different color, between textures, between shapes, and so on.

As you might expect, the graphic qualities of lines are rather stronger than those of points. Like the latter, they establish location, a static feature, but they also contain the dynamic features of direction and movement along their length. And, because the frame of a photograph is itself constructed of lines, these invite a natural comparison of angle and length.

Lines also have some capacity for expression. It is perhaps best not to make too much of this, but different forms of line have distinct associations. Horizontal lines, for instance, have a more placid effect than diagonal lines; a zig-zag can be exciting. Strong, definite lines can express boldness; thin, curving lines suggest delicacy, and so on. However, whereas in abstract art this can be used as the very basis for expression, it is not realistic to expect to make great use of it in photography. These associations, which will be described in more detail on the following pages, are real enough, but in a photograph the subject often overwhelms them. Nevertheless, being sensitive to them pays dividends when the opportunity arises.

The horizontal is, in more senses than one, the baseline in composition. As already described on pages 12-13, there is a distinct horizontal component in the way we see. Our frame of vision is horizontal, and the eyes scan most easily from side to side. Not surprisingly, horizontal lines are visually the most comfortable. Moreover, the horizon is a fundamental reference line—the most familiar of any—and even gravity is a reminder that a horizontal surface is a base that supports. For all these reasons, horizontal lines generally express stability, weight, calm, and restfulness. Through their association with the horizon they can also suggest distance and breadth. Note, though, that such expressive qualities usually only become important when there is little real information to be had from the content of the photograph.

▲ ◄ HORIZONTALS FROM PERSPECTIVE
Even irregular groupings of things become resolved with distance into horizontal bands, and eventually lines. The horizontal components of this photograph of flamingos in Ngorongoro Crater, Kenya exist only because of the acute angle of view.

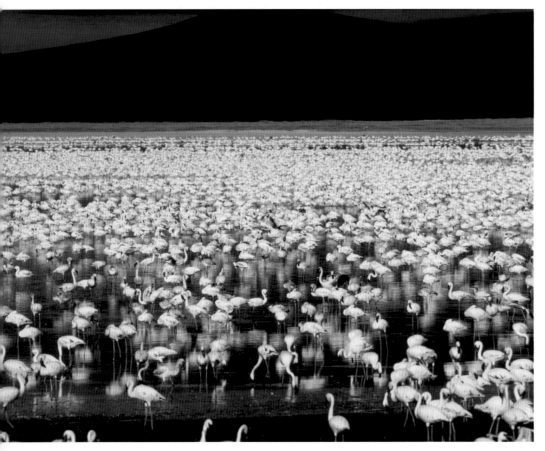

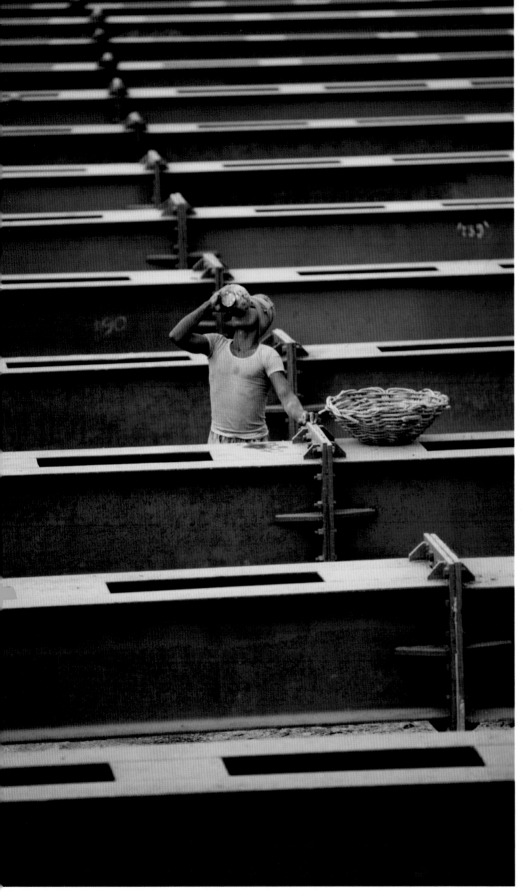

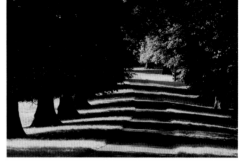

▲ SHADOW CONTRAST
In a very precise example of how lines are formed by contrast, light and shade from a row of trees form diminishing bands along the driveway of an English estate. Expressively, this helps to give a feeling of stability and tranquility to the view; graphically, the receding pattern has interest. This recession also gives a clue to the abundance of horizontal lines in views that span a distance; on a flat surface seen from only slightly above, virtually all details merge and converge on the horizon.

◄ THE IMPORTANCE OF VIEWPOINT
This row of steel girders at a Calcutta construction site become a dominant horizontal setting for the shot of a worker drinking water only through viewpoint and focal length. From a lower viewpoint they would have merged into an indistinct mass, and from a higher viewpoint they would have separated. A telephoto lens both compressed the perspective and allowed a crop that excluded distracting surroundings.

VERTICAL LINES

The vertical is the second primary component of the frame, and so is naturally seen in terms of alignment with the format and with the sides of the picture. A single vertical form understandably sits more comfortably in a vertical format than a horizontal. A series of verticals, however, acquires a horizontal structure, as can be seen from the photograph of the leg-rowers opposite; here, a horizontal frame actually allows more to be made of the series.

A vertical line is also the main component in the main image of a human figure, and of a tree. Its direction is the force of gravity, or something escaping it. Without the inbuilt associations of a supporting base that give a horizontal line much of its character, a vertical line usually has more of a sense of speed and movement, either up or down. Seen as uprights from a level viewpoint, vertical forms can, under the right circumstances, confront the viewer. Several vertical forms can have associations of a barrier, like posts, or a line of men facing the camera. To an extent, they can express strength and power. On a practical level, exact alignment is very important, as it is for horizontal lines. In a photograph, both are immediately compared by the eye with the frame edges, and even the slightest discrepancy is immediately noticeable.

Together, horizontal and vertical lines are complementary. They create an equilibrium in the sense that their energies are perpendicular to each other; each one acts as a stop to the other. They can also create a primary sensation of balance, because there is an underlying association of standing upright, supported on a level surface. If used strongly and simply in an image, this can produce a solid, satisfying feeling.

➤ CONTINUATION

In a classic example of the Gestalt Law of Good Continuation, the slightly undulating but distinctly vertical line of the palm tree "connects" with the profile of the Indian farmer leading his cow to water. The resulting top-to-bottom vertical line dominates and orders the composition.

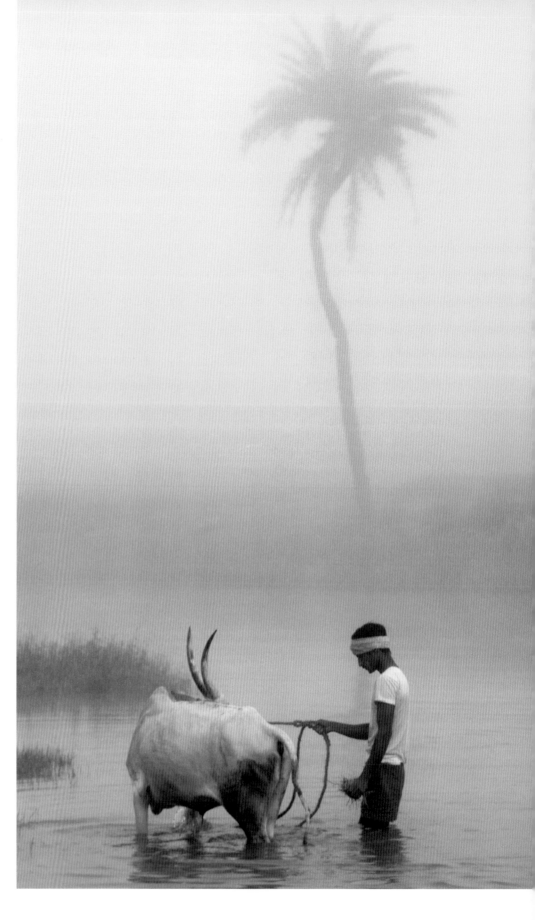

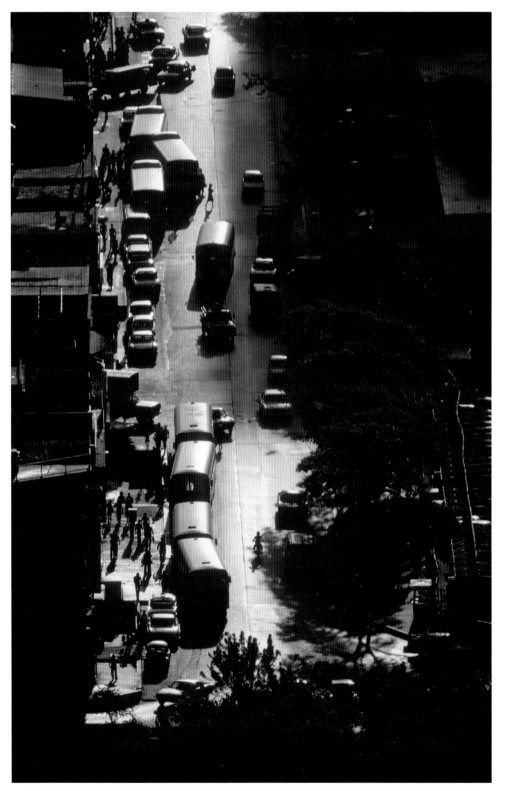

▲ VERTICALS IN A HORIZONTAL FRAME
Parallel verticals frequently fit better into a
horizontal frame, which gives them a greater
spread—important when there is a need to show
a quantity, as in this telephoto shot of leg-rowers
in Shan State, Burma. The long focal length usefully
compresses perspective. Compare with the similar
treatment of a single figure on page 163.

◄ VERTICALS FROM FORESHORTENING
Through its foreshortening effect, a powerful
telephoto lens—400 mm efl—converts what
would otherwise be diminishing perspective into
a vertical design. As with most images that feature
dominant lines of one type, it adds interest to have
some discontinuity, in this case the ragged line of
the right edge of the street.

DIAGONAL LINES

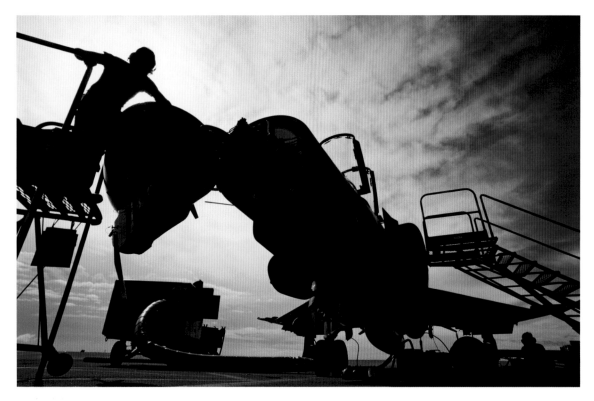

◄ **IMPOSING A DIAGONAL STRUCTURE**
One solution with a subject which has the potential for confusion is to impose a simple graphic structure. In this example, maintenance work on an F4 aircraft was just such a design problem. A corner-to-corner diagonal line is frequently quite easy to construct, given a wide-angle lens and some length to the sunset. The arm of the engineer here completes the line, and the silhouette emphasizes it by reducing tones.

▼ **DIAGONAL DYNAMICS**
Diagonals appear more dynamic when they form a stronger angle with the longer side of the frame. Parallel diagonals reinforce each other; a variety of diagonals gives the greatest energy to an image.

Freed from the need to be aligned exactly in the picture frame, diagonal lines have a variety of direction denied to horizontals and verticals. Practically, this means that in photographs which do not depend on a horizon or on some other absolute reference, there is an extra element of choice: the angle of the line.

Of all lines, diagonals introduce the most dynamism into a picture. They are highly active, with an even stronger expression of direction and speed than verticals. They bring life and activity precisely because they represent unresolved tension. If the relative stability and strength of horizontals and verticals is due to their symbolic associations with gravity (see pages 72-75), the tension in looking at a diagonal has the same source. It has an unresolved and unstable position; in the process of falling, if you like. Indeed, structurally most scenes and things are composed of horizontals and verticals, rather than diagonals, particularly in man-made environments. Through the viewfinder, most

diagonals appear as a result of viewpoint—oblique views of horizontal or vertical lines. This is very useful indeed, because they are, as a result, much more under the control of the photographer than are horizontals and verticals. The frame edges themselves provide a certain amount of contrast. This activating effect is in proportion to the angle that the diagonal forms with the edges of the frame. The maximum for a single diagonal, or parallel set, is 45°, but with two or three different diagonals combined, the strongest effect is when the relative angles are all great without being equal.

In normal eye-level views, horizontal lines that run away form the eye converge in a photograph; this is the normal effect of perspective. By converging, they become diagonals, or at least most of them do. As this is entirely familiar, diagonals carry some associations of depth and distance, particularly if there is more than one and they converge. Considerable use can be made of this in

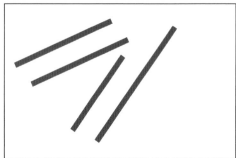

▲ **DYNAMIC DIAGONALS**

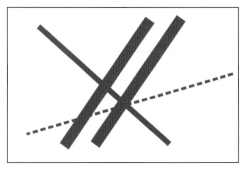

▲ **PARALLEL DIAGONALS**

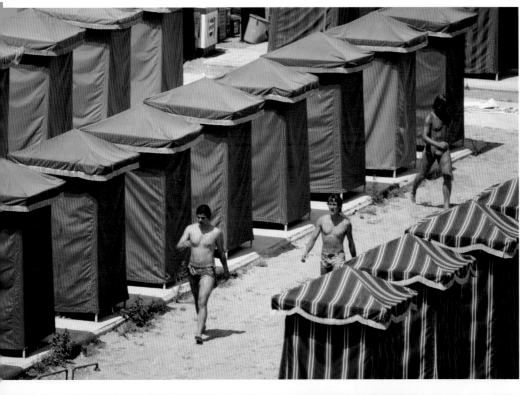

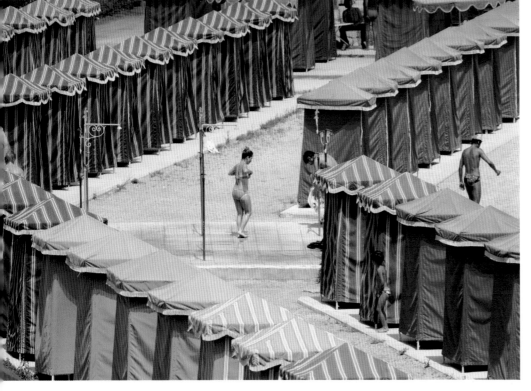

◄ ▲ ZIG-ZAGS

Oblique views of right angles produce zig-zags, a chevron effect of multiple diagonals. The angles are jointed, so the impression of movement along the diagonal is maintained, but with a sharp kink. As can be seen from this pair of photographs of rows of bathing tents, both taken within moments of each other, this type of dynamic effect is different. In the diagonal picture, the graphic movement is single-minded (the bias of direction is set by the walking figures). In the zig-zag version, the change of direction produces more internal activity.

trying to manipulate the sense of depth in an image. Including or strengthening diagonals in a landscape (often no more than a matter of aligning objects or edges) will tend to improve the impression of depth; even the arrangement of subjects in a still-life can produce, quite artificially, a feeling of distance. Related to this is movement. A diagonal leads the eye along it, more than any other line. This makes it an extremely valuable device for encouraging the attention to move in certain directions in a photograph, something we will consider in more detail on page 94.

These perspective diagonals appear stronger through a wide-angle lens, the more so from a close viewpoint. However, telephoto lenses also have their uses in treating diagonals. By giving a selective view, a lens with a long focal length can emphasize one distinct part of a diagonal. Oblique views from some height typically produce the kind of diagonals seen in the photograph of the bathing tents (page 77). What strengthens these particular images is the repetition of diagonal lines; the compressing effect that a long lens has on perspective makes them appear parallel. A wide-angle lens from closer would cause them to converge in the image.

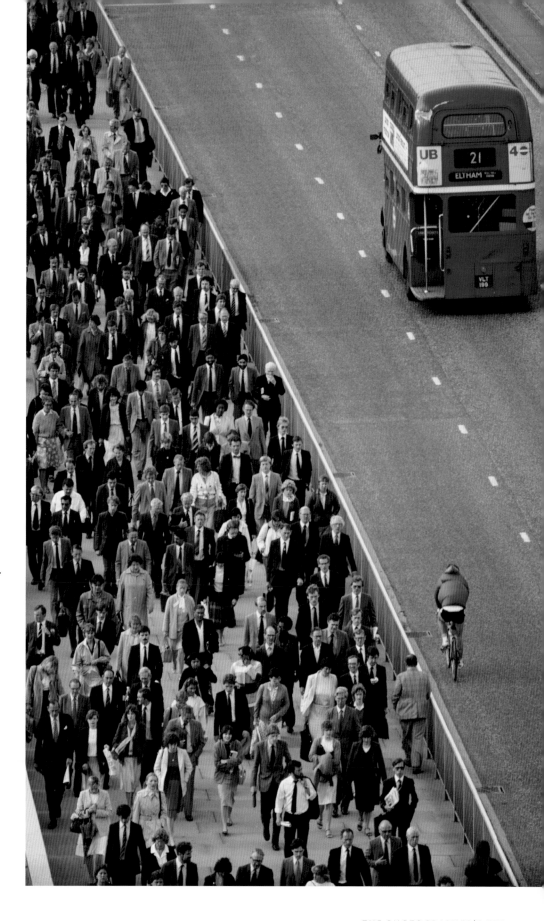

> **DIAGONALS REINFORCED BY MOVEMENT**
There is only one significant diagonal line in this picture—the railing—yet the photograph is full of "diagonality." What creates this is simply the perceived movement, the mass of commuters all marching in the same direction across London Bridge. This is reinforced by the bus and the cyclist travelling in the opposite direction, which act as a counterpoint. The shot was composed and timed for just this opposition.

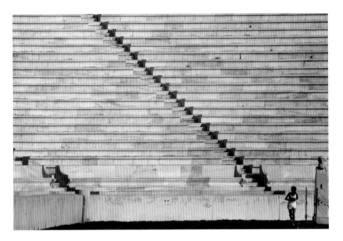

▲ SINGLE DIAGONAL LINE

In this straightforward use of a convenient, prominent diagonal line, the intention was to take a shot that showed something of the stadium with the added activity of an athlete. The difference in scale between the two subjects was a potential problem; showing a substantial part of the stadium might reduce the figure to insignificance. The solution was to use this diagonal to direct attention. The natural direction along the diagonal is downwards, and the athlete was allowed to run into position at the foot of it. The framing was chosen to give as much length as possible to the diagonal. The picture was framed in anticipation, and taken when the runner appeared in this position. Placing the ground level right at the bottom of the frame gives the maximum space to the diagonal.

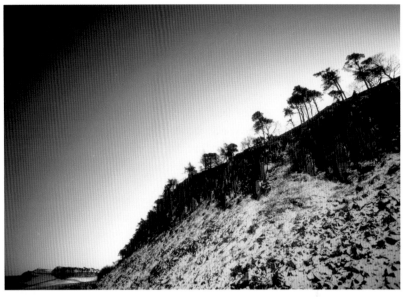

▲ WIDE-ANGLE PERSPECTIVE

A wide-angle lens close to a long wall produces a predictable diagonal that radiates from the vanishing point. In this case, the wall is Hadrian's Wall in northern England, the lens 20 mm efl, and the composition chosen to introduce some visual drama. A head-on view would have shown this section of the Roman wall as little more than an ordinary escarpment. Note that the diagonals have been enhanced by the use of a neutral graduated filter, angled to darken the sky in alignment with the diagonal line of the top of this wall.

▲ DIAGONAL INSTABILITY

Much of the dynamic quality of diagonal lines comes from the unresolved tension of their position between flat and upright.

▲ PERSPECTIVE

Perspective effects are ultimately responsible for most of the diagonal lines that appear in photographs. The steepness of the angle varies according to the viewpoint.

CURVES

So far, we have been concerned only with straight lines. Curves have entirely different qualities, both graphically and expressively. As a line, the unique feature of a curve is that it contains a progressive change of direction, and so seems to avoid, any direct comparison with the horizontal and vertical edges of the frame. Many curves are, however, aligned mainly in one direction or another, as can be seen from the examples shown opposite; in another way, a curve can be thought of as a series of straight lines at progressively changing angles. For these reasons, curves do interact with straight lines in an image.

The progressive quality of a curve gives it a rhythm which straight lines lack (other than zig-zags). The sense of movement along it, even acceleration, is also greater. For example, if a shot of a vehicle is animated by streaking its tail lights behind it (with a long exposure), the greatest impression of speed would be if these were slightly curved. Curved movement like this is smooth, and many of the other associations of curved lines are to do with being gentle, flowing, graceful, and elegant. Curves are inherently attractive to most people, particularly when they undulate. Just as diagonals have a specific character—active and dynamic—and a quality of movement, so curves have a character—smooth and flowing—and also carry the eye along them. They are, therefore, a useful second device in controlling the way in which the viewer will look at a photograph.

Curves are, however, harder than diagonals to introduce into a picture. While a diagonal is usually a straight line of any direction that is altered by viewpoint, curves must usually begin as real curves. They can be exaggerated by being viewed at a more acute angle, but the only optical method of actually creating them that is open to photographers is to use a fish-eye lens, and this simply bends all the lines into curves without discrimination. Nevertheless, it is sometimes possible to produce a curve by implication; by an arrangement of points, as in the photograph of the pelicans, or with a number of short lines or edges.

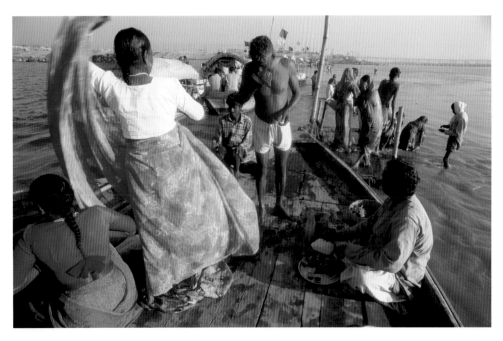

⌃ GESTURE
The upward sweep of a bright Indian sari being adjusted by a pilgrim on a boat in the Ganges creates a strong curve that acts graphically like a converging lens, drawing the attention in towards the center and right of the image.

⌃ RELATIONSHIP TO STRAIGHT LINES
Although a curve is continuously changing direction, it has implied straight-line components, particularly at either end.

⌃ RELATIONSHIP TO CIRCLES
A curve can also be seen, at least in part, as a section of a circle. This helps to explain the enclosing sensation of curves.

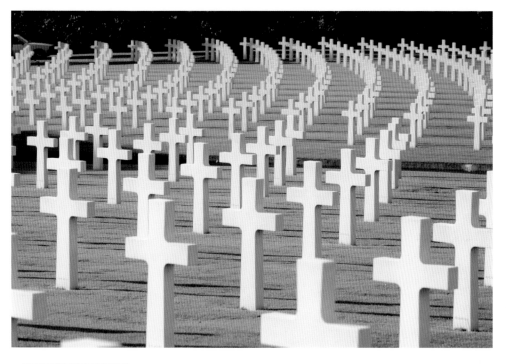

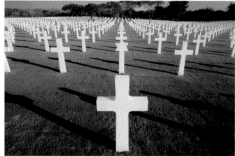

▲ CONCENTRIC CURVES

As with any other kind of line, several concentric curves reinforce each other. The strong sense of movement can be especially felt, even with these static rows of crosses at a military cemetery in the Philippines, because the rows approach the camera.

This photograph also demonstrates how a low viewpoint, giving an acute angle of view to the lines, strengthens the curvature (white represents high angle, purple low in the schema). The smaller image demonstrates the singular importance of viewpoint.

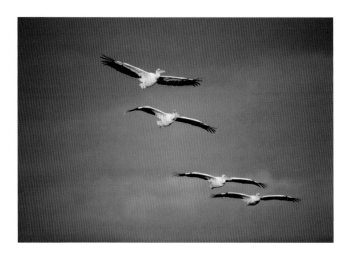

▲ IMPLIED CURVE

One method of creating a curve is by aligning other elements. In this case, pelicans in flight appear, from the camera position, to form a curve, and this becomes the structure of the photograph.

➤ CONTRAST OF LINE

Curved lines make a more substantial contrast with straight lines than do the different types of straight lines among themselves. Here, the contrast is used quite gently: the intricate curved pattern of oil globules in seawater forms a background for the diagonal line of baby shrimps.

EYE-LINES

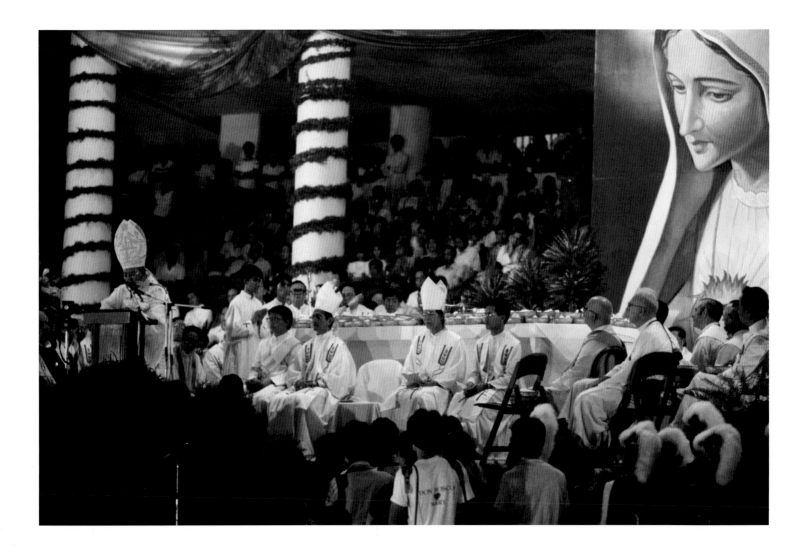

This brings us to one of the most valuable implied lines that can be used in designing a photograph. So strong is our attraction to images of the human face that we pay instant attention to any face that appears clearly in a photograph. In particular, if the person in the photograph is looking at something, our eyes naturally follow that direction. It is simple, normal curiosity, to see where the eyes are looking, and it creates a strong direction in the image. Known as eye-lines, whenever they occur they are nearly always important elements in the structure of the image.

Eye-lines are an example of the Gestalt Law of Good Continuation at work (see page 38),

but owe their insistence to the high importance attached to any image of the face, particularly on the eyes (see pages 58-59). While direct eye contact between the person photographed and the viewer is always the strongest attractant, we still want to know what people are looking at, on the reasonable grounds that if that something is interesting to one person, it might interest us too. The gaze "points" us at another element in the image or, if it is directed out of the frame—as in the image of the spectators on page 141—it is unresolved and creates some doubt in the viewer's mind. This is by no means a fault, and can be useful in creating ambiguity (see pages 140-143).

▲ DIAGONAL EYE-LINE

The painting of the Virgin, for a public celebration held in the Philippines, was, of course, already positioned to appear to look at the cardinal on the stage. To make the most effective use of this in the photograph, the painting was placed at the extreme edge of the frame, so that the eye-line would dominate. In other words, as the eye is naturally drawn first to the strong image of the Virgin's face, placing this at the edge means that there is no distraction on the opposite side of the frame. The attention starts at one predictable place and moves in one predictable direction.

⋀➤ MANDALAY HILL

Through a combination of design elements, this photograph of novice monks in a Burmese temple is organized to be seen in just one way. Although the moment for taking the shot was very short—just the time taken for the gesture and glance of the second boy—there was plenty of time to prepare and to anticipate most of the possibilities, including the fact that the gilded statue in the background could be taken as looking at the foreground. The actual coincidence of expression of the face of the two boys was, of course, unplanned, but anticipation made it easy to recognize the potential and shoot in time. The result is a very structured image, due to the way in which the three eye-lines combine to project outward to the viewer.

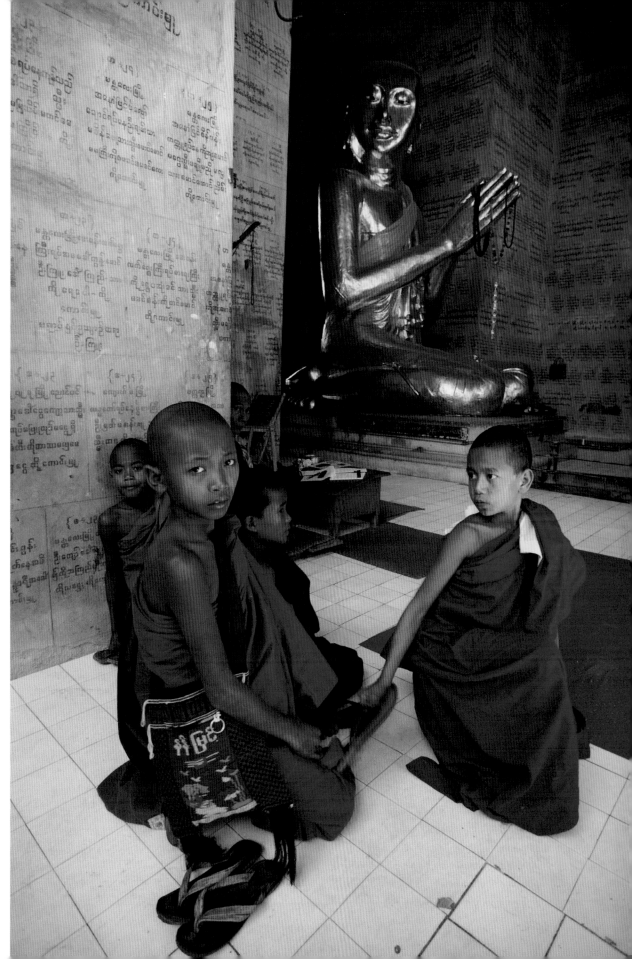

TRIANGLES

In photographic composition, triangles are the most useful shapes, for a number of reasons. They are common, partly because they are simple to construct or imply (they need only three points for the apices, and these do not need to be in any particular arrangement) and partly because of convergence—the natural graphic effects of perspective make convergent diagonals very common in photography, particularly with wide-angle lenses. They are also the most basic of all geometric shapes, having the least number of sides. Moreover, they have the interesting combination of being both dynamic, because of the diagonals and corners, and stable—provided that one side is a level base.

The triangle is such an inherently strong shape that it appears easily to the eye. With lines, often two are sufficient; the third can be assumed, or else an appropriate frame edge can be taken as one side. As for points, any three prominent centers of interest will do, particularly if they are similar in content, tone, size, or some other quality. Unlike rectangles and circles, both of which need to have their principal components in an exact order, triangles can be formed in almost any configuration. The only arrangement of three points that does not create a triangle is a straight row. For example, a portrait of three people will almost inevitably contain a triangle, with each face an apex.

The natural tendency of linear perspective is for lines to converge on a vanishing point in the distance, and form two sides of a triangle. It the camera is level, the prime apex of the triangle will be pointing more or less horizontally (you could think of the triangle formed by a receding row of houses as lying on its side, with the apex on the horizon and the base the nearest upright to the camera). If the camera were pointing upward instead, at a building, trees, or any other group of vertical lines, the apex would be at the top of the picture, and the base level at the bottom. This is also the most stable configuration of a triangle.

The sense of stability inherent in many triangles comes from structural association; it

▲ TRIANGLES BY IMPLICATION
Any arrangement of three objects (except in a straight line) produces an implied triangle.

▼ VERTICAL CONVERGENCE
An upward-tilted view with a wide-angle lens creates a triangle by convergence.

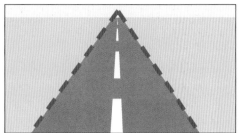

▲ TRIANGLES BY CONVERGENCE
Convergence caused by linear perspective, particularly a wide-angle lens, creates at least two sides of a triangle. Vertical surfaces which recede to the horizon create triangles that appear to lie on one side. The principal apex is directed towards the vanishing point.

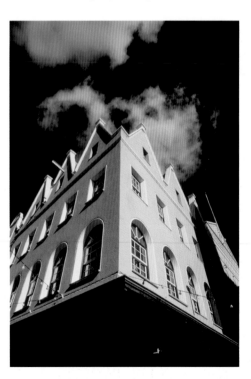

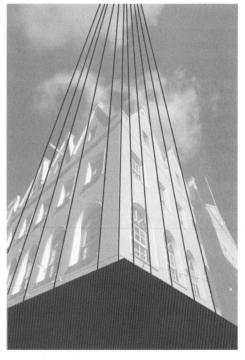

This sequence of frames illustrates well how an implied triangular structure can strengthen the organisation and dynamics of an image. The setting is the malaria ward of a hospital in Sudan, where patients have to share beds. A wide-angle lens was chosen to show maximum information. While the initial two shots were satisfactory, the movement of the doctor, and in particular his stretching gesture, suddenly organised the entire image. A moment later, this strong geometry weakened.

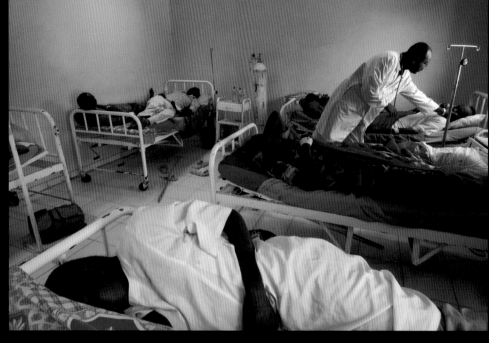

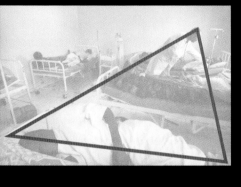

is the shape of a pyramid, or of two buttresses leaning in towards each other. Therefore, arranging three objects so that two form a base and the third an apex above creates a stable form, and this association is carried into the image. It is the classic three-figure shot, and in photography that allows the subjects to be manipulated, it is a standard and usually successful technique to reposition things in this way. The two diagonals in such a triangle help it to escape the heaviness of a square or rectangular arrangement.

The reverse configuration, with the base at the top of the picture and the apex at the bottom, is an equally useful shape to introduce into a design. It has different association: less stable, more aggressive, and containing more movement. The apex points more obviously, probably because it appears to face the camera and viewer, and there is the kind of tension that you would expect from a shape that symbolizes extremely precarious balance. A special use for inverted triangles in design occurs in still life and other group pictures where objects are of different sizes yet need to be unified in one shot—placing the smallest nearest the camera, at the apex of the triangle, and the rest of the objects behind. A wide-angle lens, used from a raised position looking slightly down, will emphasize the proportions of an inverted triangle, just as a wide-angle lens pointing up will create upward-converging verticals.

Under what circumstances is it useful to try to impose a triangular structure? It is important to see implied triangles as one of a few devices for bringing order to an image, or of arranging the things being photographed. The occasions when such organization is needed are usually those when there is a need for clarity. This is common in still-life photography and in various forms of reportage when the most important thing is to make a clear representation of something, often in a visually untidy setting. As this is a common condition in professional photography, the idea of structuring an image in a simple graphic arrangement is principally professional.

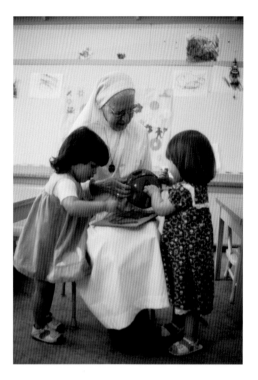

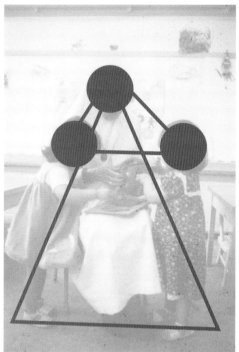

▲ THREE-SHOT
Three-figure shots usually contain the potential for a triangular structure. Here it has been deliberately strengthened by the viewpoint, which not only shows a triangular relationship in the heads, but a triangle in the outline of three figures.

➤ INVERTED TRIANGLE FOR FOCUS
A triangle with its apex at the front of the picture makes a useful configuration, not only for groups of objects as in a still-life, but also to focus attention more strongly on the apex, when the converging sides draw the eye toward this foreground point. In this instance, the device was chosen because the subject, the rice, was visually bland.

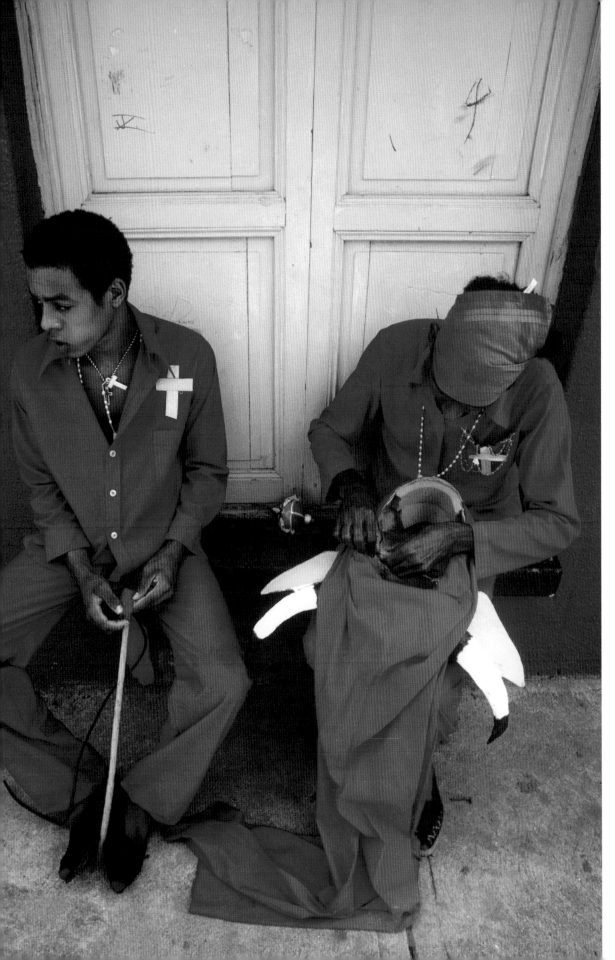

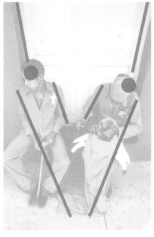

◄▲ INVERTED TRIANGLE
In itself, the arrangement of the two seated figures only mildly suggests a triangular shape, but a standing shot, looking down with a 20 mm lens, strengthens the structures by convergence.

CIRCLES AND RECTANGLES

After the frequency of triangular structure, the other basic shapes—circles and rectangles—tend to be rarer in photography and so less of an option in composition. As with triangles, they are more interesting when implied—suggesting a shape rather than being a pre-formed one.

Circles have a special place in composition. Unlike triangles and lines, they are not so easy to imply, because they need to be almost complete and have a very precise, recognizable shape. Nevertheless, they do occur often, both man-made and naturally. In nature, radial growth, as you would find in a flower head or a bubble, tends to make a circle. Circles are valuable in composing a picture because they have an enclosing effect. They "contain" things placed within them, and they draw the eye inward, and for this reason they are useful in arranged photographs, particularly still-life, when the photographer sets out to create a composition from scratch. The effect of focusing the viewer's attention can be so strong as to make the surroundings visually less important, so circles should be used with caution. There is some slight implication of movement around the circumference, because of associations of rotation.

Derivatives of circles are ellipses, other flexing, cyclic shapes, and more or less any squat shape made up of curves rather than lines and corners. Ellipses represent a special case in photography, because this is the shape that a real circle projects onto the film when seen from an angle. To an extent, the eye resolves ellipses into assumed circles.

Rectangles abound in man-made structures, more rarely in nature, and are useful in composition in that they are the easiest form for subdividing the frame. Indeed, the shape that bears the closest correspondence to the frame of a photograph is a rectangle. A high degree of precision is called for, as the most usual way of arranging rectangular shapes in a frame is to align them with the horizontals and verticals of the frame itself. Misalignments are then easy to spot, and easy to correct digitally. In fact, correcting distortions due to lens design and to tilting is standard digital post-production procedure, as for example in Photoshop's *Filter > Distort > Lens Correction* facility.

Rectangles have associations of gravity, solidity, precision, and sharp limitation, a result of their connotations with the two kinds of lines—vertical and horizontal—that compose them. They tend to be static, unyielding, and formal. As the perfect form of the rectangle, the square exhibits these qualities the most strongly. For a rectangular form to appear rectangular in the picture, it must be photographed square-on and level. Angled views and wide-angle lenses tend to distort rectangles into trapezoids. Hence, the manner of shooting that uses rectangular structures is itself usually formal and considered.

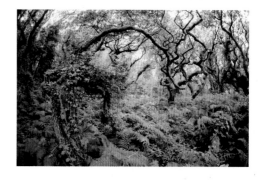

▲ FISH-EYE LENS
The subject is a fairly dense oak forest, but the design problem is its lack of structure. The solution here was to find one view with a little potential structure (the prominent curving branch), and then exaggerate this by using a full-frame fish-eye lens. Although almost fully corrected in regular lenses, curvilinear distortion is deliberately maintained in fish-eye lenses. All lines except radial ones are curved: the farther from the center, the more extreme the curve.

▼ ORDER IN SHAKER DESIGN
This is an example from a book which was photographed entirely with a motif of rectangular shapes. The subject is Shaker architecture and crafts, and the severe, functional nature of the material suggested an appropriate treatment. The defined regularity of rectangles makes them especially adaptable to design that stresses balance and proportion.

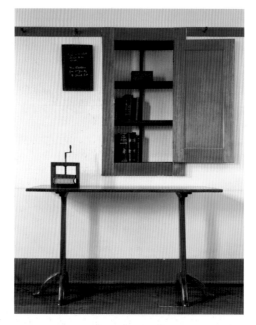

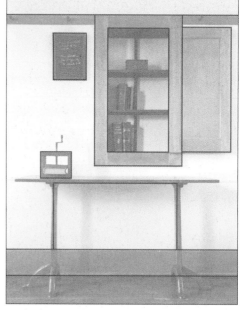

PEARLS

This arrangement of a variety of different types of pearls was for a magazine cover, and so not only had to be clear in displaying the pearls but also had to be attractive and simple, with room at the top for the masthead. The problem was that several pearls needed to be shown, too many to arrange in a single group. The solution was to split them up into three groups yet tie them together visually in such a way that the arrangement looked fairly natural and the eye could move smoothly around the picture.

The key to the picture's success is in the choice of oyster shells of different species, with the iridescent coloring typical of mother of pearl. Specifically, the two principal shells provide circular enclosures, one fitting into the curve of the other. The 15mm South Sea pearl at right is large enough to be its own circle, and the three circles are linked in two ways—first by their triangular relationship, and also by the sinuous S-curve, which helps to direct the eye between them.

As in any still-life, the arrangement is built up carefully, with the camera locked in position. The main group was assembled in the large shell first, then a smaller group was added to the shell below, and some additions made to the first group. Finally, the large pearl was placed against a darker shell for contrast.

The principal design structures are the circles, the two largest formed by the shells. In turn, these three circles are inevitably linked into a triangular pattern. Finally, the arrangement of the background deliberately makes use of the reverse curve of the large shell to create an S-shaped curve.

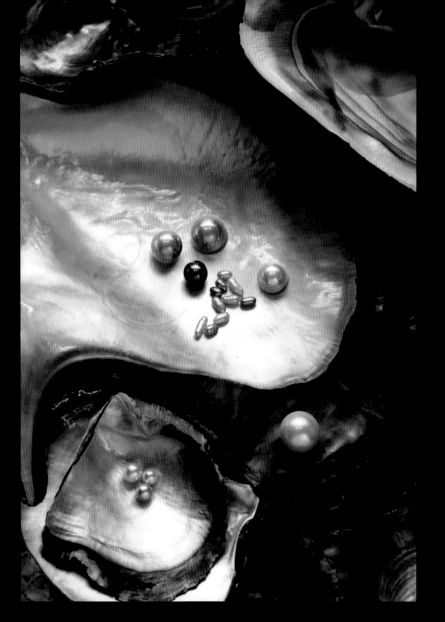

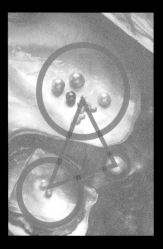

IMPLIED CIRCLES **TRIANGULAR RELATIONSHIP** **S-CURVE**

VECTORS

We have seen how readily the eye follows a line, or even the suggestion of one. This tendency is the most important single device available to a photographer in designing an image so that it will be looked at in a certain way. In principle at least, if you can balance a picture so that the attention is first taken by one predictable point, and then provide a line which suggests movement in one direction, you will have provided a route for the eye. Vectors are graphic elements (or combinations) that have movement, and so impart a dynamic quality to the image. Kinetics is another term sometimes used.

The strongest lines that can be used in this way are those with the clearest sense of direction and movement. Diagonals, therefore, are particularly useful, and if there are two or more, and they converge, so much the better. Curves also have feeling of movement, and on occasion even of speed and acceleration. However, the opportunities for using real lines are limited by the scene, naturally enough, and they are often not available when you want them. Implied lines are not as definite and obvious, but can at least be created by the photographer, using viewpoint and lens to make alignments. These alignments may

be of points, or of different short lines, such as the edges of shadows.

Another device is any representation of movement. The image of a person walking contains a suggestion of direction, and this has momentum. The eye has a tendency to move a little ahead of the person, in the direction that is being taken. The same is true of any object that is obviously in movement, such as falling or flying. Because movement in photographs is frozen, even the direction in which an object is facing imparts a slight suggestion of movement; it needs to be recognizable, as in the case of a car, for example.

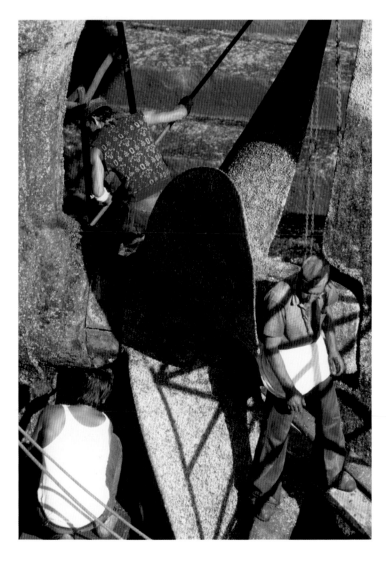
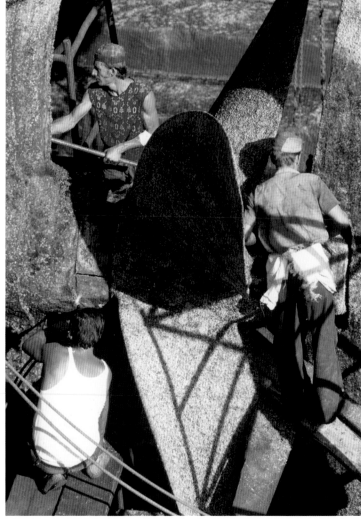

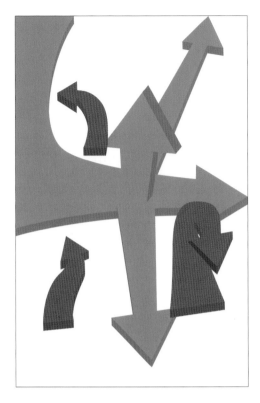

◄ ▲ ► SPIRAL ROTATION

The central subject of this scene, the propeller of a large ship in dry dock, suggests the structure of the picture, a spiral composed of three principal curved lines. However, the necessary reinforcement comes from the three men working on the propeller. To complete the image, the three men needed to be evenly spaced, visible, and facing in directions that helped to confirm the direction of the spirals. Once the viewpoint had been selected, the only thing to do was to wait until the appropriate moment. The less dynamic shots are included to demonstrate the lesser effect.

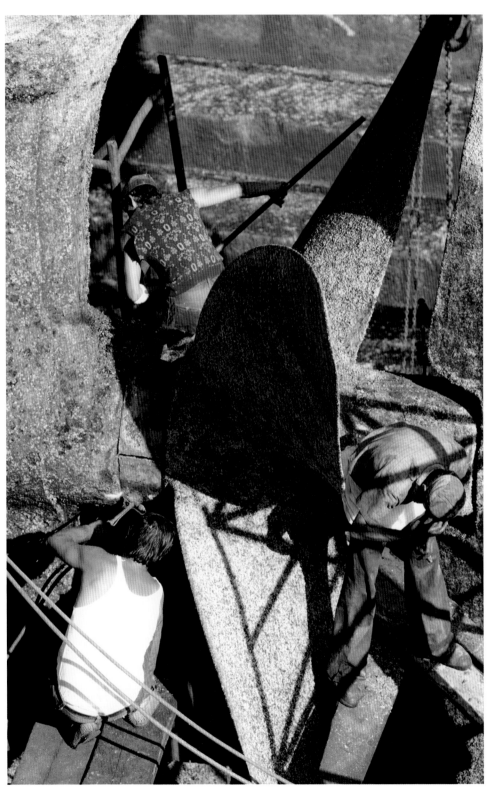

▲ CONVERGING DIAGONALS

This is an arranged shot, intended to show the equipment and procedure for seeding a pearl oyster. It was decided that the style of the photograph would be clean, spare, and clinical, in keeping with the idea that the process is rather like a surgical operation. The ingredients needed were the oyster, the special surgical tools, the seed (actually a small sphere), and, of course, the action of inserting it.

The seed is the central element, but also the smallest, hence the graphic structure is designed to focus attention on it. The basic form is three lines converging on the seed so that, despite the bulk of the oyster as it appears in silhouette, the seed is very much the center of attention. The angle of the lines was chosen so as not to be symmetrical, which would have been a little predictable and dull.

The instruments on the right were fanned to avoid every line pointing severely at the center, and the open mouth of the oyster introduces a sense of movement. The eye moves to the seed at the center, and then a little down and left to the oyster. The action is made clear by the lines.

➤ DIRECTING THE ATTENTION

Here, the subject is food: a Thai dish and its various accompaniments. Partly because this type of Asian cooking tastes better than it looks in detail, and partly because an attractive location was available, it was decided to shoot it in an outdoor setting.

Once this decision had been made, the important issue was the balance of attention. There is no point in going to the trouble of arranging a good location if the audience cannot see enough of it to get some atmosphere. On the other hand, the subject is the food. Fortunately, as already explained, there was no compelling reason to show the food in great detail. It was decided that the food would occupy about one third of the frame, and that the structure would attempt to move the eye between the background and the food, so both would receive proper attention.

The result was a variety of lines and shapes. The food was placed at the bottom of a vertical frame, which alone will encourage the eye to drift down. The circular tables concentrate attention locally inward. The trunk of the palm gives a major downward thrust from the setting to the food, and this is picked up by the diagonal shadow. The curve of the tables then moves, as shown in the (central) diagram below, back up to the fields beyond. The figure of the girl is included for atmosphere, but she stoops to lower the baskets for two reasons: the way she faces imparts a movement downward, as does the (assumed) eye-line, without being too contrived.

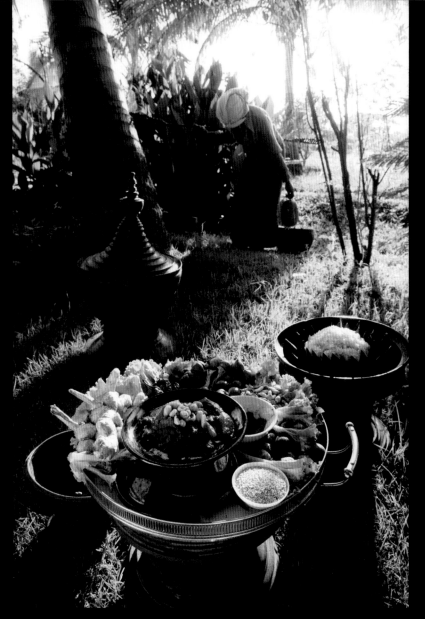

 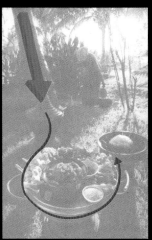

CIRCLES FOCUS ATTENTION **TRUNK ADDS TO VECTOR** **VECTOR FROM FIGURE**

FOCUS

Sharp focus is such an accepted standard in photography that it is rarely treated as anything other than a way of producing a "correct" image, just like inserting the memory card before shooting and other obvious essentials. Only occasionally does it occur to most people to vary the focus for the effect it has on the design. Yet, under the right circumstances, this can be effective.

The question of where to focus seldom arises, because the normal practice of making a photograph is first to decide what the subject should be and then to aim the camera. Natural enough, certainly, and the usual focus problems are those of accuracy rather than of selection. Under normal circumstances, the point to be focused on—the eyes in a face, or a figure standing in front of a background—presents itself without an alternative.

Certain situations, however, do offer a choice, and this lies mainly in how you define the image. When photographing a group of objects, should they all appear in sharp focus? Would it be more effective if just one or a few were sharp and the rest progressively soft? If so, which ones should be in focus and which not? Moreover, there might not necessarily be such a choice of deep or shallow focus. If the light level is low for the combination of film and lens, it may only be possible to have one zone of the image in focus, and in this case you will be forced into a selective decision.

Whatever the reasons, never underestimate the visual power of focus. The fact that sharpness is the virtually unquestioned standard is enough to show that whatever is focused on becomes the *de facto* point of attention. Deliberate misuse— or rather, unexpected use—works extremely well because it flouts established procedure.

If you are using focus in an expected way, it is important to appreciate its different uses with different focal lengths. Even without any knowledge of the techniques of photography, most people looking at a photograph are familiar with the way the focus is normally distributed. With a telephoto lens, the depth of field is shallow, and there is typically a range of focus that can be

seen in one photograph, from soft to sharp. As the sharp area is expected to coincide with the main point of interest—where the eye is expected finally to rest—the range of focus contains a sense of direction from unsharp to sharp. This is not nearly such a strong inducement to the eye as the lines of view that we have just looked at, but it works nevertheless. What is important is that it works through the familiarity of the viewer with the way his or her own eyes will focus on an object.

⌄ ➤ SENSE OF MOVEMENT IN FOCUS
With a 600 mm lens focused on the distance, depth of field in this shot of Lake Magadi in Ngorongoro Crater, Tanzania is very shallow. From a slightly elevated viewpoint (the roof of a vehicle), the focus is progressive, leading the eye rapidly upward to the point of focus, where a hyena has taken a flamingo. Placing this main subject of interest high in the frame makes the best use of this effect.

Shorter focal lengths give images with better depth of field than do longer focal lengths, and we are accustomed to seeing wide-angle views that are sharp throughout. With a typical telephoto image, loss of focus either in the background or foreground is such a familiar condition that we expect it. With a wide-angle view, on the other hand, out-of-focus areas are not expected, and when this happens with a fast wide-angle lens used at maximum aperture on a deep subject, it can easily look in some way wrong.

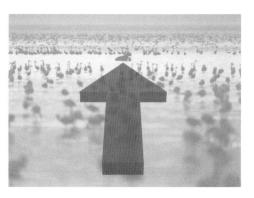

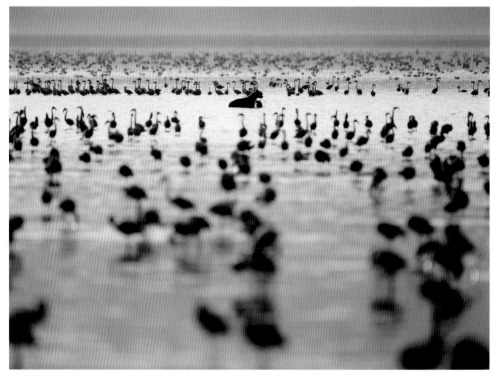

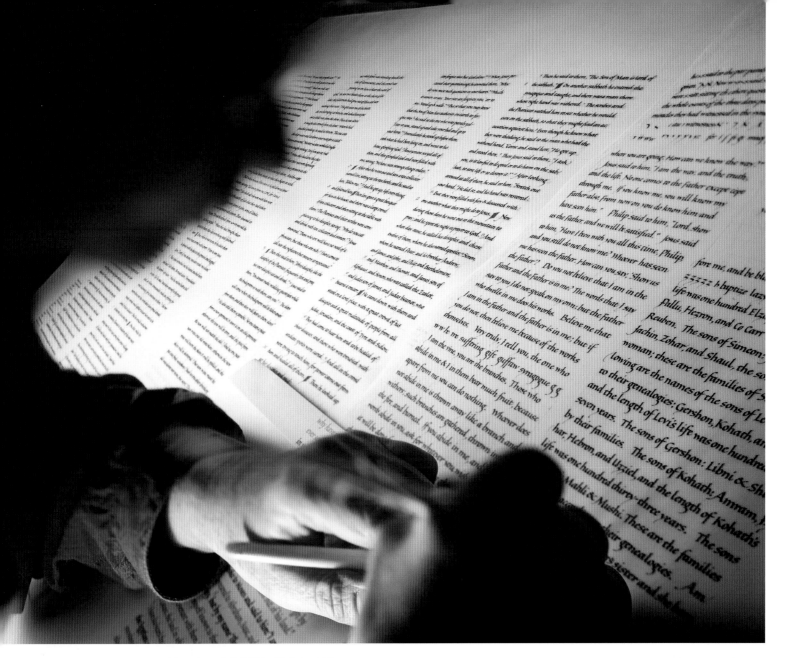

◄ COLOR WASH
Shallow depth of field is typical of macro images—indeed, virtually unavoidable. The extreme blurring on either side of the point of focus creates a wash of greens and yellows, so that the main subject becomes the pure colors of Spring.

▲ SELECTIVE FOCUS
The great value of limited focus is that it concentrates attention on a specific part of the image of the photographer's choosing, and all works well provided that the out-of-focus elements remain intelligible. In this case, a scribe working in a scriptorium, the purpose of the technique was to register the calligraphy, despite its relatively small size in the frame. The selective focus is particularly extreme here through the use of a 4x5-inch view camera with the lens panel tilted to give the minimum depth of field, with the lens at full aperture.

MOTION

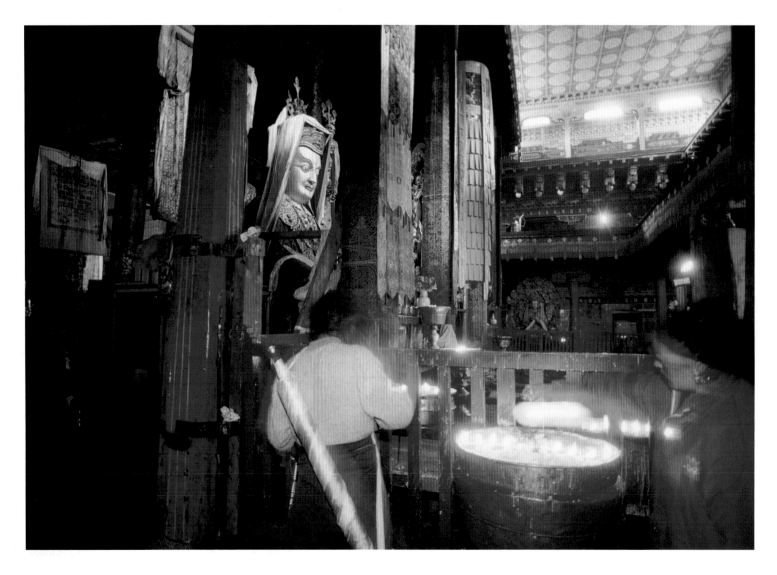

The range from sharp to unsharp in photography is not confined to focus. It also occurs in a different form as motion blur. As users of digital filters in Photoshop and other applications know, there are also different kinds of motion blur, and each has its own character and sense. There is the jerky blur from camera shake, usually producing ghosted double edges. There is the complex streaking from a subject that moves during the exposure, and the more linear one from panning the camera or shooting from a moving vehicle. There are many combinations and permutations, such as panning plus independent subject movement (as in the seagull example on page 97), and the now familiar rear-curtain shutter technique in which motion streaking from a long exposure is crisply finished off with a sharp flash image superimposed.

As on pages 94-95, which deal with focus, here I'm concerned with uses for unsharpness rather than ways of avoiding it. Convention suggests that motion blur is a fault, but this very much depends on the effect that the photographer is looking for. As an expressive element it can work very well, and there are strong arguments against being constantly fixated on sharpness. Henri Cartier-Bresson railed against what he called "an insatiable craving for sharpness of images. Is this the passion of an obsession? Or do these people hope, by this *trompe l'œil* [a realist art school] technique, to get closer to grips with reality?" Motion blur, in the appropriate circumstances, can convey movement and actuality, and the element of uncertainty in capturing it with slow exposures brings a sense of experiment to shooting. Perhaps the most important decision is knowing whether to deal with motion in this way or to freeze a particular moment in time. We will examine the latter on pages 98-99.

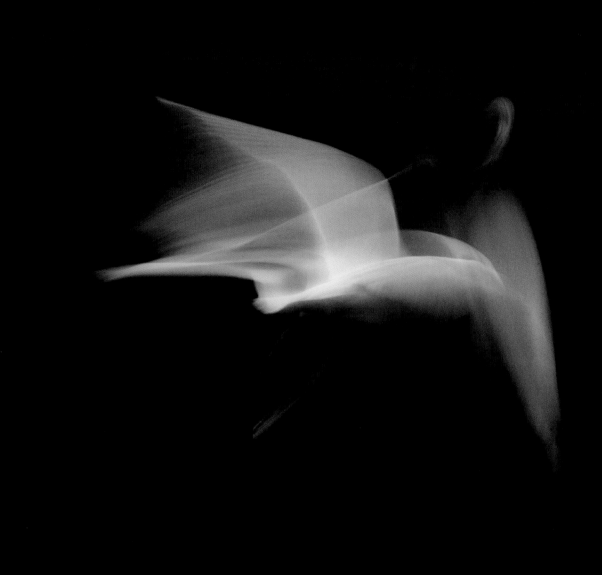

◄ TRIPOD WITH SUBJECT MOVEMENT
A dimly lit chapel in the Jokhang, Lhasa, shot with
the camera on a tripod with a half-second shutter
speed. The movement of people is inevitably blurred,
but this is acceptable because the setting is sharp.

▲ FOLLOW-FOCUS MOTION BLUR
A seagull in flight against a dark background,
photographed with a 400 mm lens at a shutter
speed of one second, reveals its wing movements
in a just-recognizable pattern.

MOMENT

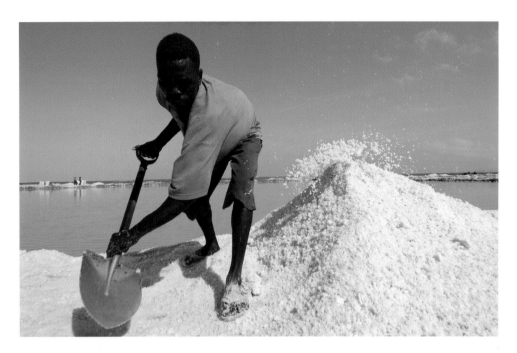

◄ **REPETITIVE ACTION**
Certain kinds of action allow anticipation, in this case a worker shovelling salt into mounds. After seeing this several times, I chose this moment, with a load of salt suspended in the air, taking a low camera position so that it would show clearly.

Timing is not only an essential quality in taking most photographs, it has a direct effect on the actual design of the image. Photographs of all except completely static subjects—so the majority of photographs—must be timed. To take a photograph is to make a picture of an event. The event may be brief—a matter of milliseconds—or it may be long enough, as in the change of daylight over a landscape, that the timing is chosen in terms of hours.

The very word, of course, invokes one of photography's most famous expressions, "the decisive moment." Henri Cartier-Bresson, the consummate photojournalist who applied the phrase to photography, took it from the 17th-century Cardinal de Retz, who wrote, *"Il n'y a rien dans ce monde qui n'ait un moment decisif,"* ("There is nothing in this world without a decisive moment") and defined it as follows: "Inside movement there is one moment at which the elements in motion are in balance. Photography must seize upon this moment and hold immobile the equilibrium of it."

This makes such complete sense that it has dogged many photographers since, and there

have been many attempts to argue against it, most recently in a post-modernist vein. The American photographer Arnold Newman, for example, made this not wholly convincing criticism: "Every moment is a decisive moment, even if you have to wait a week for it.... It's a good phrase, like all simplistic catchphrases, that really gets students questioning their own way of working. The real problem is that so often they think, 'Well, if it's the decisive moment, that's what I'm looking for.' What they should be looking for is photographs, not the decisive moment. If it takes an hour, two hours, a week, or two seconds, or one-twentieth of a second—there's no such thing as only one right time. There are many moments. Sometimes one person will take a photograph one moment; another person will take a photograph the other moment. One may not be better, they'll just be different."

Newman's view is full of common sense, but also compromise, and is in effect making an excuse for the less-good moments. Photography, as any art, plays to an audience and is judged. Some images, and therefore some moments, are indeed considered to be more telling than others,

and when the person doing the evaluating is the photographer, the judgement is even more critical. I think the real problem is that Henri Cartier-Bresson was a hard act to follow, and that good reportage photography that goes for the decisive moment is a relatively uncommon skill.

Whatever the action, whether it is a person walking through the scene or clouds gathering over a mountain, it will certainly have to move across the frame. The action, therefore, inevitably affects the design of the picture, because it alters the balance. Take, for example, a scene in front of which someone is about to pass. Before this happens, the composition that suggests itself is likely to be different from the one including the person. Anticipating the changed dynamic is always vital. It may seem obvious, but the natural reaction in any photographic situation is to follow movement and to make what seems intuitively to be the most satisfying composition at any moment. If, however, an image is planned in advance, it is important to imagine the result when everything will be in place. Then, it is usually easier to frame the view as it will be and wait for that movement to pass into the frame.

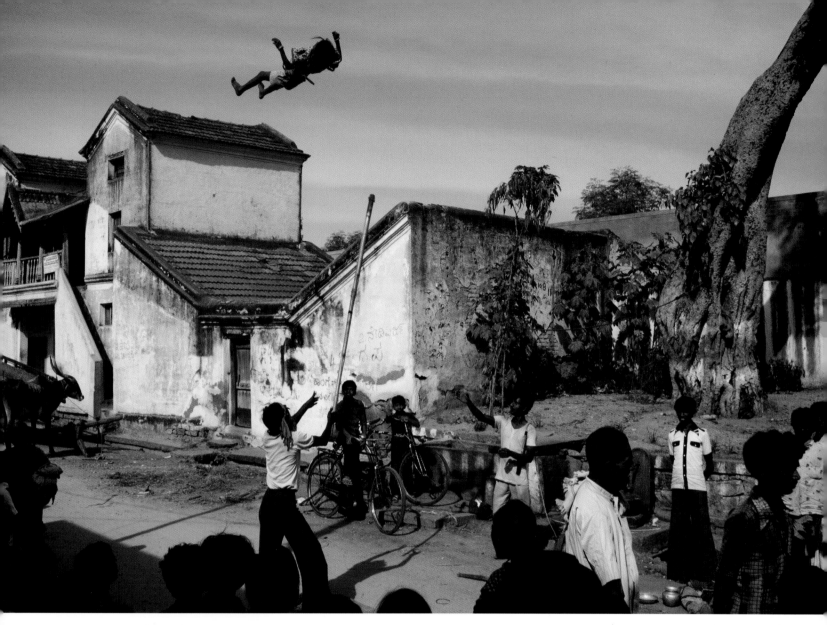

⌃ ANTICIPATION

In this scene of itinerant acrobats in an Indian town, it is obvious that the girl is about to be tossed in the air, but how far? There may not be a second chance for the reason that this is India, and as soon as the camera is noticed there are likely to be passers-by staring at it. The scene is first framed approximately and then, as the girl is thrown upward, the camera is panned upward to follow. The assumption is that at the peak, the image of the girl will clear the top of the buildings, and this does, in fact, happen, though there is time only for one frame. The shutter speed of 1/250 sec is enough to freeze the movement.

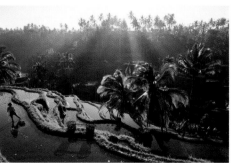

⌃ FIGURE IN A LANDSCAPE

In this scene, of rice terraces in Bali, landscape is the subject, but will clearly be enhanced by the farmer being in a clear, appropriate position. The situation was fairly simple to plan in advance. The ideal position for the man planting rice was felt to be at the far

left, to occupy the brightest part of the flooded rice terrace and so be clearly visible. The first shot, with the man in a less satisfactory position farther away was taken for safety. In the event, the man moved as anticipated, back to the baskets at lower left.

OPTICS

As the image in photography is formed optically, so the choice of lens is an essential part of the design process. The choice of focal length does much more than alter the coverage of a scene. Focal length determines much of the geometry of the image, and can deeply affect its character also. In addition there are some special optical constructions, especially fish-eyes and shift lenses, which will also change the shape of things in the photograph.

Although all that varies with a change of focal length is the angle of view, this has pronounced effects on the linear structure of an image, on the perception of depth, on size relationships, and on more expressive, less literal qualities of vision. Focal length can, for example, affect the involvement of a viewer in the scene, so that a telephoto lens tends to distance a subject, while a wide-angle lens will draw the viewer into the scene.

The reference standard is the focal length that gives approximately the same angle of view as we have ourselves. Only approximation is possible, because human vision and lens imagery are quite different. We see by scanning, and do not have an exactly delineated frame of view. Nevertheless, for a 35mm camera, a focal length of around 40 to 50mm gives roughly the same impression.

Wide-angle lenses have shorter focal lengths and the angle of view is directly proportional to the focal length. They affect the structure of the image in three main ways. They change the apparent perspective and so the perception of depth; they have a tendency to produce diagonals (real and implied) and consequently dynamic tension; and they induce a subjective viewpoint, drawing the viewer into the scene. The perspective effect depends very much on the way the lens is used, specifically the viewpoint. Used from the edge of a clifftop or the top of a tall building, with no foreground at all in the picture, there is virtually no effect on the perspective; just a wider angle of view. However, used with a full scale of distance, from close to the camera all the way to the horizon, a wide-angle lens will give an impressive sense of depth, as in the example opposite. (See pages 52-57 for more on the techniques of enhancing depth perception.)

The diagonalization of lines is linked to this effect on apparent perspective. The angle of view is great, so more of the lines that converge on the scene's vanishing points are visible, and these are usually diagonal. Moreover, the correction of barrel distortion in the construction of a normal wide-angle lens results in rectilinear distortion, a radial stretching that is strongest away from the center of the frame. A circular object, for example, is stretched to appear as an oval in the corner of the frame.

Wide-angle lenses tend to be involving for the viewer because, if used as shown here and reproduced large enough, they pull the viewer into the scene. The foreground is obviously close and the stretching toward the edges and corners wraps the image around the viewer. In other words, the viewer is made aware that the scene extends beyond the frame, and this is a style widely used in photojournalism—fast, loosely structured, and involving. The things photographed are mostly people and movement. In the cinema, the equivalent style is known as subjective camera, and its characteristics are all the qualities you would associate with participating in an event. This is eye-level SLR photography, using wide-angle or standard lenses (never a telephoto, which gives a cooler, more distanced character to the image). At its most effective, the framing includes close foreground, and truncates figures and faces at the edges; this seemingly imperfect cropping extends the scene at the sides, giving the viewer the impression that it wraps around. Imperfections in framing and depth of field can help to give a slightly rough-edged quality which suggest the photograph had to be taken quickly, without time to compose carefully. Note, however, that photographs taken by experienced photojournalists are usually well composed, even under stress.

On the other side of the standard lens is the telephoto (actually a construction of long focus lens, but now the most commonly used term),

➤ ONE SCENE, TWO LENSES
This pair of photographs, of the same subject but from different distances, illustrates the principal characteristics of wide-angle and telephoto lenses. The first picture was taken with a 20mm lens, the second with a 400mm lens. The reference for both pictures is the width of this building. In both photographs it occupies half the frame width.

400mm
- Small angle of coverage.
- Horizontal and vertical lines more prominent than diagonals.
- Size relationships altered by compression; building behind appears relatively larger.
- Although the camera is still slightly lower than the buildings, greater distance needs smaller upward tilt and there is virtually no convergence.
- Lens line structure: mainly horizontal and vertical.
- Lens plane structure: flat, close.

20mm
- Size relationships exaggerated; the building behind appears much smaller.
- Diagonal lines prominent.
- Angular coverage greater.
- Slight upward camera angle causes convergence of vertical lines.
- Lens line structure: mainly diagonal.
- Lens plane structure: deep, angled.

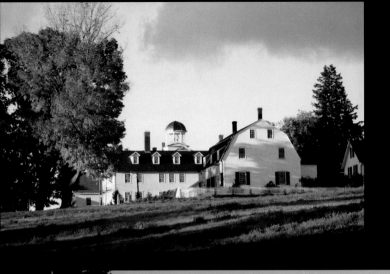

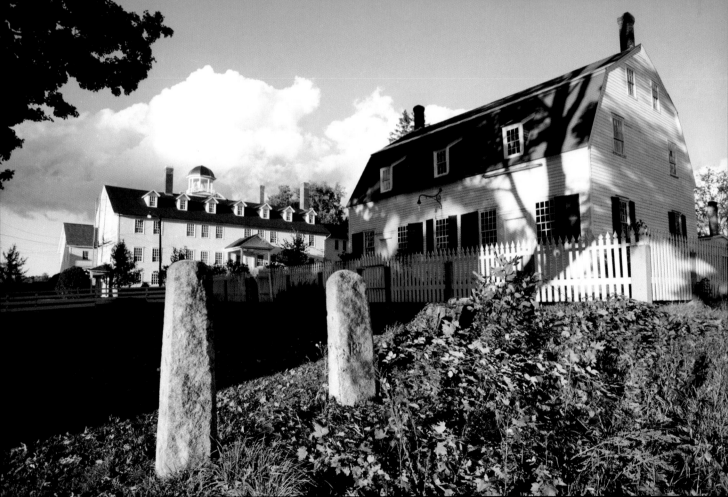

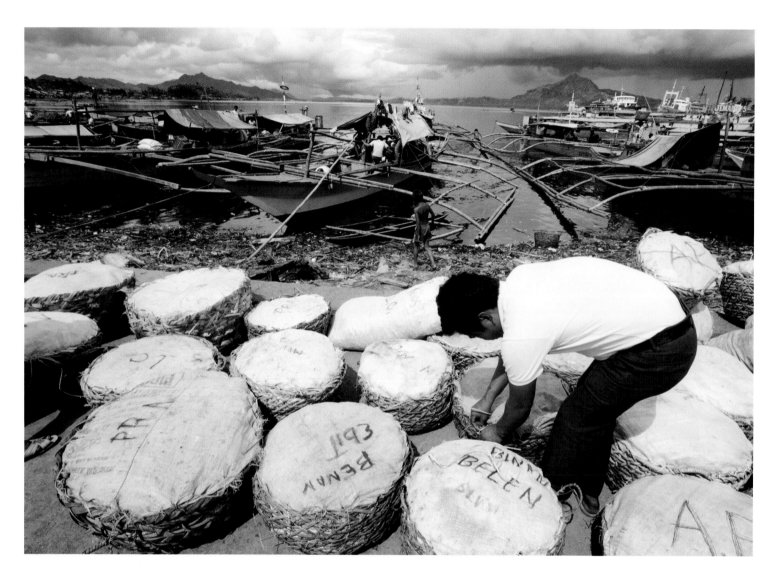

and it too has various effects on the structure of the image. It reduces the impression of depth by compressing the planes of the image; it gives a selective view, and so can be used to pick out precise graphic structures; it generally simplifies the linear structure of an image, with a tendency towards horizontals and verticals; it facilitates juxtaposing two or more objects; and it creates a more objective, cooler way of seeing things, distancing the viewer from the subject (as the photographer is distanced when shooting).

The compression effect is valuable because it is a different way of seeing things (the unusual can be attractive for its own sake), and also because it makes it possible to compose in a two-dimensional way, with a set of planes rather than a completely realistic sense of depth—with obvious comparisons to traditional Chinese and Japanese painting. A specific practical use is to give some height to an oblique view of level ground. With a standard lens, the acute angle of view tends to interfere; a telephoto lens from a distance gives the impression of tilting the surface upwards, as the photograph on page 105 shows.

The selectivity from the narrow angle of view makes it possible to eliminate distracting or unbalancing elements. Precise balance is also often easier, needing only a slight change in the camera angle; the arrangement of areas of tone or color can be altered without changing the perspective. For the same reason, the direction of lines tends to be more consistent. Whereas a wide-angle lens used close pulls lines into a variety of diagonals, a telephoto leaves parallel lines and right angles as they are. Expressively, this often makes for a more static, less dynamic character.

Juxtaposition is a major compositional use of telephoto lenses (see pages 178-179). This can be done with any lens simply by changing the

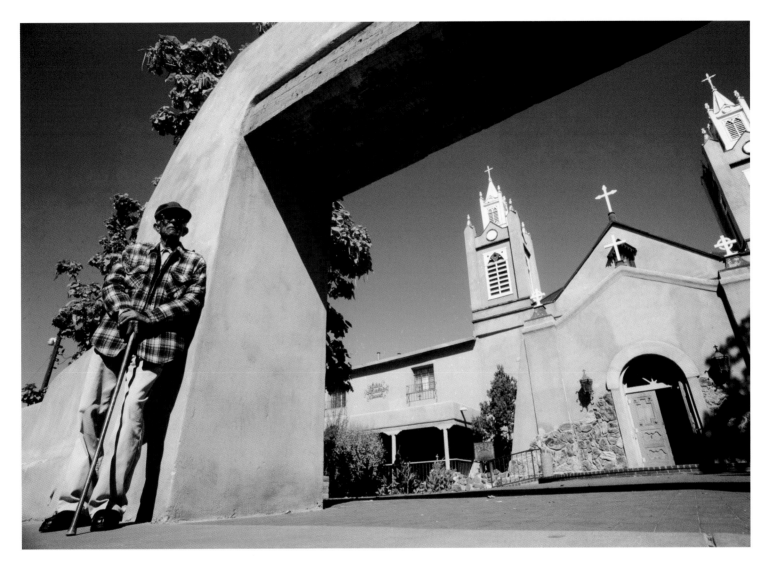

◄ **WIDE-ANGLE PERSPECTIVE EFFECTS**
Two perspective effects are combined here by
a 20mm lens: linear perspective from the lines
that converge on the horizon, and diminishing
perspective from the apparently similar shapes.

▲ **WIDE-ANGLE: DYNAMIC LINES**
With the appropriate camera angle, a
wide-angle lens produces strong diagonals,
particularly if the foreground is included.

viewpoint or by moving one of the objects, but only a telephoto lens allows it to be done without major changes to the rest of the image. Moreover, when the two things are a distance apart, the compression effect of a telephoto lens helps to bring them together.

Finally, the way that a telephoto lens is normally used—from a distance—communicates itself to the viewer and leaves an objective, less involved impression. There is a major difference in visual character between shooting within a situation with a wide-angle lens and an across-the-street view away from the subject.

Certain other designs of lens, apart from variations in focal length, alter the shape of the image. Their intended uses are specialized, but enable the image to be stretched or curved in various ways. One such is the fish-eye, of which there are two varieties, circular and full-frame. Both have an extreme angle of view, 180° or more, but in the full-frame version, the projected circle is slightly larger that the normal rectangular SLR frame. The pronounced curvature is highly abnormal, and at best it has only occasional use. Little subtlety is possible with this type of lens, unless the subject lacks obvious straight lines (such as in the forest photograph on page 88).

Another way of changing the image structure is by tilting the lens or camera back, or both—a procedure relatively common in view camera photography. Tilting the lens tilts the plane of sharp focus, so that, even at maximum aperture, the sharpness in an image can be distributed more or less at will. Tilting the sensor or film also controls the sharpness distribution, but distorts the image, stretching it progressively in the direction in which the sensor or film is tilted. The example of the raindrops here shows how this works.

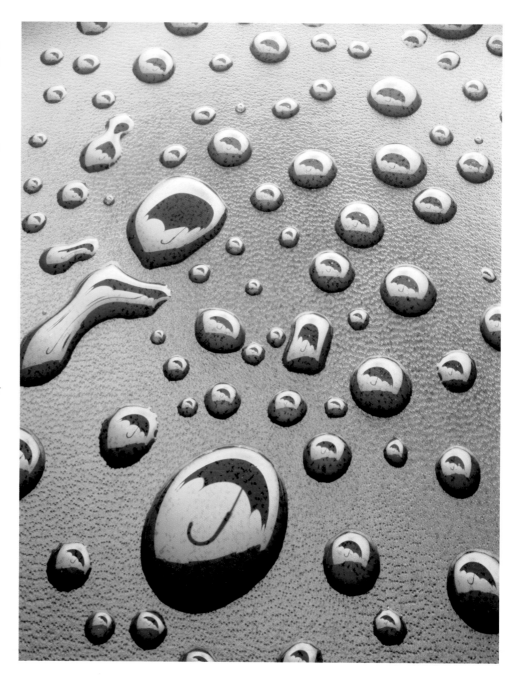

▲ **TILT LENS: ALTERING SHARPNESS DISTRIBUTION**
By tilting either the lens or the back of the camera (the latter only possible with specialist cameras), the plane of sharp focus can be tilted from its normal vertical position facing the camera. In this example, a close view of raindrops, front-to-back sharpness was possible (depth-of-field adjustment by means of the aperture would not have been sufficient).

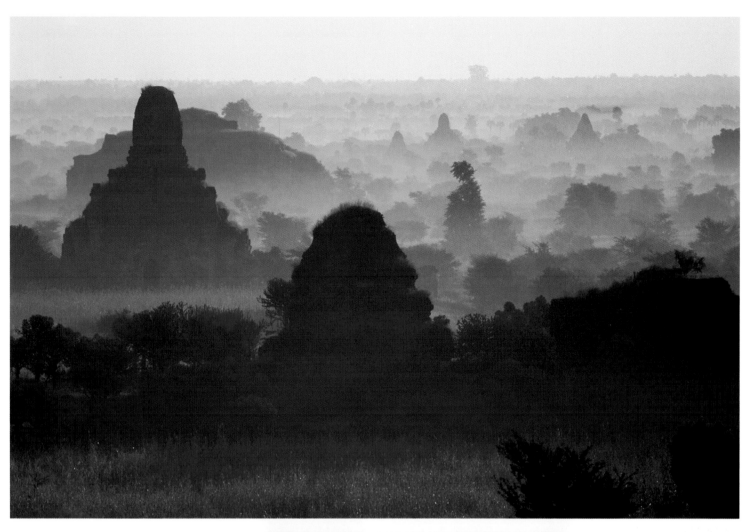

⋀ ➤ SUBJECTIVE CAMERA
A wide-angle lens used close into a crowd scene gives the sense of being in the thick of things that is typical of subjective camera shots. Truncation and loss of focus at the sides and extreme foreground help this impression of being inside the view.

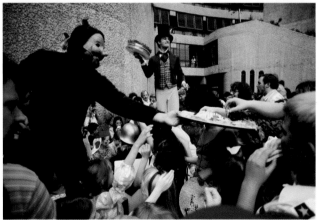

⋀ TELEPHOTO: COMPRESSION
One of the distinctive visual impressions of a telephoto distant view is as if the planes of the subject have been tilted upward to face the camera.

EXPOSURE

In the same way that focus is most commonly used in a standardized way, to produce a kind of technical accuracy in a photograph, exposure is often also assumed to have a "correct" role. I should stress that this is how it is seen conventionally, not how it can or ought to be used. Deciding on the right exposure involves both technical considerations and judgement. From the technical side of things, the upper and lower limits of exposure are set first by what is visible, second by the expected appearance. In other words, part of the task of the exposure setting is to normalize the view—to approximate how we see the real scene.

The conventions of exposure have much in common with those of focus. The eye has a tendency to move towards the areas of "normal" exposure, particularly if these are bright. Higher contrast in a scene, therefore, is likely to direct attention from shadow to light, while lower contrast allows the eye to wander across the frame, as the two versions of the hills at sunrise show. A variation of this is the radial difference in brightness due to vignetting, quite common with wide-angle lenses, because their typical design allows less light to reach the edges than the center.

In color, exposure can have a critical effect on saturation, depending on the process. Kodachrome film, first produced in 1935, achieved prominence in professional photography from the 1950s onward when it was used by widely reproduced photographers such as Ernst Haas and Art Kane. Its unique technology favored underexposure to give rich, saturated colors, but it was intolerant of overexposure. This initiated the strategy of exposing for the highlights that has dominated color photography, more or less, ever since—with particular significance in digital capture.

Two dominant features of exposure in photography that could be considered graphic elements in their own right are silhouette and flare, and we'll return to these at the end of the book when we consider the changing syntax of photography. Exposing for the highlights is a precondition for silhouette, in which the complete absence of detail in the unlit foreground shape leads to a technique of choosing orientation, viewpoint, and timing to communicate by means of outline only. On the opposite side of the exposure scale is flare, which can take many forms, but the key one for photographic composition is an intense glow with diffuse edges.

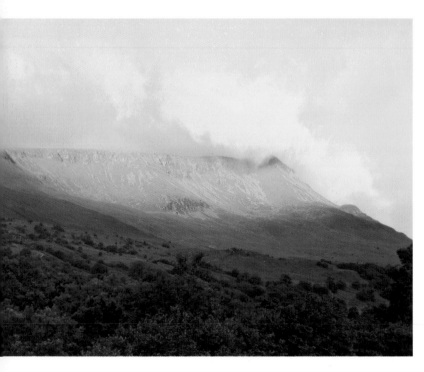 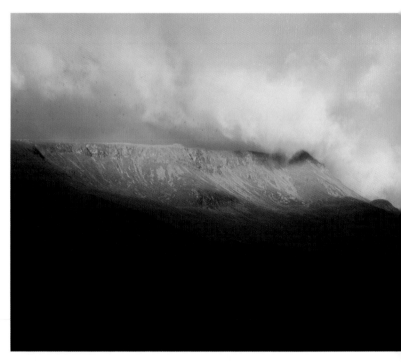

▲ DIFFUSING OR CONCENTRATING ATTENTION
Exposure can narrow or broaden the attention in a picture if there are two distinct areas of brightness, as in this single digital image of the early morning sun striking the spur of a Welsh mountain through the clouds. There are two interpretations, meaning two ways of processing the Raw image file in this digital image. Automatic optimization opens up the shadows, with the result that the eye slides away from the sunlit area to the rest of the scene. The exposure has thus helped to radiate the attention outward. Increasing the contrast and lowering the exposure, on the other hand, concentrates attention on the briefly lit edge, makes this the subject, and increases the drama of the lighting. It also heightens the sense of timing; we are conscious that, in the first moments of the day, the sun is picking out one small area, just for an instant.

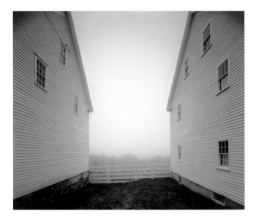

⌃ VIGNETTING

Radial darkening toward the corners in this wide-angle photograph of the space between two Shaker buildings in Maine focuses attention inward, reinforcing the strong diagonals.

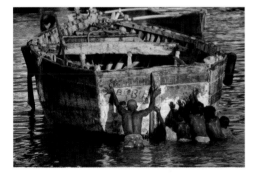

⌃ KODACHROME EXPOSURE CONCEPT

The widely used color technique of exposing to hold the highlights began with Kodachrome film. Under-exposed mid-dark tones retain rich saturation, and this can be opened up during repro or in digital post-production. It is essential not to overexpose significant highlights, and in a digital camera the highlight warning display is a crucial help.

➤ FLARE

Lens flare is a graphic entity in its own right, and whether considered a fault or a contribution to the image depends entirely on the photographer's taste and choice. This aerial view of the Orinoco River in Venezuela could have been shot without the flare streaks from the sun by simply shielding the lens. Instead, they are used to help unite the composition and give the sense of blinding sunlight.

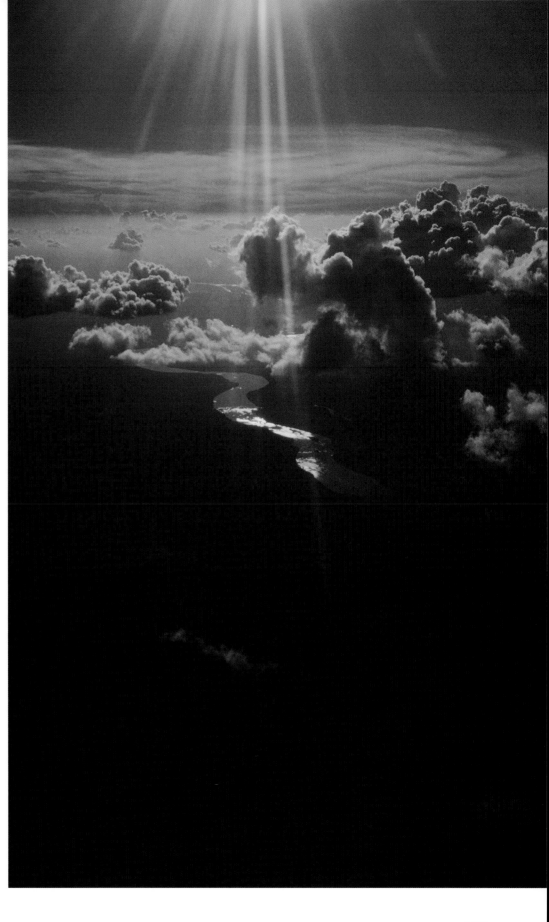

GRAPHIC & PHOTOGRAPHIC ELEMENTS

CHAPTER 4:
COMPOSING WITH LIGHT AND COLOR

Another perspective on composition in photography is that of the distribution of tones and colors. This is intimately connected with exposure and with the ways in which this is later interpreted—traditionally in the darkroom during printing and development, now in digital post-production when the image file is optimized and adjusted. This interconnects with the handling of graphic elements that we examined in the previous chapter—indeed, the two are inseparable. A point functions in a photograph because it has a tonal or color contrast with its background. Lines and shapes also have an effect in proportion to how distinct they are, and ultimately this comes down to tonal and/or color relationships. These are the spectral components of design.

Tone and color are related yet remain distinct, in a complex inter-relationship. One of the less obvious benefits of digital photography is that the process of optimizing images on the computer has taught more people about the science of imaging than would ever have been possible without digital technology. Most serious photographers are now thoroughly familiar with what used to be considered arcane features such as histograms, curve adjustments, black points, and white points. Adjusting images with Levels, Curves, and Hue-Saturation-Brightness sliders makes it perfectly obvious how closely connected are tone and color.

At the same time, color has its own influences on our perception, and its multi-layered complexity has been recognized from the beginnings of art. There are color optical effects like successive contrast that work independently of taste, culture, and experience, but there are also emotional and contextual effects that, while not completely understood, are nevertheless very powerful. Interestingly enough, photography itself has helped to promote this distinction between tone and color through its historical development.

Color arrived relatively late on the photographic scene—in terms of mass use only in the 1960s—and was not universally welcomed. It was not only traditionalist photographers who were suspicious (naturally enough, because it challenged their hard-won skills and ways of seeing), but also critics and some philosophers, a number of whom considered it tainted with the commercialism of advertising and selling products.

Nevertheless, color photography was embraced by many professionals and artists, and of course by the public. The influential Swiss photographer Ernst Haas, who moved to the United States in 1951, identified his love of color in photography with the European wartime experience: "I was longing for it, needed it, I was ready for it. I wanted to celebrate in color the new times, filled with new hope." As we will see, the interpretation of color has since then been the subject of ongoing experiment and argument.

Black and white, meanwhile, remains vigorously healthy, and far from succumbing to color photography, continues to be used with enthusiasm, not just by artists and traditionalists but by art directors and picture editors in published media.

CHIAROSCURO AND KEY

Contrast, as we saw at the beginning of Chapter 2, underpins composition, and one of the most basic forms of contrast is tonal. The Italian expression chiaroscuro (literally "light/dark") refers specifically to the dramatic modeling of subjects in painting by means of shafts of light illuminating dark scenes. In a more general sense, it conveys the essential contrast that establishes tonal relationships. Johannes Itten (see pages 34-35) identified it as "one of the most expressive and important means of composition" in his basic course at the Bauhaus art school. It not only controls the strength of modeling in an image (and so its three-dimensionality), but also the structure of an image and which parts draw the attention.

Whether or not to use the full range of tones from pure black to pure white is a basic decision, all the more important now in digital photography, which offers the histogram and levels controls in post-production. Most of the information content in photographs is carried in the midtones, and a great deal of conventional photography works mainly in these "safe" tonal areas. Shadows and highlights, however, can contribute strongly to the mood and atmosphere of a photograph.

The schematics below show all the possible kinds of tonal distribution for a photograph—in a sense, the lighting styles. If we ignore color for the time being, these variations are defined by two axes—contrast and brightness—which are immediately familiar to anyone working on digital images in Photoshop. Within these groupings, there is an infinite variety of ways in which the tones can be distributed. Chiaroscuro in its limited sense occupies the high-contrast end of the scale. The second axis, of overall brightness, defines much of the mood of an image. When the general expression is dark, favoring shadow tones, the image is low key. The opposite, with all the tonal modulation taking place in light tones, is high key. Plotting one against the other, the range of possibilities forms a wedge-shaped pattern, because maximum contrast in an image demands roughly equal areas of black and white.

Using these two axes, contrast and brightness (contrast and key), as a guide, the choice of style for an image depends on three things: the characteristics of the scene (dark vegetation, pale skin, bright sky, and so on), the way the scene is lit, and the photographer's interpretation. The last of these is now, through digital post-production, more influential than ever. On pages 112-113, I've taken one image, of elephants under an acacia tree, and shown how it can be simply rendered in different keys—and how any of these can be valid.

One interesting feature of key is its different appearance between black and white and color, specifically that it is more difficult to make high key work in color. Whereas high-key black-and-white images seem luminous and graphic (with the right choice of subject), color images are more often interpreted in negative terms, as washed out and wrongly exposed. Partly this has to do with color photography being more literally connected with reality, and partly to do with taste and familiarity—the Kodachrome-induced strategy of exposing to hold the highlights.

LOW CONTRAST

AVERAGE CONTRAST

HIGH CONTRAST

> **COLOR INTENSITY**
Exposed—as always in this kind of picture—for the highlights, the chiaroscuro of morning sunlight through a window on a Chinese opium pillow enhances by contrast the impression of rich, saturated color.

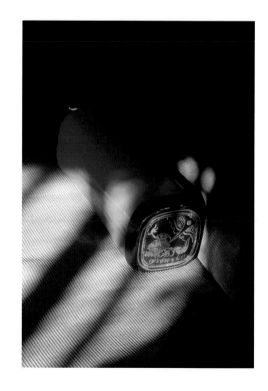

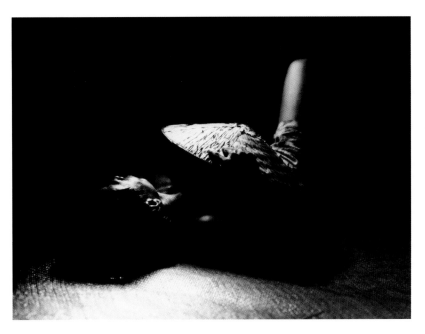

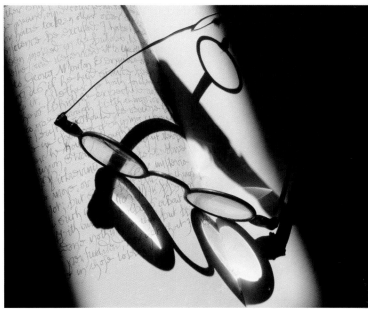

▲ AMBIGUITY
An Iban farmer in Borneo resting by a window in the longhouse. The extreme contrast makes it difficult at first to make sense of the image, and this delay and ambiguity give it its appeal.

▲ CAUSTICS
Caustic light patterns like these are formed when light is strongly reflected or refracted, and partially focused, onto a diffuse surface such as this paper.

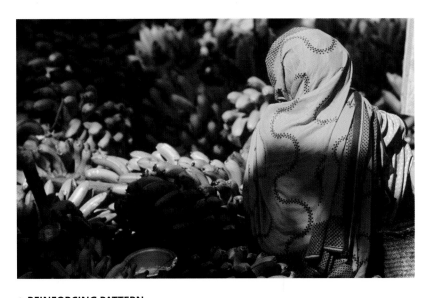

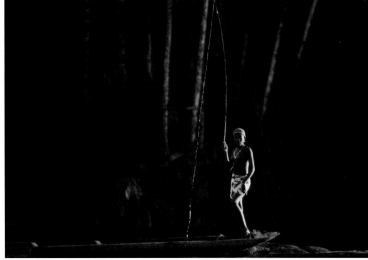

▲ REINFORCING PATTERN
The shadows in a high-contrast scene can also reinforce shape and pattern within the scene, as in the undulating shadow that picks up the curves of the woman's headscarf and the bananas.

▲ LOW KEY IN COLOR
Only the edges of the girl and her fishing line, briefly caught by the last rays of the sun, define this image taken on a river bank in Surinam. The shadowy forms of the trees behind complete the scene, which is all, except for the thin edges, in the lower register of the tonal scale.

➤ SCENE AND KEY VARIATIONS

One image treated in different tonal registers. The
original was Kodachrome, but after scanning it was
optimized as a digital file. Low key, by reducing the
brightness, interprets the scene as glowering and
stormy, with emphasis on the clouds. High key gives
an impression of permeating bright light from the
wide African sky, and is more graphic, with the tree
and elephants almost floating in limbo. Note that
the least successful version is high key in color, which
seems more wrongly exposed than intentional.

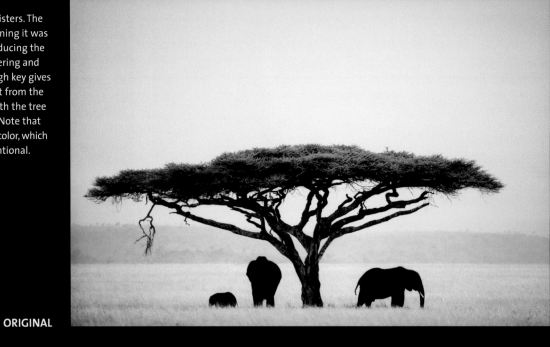

ORIGINAL

COLOR LOW KEY

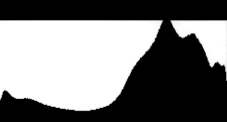

COLOR HIGH KEY

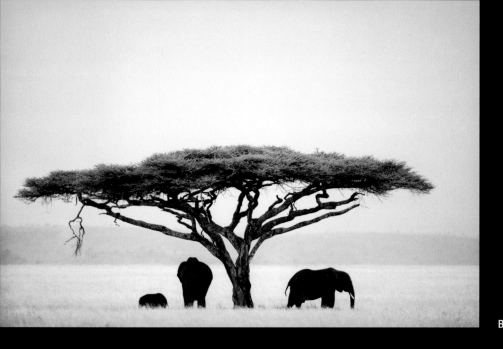

BLACK AND WHITE

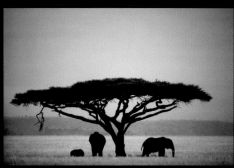

BLACK AND WHITE
LOW KEY

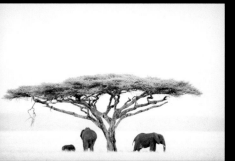

BLACK AND WHITE
HIGH KEY

COLOR IN COMPOSITION

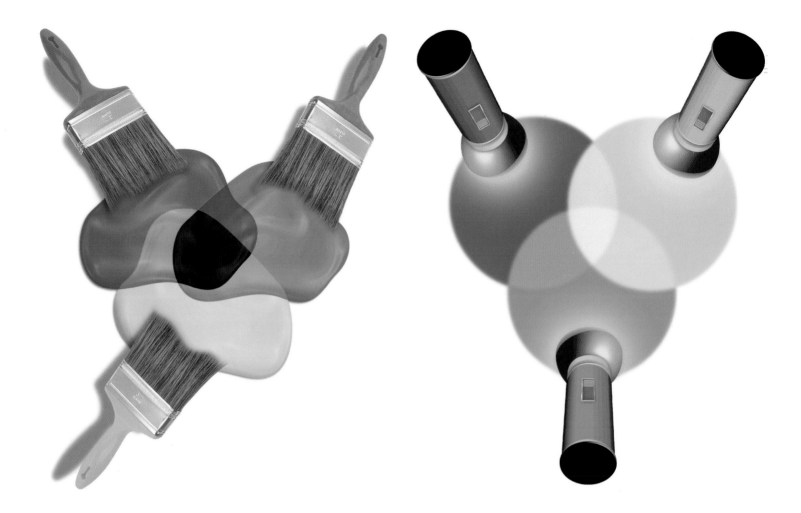

Color adds a completely different dimension to the organization of a photograph, not always easy or possible to separate from the other dynamics that we have been looking at. The ways in which we sense and judge color are in any case complex, from the optical to the emotional, and the general subject of color in photography is, like color in art, a huge one. My earlier book, *Color*, in the *Digital Photography Expert* series, goes into much more detail than is possible here, including color theory and management (see bibliography). The critical color issue before us in these pages is how it can affect a photograph's composition.

We'll begin with strong colors, because the effects and relationships work most strongly with these, although the broad range of colors met with in front of the camera tend to be muted in various ways. The strength of color is determined mainly by its saturation, and this is one of the three parameters in the color model that is most useful for our purposes. One of the side benefits of digital photography is that post-production in Photoshop and similar applications has made most of us familiar with the technical language of color. The three most widely used parameters, or axes, of color are hue, saturation, and brightness. Hue is the quality that gives each color its name, and is what most people mean when they use the word "color." Blue, yellow, and green, for example, are all hues. Saturation is the intensity or purity of hue, with the minimum being a completely neutral gray, and brightness determines whether the hue is dark or light. Another way of looking at this is that saturation and brightness are both modulations of hue.

Color effects naturally work most strongly when the colors involved are intense, and the examples shown on the next few pages favor these for clarity. Hue is the essence of color, and in its simplest representation, the hues are arranged in a circle. In the centuries of thought that have gone into color in art, the idea of primary colors has been central, and general opinion has settled on three—red, yellow, and blue—known as painters' primaries (refined to CMY(K) by printers). These obviously do not square with the three primaries—red, green, and blue—that are used in color film, computer monitors, and

◄ RYB VERSUS RGB

The three reflected-light primaries red, yellow and blue mix as pigments, inks or dyes on paper and give the intermediate colours green, violet and orange, and close to black when all three are combined. The three transmitted-light primaries red, green and blue combine by projection, and they combine quite differently, to give cyan, magenta and yellow, with white as the result of all three together.

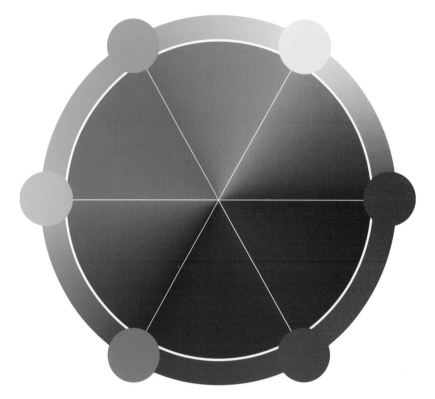

digital cameras. The core reason is that painters' primaries are those of reflected light, on paper or canvas, while the RGB familiar to photographers are those of transmitted light. The actual red and blue of each system differ. Comparing the two sets of primaries is not, in any event, a very useful exercise, because one deals mainly with the perceptual effect of color (RYB) while the other is concerned mainly with the creation of color digitally and in film. As our purpose here is color effect, I'll stick to the painters' primaries.

Strong hues are perceived in multi-leveled ways, with various associations that have as much to do with culture and experience as with optical reality. Red is perceived as one of the strongest and densest colors. It tends to advance, so that when in the foreground it enhances the sense of depth. It is energetic, vital, earthy, strong, and warm, even hot. It can connote passion (hot-bloodedness) and can also suggest aggression and danger (it is a symbol for warning and prohibition). It has temperature associations, and is commonly used as the symbol for heat.

Yellow is the brightest of all colors, and does not even exist in a dark form. Expressively, it is vigorous, sharp, and insistent, sometimes aggressive, sometimes cheerful. It has obvious associations with the sun and other sources of light, and especially against a dark background appears to radiate light itself.

Blue recedes more than yellow, and tends to be quiet, relatively dark, and distinctly cool. It has a transparency that contrasts with red's opacity. It also appears in many forms, and is a color that

▲ THE COLOR CIRCLE

Hue is typically measured in degrees, from 0° to 360°, and in this arrangement, the relationships across the circle are important. Colors opposite each other are known as complementaries, and these form the basis of the principle of color harmony. Here the classic digital color wheel shows that the printer's primaries (cyan, magenta, and yellow) lie directly opposite red, green, and blue. The painter's primaries, however, do not produce such even spokes, with varying definitions of blue and green.

many people have difficulty in judging precisely. The primary symbolism of blue derives from its two most widespread occurrences in nature: the sky and water. Thus, airiness, coolness, wetness are all possible associations. Photographically, it is one of the easiest colors to find, because of sky reflections.

The secondary colors that are complementary to these primaries are green (opposite red on the color wheel), violet (opposite yellow), and orange (opposite blue). Green is the first and foremost color of nature, and its associations and symbolism, usually positive, come principally from this. Plants are green, and so it is the color of growth; by extension it carries suggestions of hope and progress. For the same reasons, yellow-green has spring-like associations of youth. Negative associations of green tend toward sickness and decomposition. We can perceive more varieties of green, between yellow on the one hand and blue on the other, than any other color.

Violet is an elusive and rare color, both to find and capture, and to reproduce accurately. It is easily confused with purple. Violet has rich and sumptuous associations, and also those of mystery and immensity. The similar color purple has religious, regal, and superstitious connotations.

Orange borrows from red on the one side and yellow on the other. It is warm, strong, brilliant, and powerful, at least when pure. It is the color of fire and of late afternoon sunlight. It has associations of festivity and celebration, but also of heat and dryness.

2

RED

BLUE

YELLOW

3

4

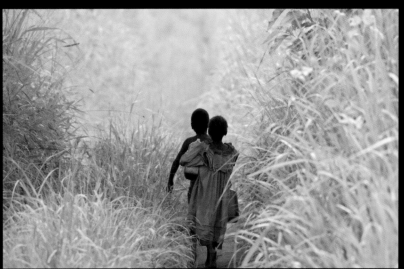

5

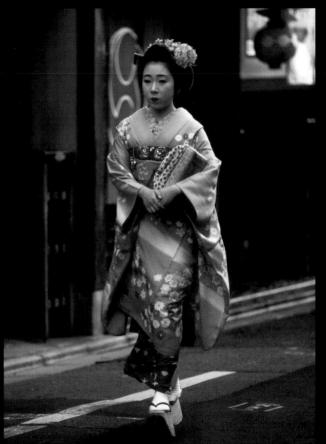

6

4. ORANGE

5. GREEN

6. VIOLET

COLOR RELATIONSHIPS

Ultimately, colors have to be treated in relationship to each other—and they are perceived differently according to the other colors they are seen next to. Red next to blue appears to have a different nature from red next to green, and yellow against a black background has a different intensity from yellow against white. Digital photography now gives a huge degree of control over the appearance of color in a photograph, and the hue, saturation, and brightness are all adjustable. To what extent and in what direction these adjustments should be made is a relatively new issue for photography.

Arguably the greatest problem with color in photography and in art is the notion of rightness and wrongness. As we've just seen (pages 114-115), colors evoke reactions in the viewer that range from the physiological to the emotional, yet few people are able to articulate why they like or dislike certain colors and certain combinations. Indeed, few people are interested in analyzing their visual preferences, while at the same time expressing definite reactions.

As early as the fourth century BC, the Greeks saw a possible connection between the scale of colors and the scale of music, and even applied color terminology to music by defining the chromatic scale, which was divided into semitones. This relationship has persisted, and it was a short step from this to theories of harmony. Harmony in both music and color has had different meanings throughout history, from the Greek sense of fitting together to the more modern one of a pleasing assembly. Taste and fashion enter this, with the result that there have been many, and conflicting, theories about how colors "ought" to be combined. This is a huge subject, dealt with at some length in my book *Digital Photography Expert: Color*, and in the greatest detail of all in John Gage's *Color and Culture*, but here I'm concerned with the need to take a balanced, non-dogmatic view. On the one hand, there are ways of combining colors that tend to be acceptable to most viewers, and it would be foolish to ignore them. On

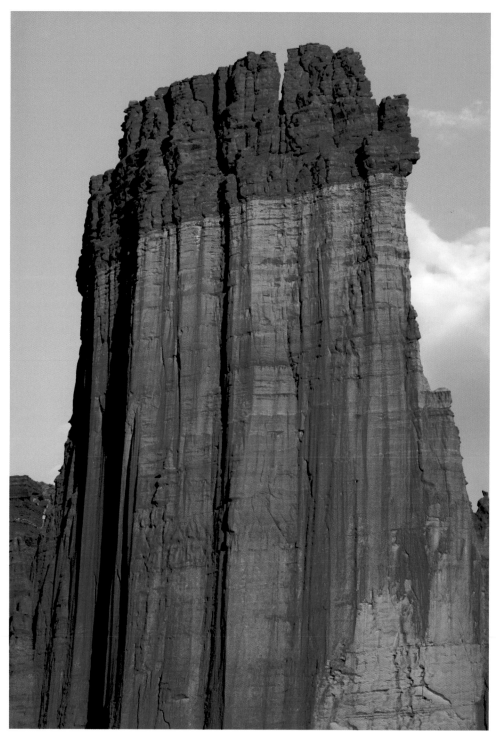

▲ ORANGE-BLUE
A classic and by no means uncommon photographic color combination.

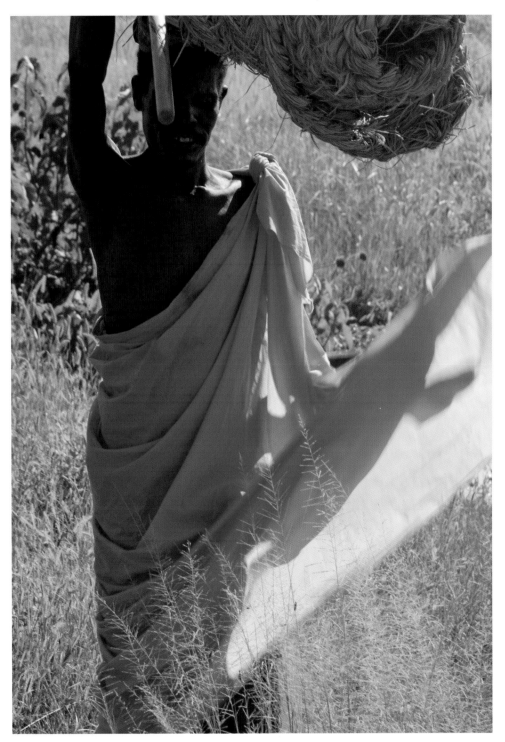

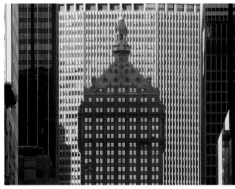

▲ COLOR TEMPERATURE
The warmth of direct sunlight contrasts with the higher color temperature of reflected sky.

▲ GREEN-ORANGE
The green color here contrasts with the orange of reflected light in this pool.

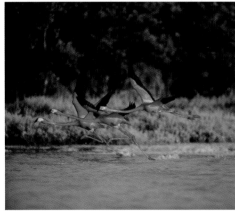

▲ PINK-GREEN
The pink of this man's robe is in almost direct opposition to the hue of the grass beneath.

▲ RED-GREEN
Red feathers contrast with the green foliage, seeming to lift the birds from the background.

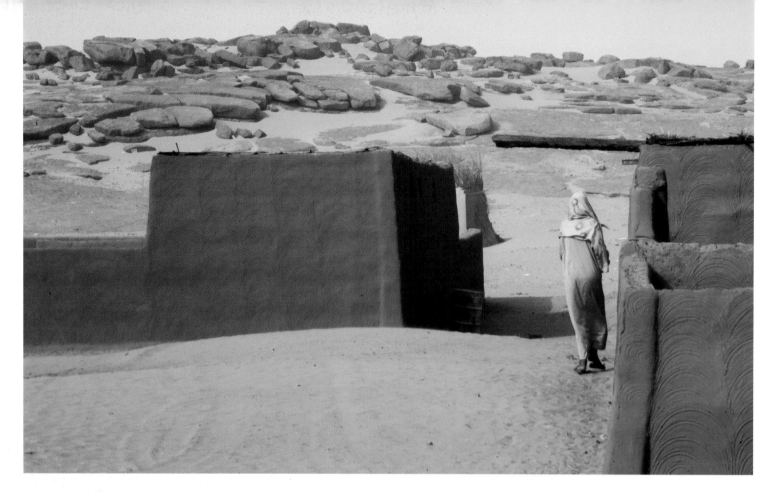

the other, the creative use of color demands personal expression—meaning not following rules. This dualism—acknowledging that certain relationships and techniques work, yet not necessarily using them—takes us back to the fundamental principle of balance that we looked at in Chapter 2 (pages 32-63, specifically page 40).

If we treat harmony in the sense of pleasing, acceptable relationships, there are two well-established classes. One is complementary harmony (hues across the color circle), and the other is harmony of similarity (hues from the same sector of the color circle). The experimental basis for complementary harmony, which we don't need to go into in great detail here, rests on successive and simultaneous contrast, and on the arrangement of the color circle, in which hues are laid out in sequence according to their wavelength. Simply put, in successive contrast, if you stare at a colored patch for at least half a minute and then shift your gaze to a blank area of white, you will see an after-image in the complementary color—the opposite across the

color circle. There is a similar but less dramatic effect when colors are seen side by side, in which the eye tends to compensate; while in the color circle, mixing two opposites produce a neutral.

Harmony of similarity is more obvious. Colors next to each other in any color model, from a color circle to a three-dimensional shape such as a Munsell solid, simply go well together because they present no conflict. "Warm" colors, from yellow through red, have an obvious similarity, as do "cold" colors from blue to green, or a group of greens, for example.

Another consideration is relative brightness. Different hues are perceived as having different light values, with yellow the brightest and violet the darkest. In other words, there is no such thing as a dark yellow, nor is there a light violet; instead, these colors become others—ochre, for example, or mauve. The German poet and playwright J.W. von Goethe was the first to assign values to hues—yellow as nine, orange as eight, red and green both six, blue as four, and violet as three—and these are still considered workable.

▲ **COLOR ACCENT 1**
Against the drab desert colors in this village on the banks of the Nile in Nubia, the woman's mauve headscarf brings a visual relief, and also a point of focus for the attention.

As the color bars on page 121 show, for the most predictable harmony, colors are combined in inverse proportion to their light values.

Do theories of harmony mean that colors can be discordant? Maybe. Colors can appear to some people at some time to clash, yet to others at a different time they may be perfectly acceptable. The painter Kandinsky certainly thought so, declaring in 1912 that "Clashing discord … 'principles' overthrown … stress and longing … opposites and contradictions … this is our harmony." Pink and lime green, for example, may not be everyone's idea of color harmony, but if you like kitsch, and in particular the Japanese "cute" use of it, their combination is close to ideal.

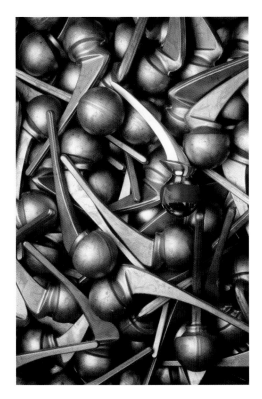

⌄ COLOR ACCENT 2
The purpose of this shot was to show a mass of titanium prosthetic knee joints, but without the one taped in red, the composition would have been directionless. The red color provides a point for the eye to return to after looking around the frame.

Color accent is an important variation on color combinations. In the same way that a small subject that stands out clearly from its setting functions graphically as a point (see pages 66-69), a small area of contrasting color has a similar focusing effect. The color relationships that we just looked at continue to apply, but with less force because of the size disparity in the areas. The most distinct effect is when the setting is relatively colorless and the two more pure hues occupy localized areas. This special form of color contrast inevitably gives greater prominence to what painters call "local color"—the supposedly true color of an object seen in neutral lighting, without the influence of color cast. Color accents above all stress object color.

COLOR PROPORTIONS
According to classic color theory, colors harmonize most completely with each other when their areas are in inverse proportion to their relative brightness. As proposed by Goethe, red and green are equally bright, so combine 1:1; orange is twice as bright as blue and so their ideal combination is 1:2; while yellow and violet are at the extremes of the brightness scale, with ideal combined proportions of 1:3. Three-way combinations follow the same principle.

Orange (3) and Blue (8)

Orange (3), Green (4), and Violet (8)

Red (4) and Green (4)

Yellow (3) and Violet (9)

Yellow (3), Red (4), and Blue (9)

MUTED COLORS

Except in manmade environments, strong colors are relatively scarce in the world. We may remember them more clearly, as in the colors of flowers or sunsets, but they occupy much less visual space than the subdued greens, browns, ochers, flesh tones, slate blues, grays, and pastels that make up most natural scenes. Anyone doubting this need only go out and try to capture with a camera the six strong colors that we've just been looking at (pages 114-121)—without resorting to manmade colored objects.

There are several ways of describing this majority of less-than-pure colors: muted, broken, muddy, desaturated, shadowy, washed out. Neutrals that have a tinge of color are sometimes referred to as chromatic grays, blacks, or whites. Technically, they are all pure hues modulated by desaturating, lightening, or darkening, or a combination of these. High-key and low-key color images are by necessity muted, unless there is an added strong color accent. Complementary and contrasting color relationships are, of course, less obvious, but there are greater possibilities for working within one sector of the color circle. In general, muted colors can offer

more subtlety and a quieter, even more refined pleasure, as the images on these pages illustrate.

How the colors of real life are translated into an image by sensor or film is yet another matter. Indeed, translation is a more accurate term than recording, because the process, both in film and digitally, involves separating complex colors into three components—red, green, and blue—and then recombining them in certain proportions. There is considerable room for decision-making here, and in the heyday of color film, manufacturers devised different strategies for different brands. Kodachrome, which was the first color film generally available to the public, but also the professional film of choice for several decades, was known for its rich, saturated colors, particularly when underexposed to an extent (see page 112). Paul Simon even wrote a song called "Kodachrome" in 1973, drawing attention to the *"nice bright colors"* and the way the saturated effect *"makes you think all the world's a sunny day."*

This translation of color, however, gained little favor in the art world, even in the hands of a master like Ernst Haas, and was generally considered tainted by commercialism and excess.

The Color Formalists (see page 152) approached color more circumspectly, even when, as in the case of William Eggleston, they used Kodachrome from which to make prints. Yet in the wider world of photography, saturation continued, and the film that was partly responsible for Kodachrome's demise, Velvia from Fuji, was also manufactured to create rich and vivid hues. Now, with digital photography, the translation is entirely in the hands of users, and muted colors can be enlivened as easily as rich colors can be subdued. Photographers now have a palette as controllable as that of any painter.

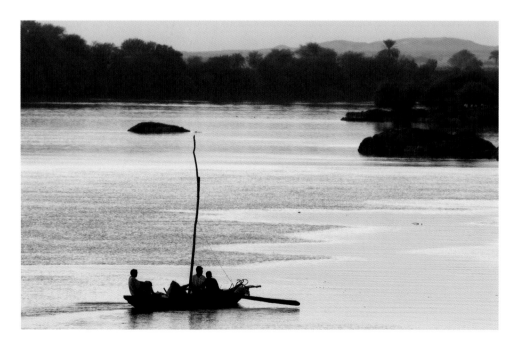

◄ AN ORIENTALIST PALETTE
Sunset over the Nile below Khartoum. A range from pale orange to mauve is set off against pale blue reflections where a breeze has ruffled the water in a muted relationship of complementary colors.

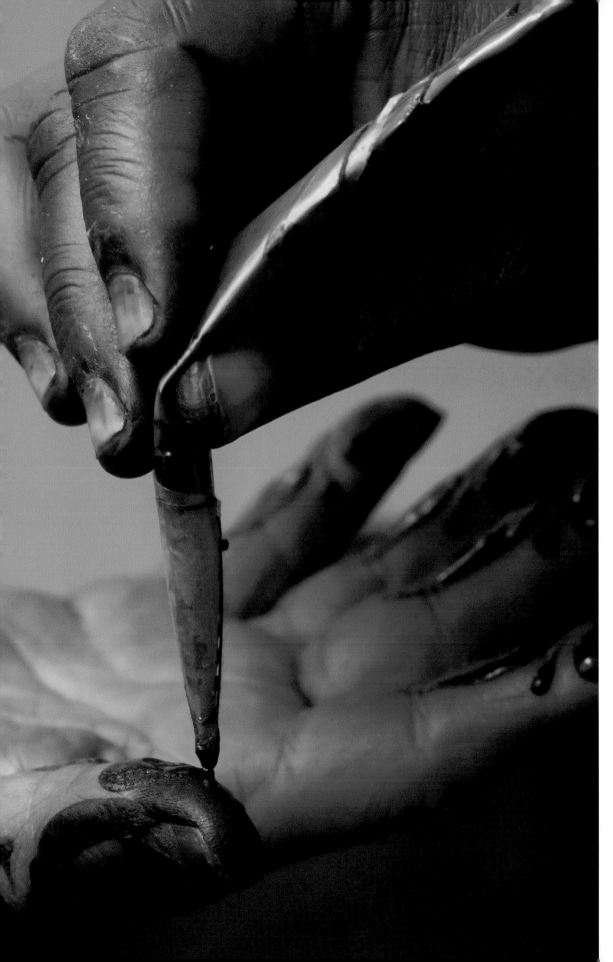

◄ HENNA
Brown, which is technically a heavily desaturated red, is the classic broken color, with earthy connotations. Here, henna is being applied to a Sudanese woman's hand.

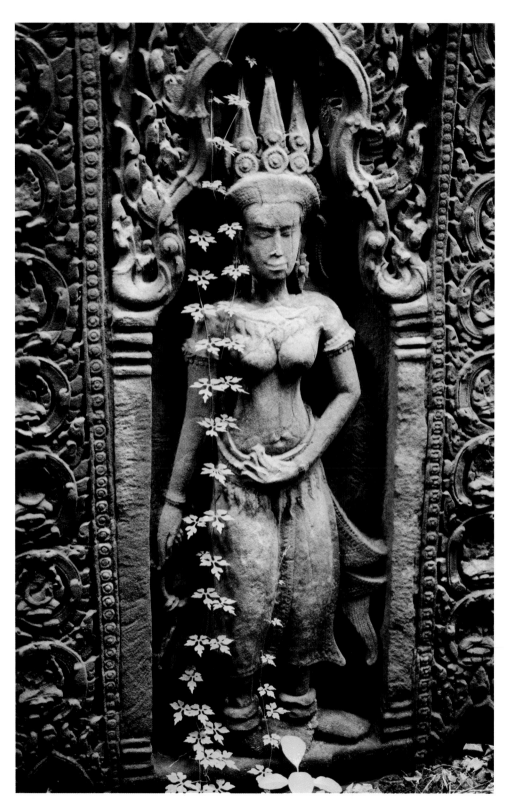

MOSSY GREENS
Soft greens, as in this moss covering an Angkorean bas-relief figure, connote rain, dampness, and undergrowth.

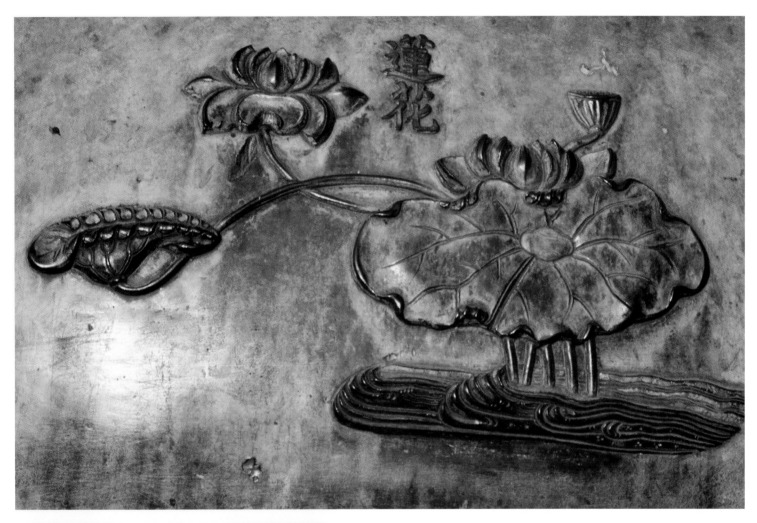

METALLICS
Hazy sunlight reflected in the patinated bronze of a Vietnamese dynastic urn defines the metallic quality of the surface by means of reflection and a delicate hue change.

INTERFERENCE COLORS
A fugitive rainbow effect occurs with some surfaces, notably soap bubbles and oil slicks, most obviously in a hard, bright light and with a dark background. Reflections from a sandwich of transparent surfaces, as here, causes light waves to interfere with each other, producing a shimmering spectral range of hues.

BLACK AND WHITE

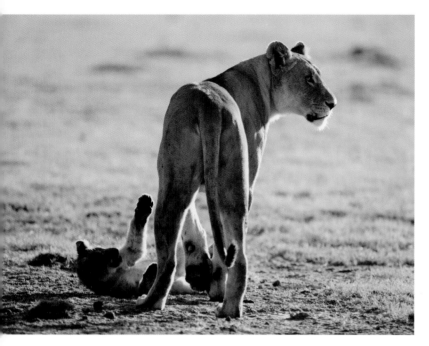
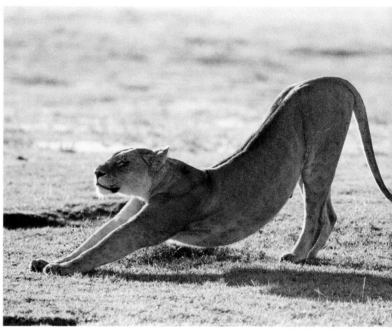

The black-and-white photographic image occupies a unique place in art. It is not that black and white is in any way new to art—drawing, charcoal sketches, woodcuts, and etching have been executed without color throughout history—but that in photography it was the norm, initially entirely for technical reasons. More interesting still is that when the technical limitations were swept away by the invention of color film, black and white remained embedded as the medium of choice for many photographers. This continues today.

In the popular view, photography is more realistic than any other graphic art because the camera takes its images directly, optically from reality. By extension, color photography must be more realistic than black and white because it reproduces more information from the real world. However, all art is illusion (see E. H. Gombrich's classic study *Art and Illusion*), and a photograph as much as a painting is a two-dimensional exercise in triggering perceptual responses, not a two-dimensional version of the real world. The argument for black-and-white photography is

that it makes less attempt than color at being literal. In visual terms, black and white allows more expression in the modulation of tone, in conveying texture, the modeling of form, and defining shape. What is no longer true, however, is the former argument of committed black-and-white photographers that it allows the greatest freedom in darkroom interpretation. This was the case, but now digital post-production and archival desktop inkjet printing have made full expressive interpretation in color photography a reality. Black and white, incidentally, has also benefitted from digital post-production in that the three channels—red, green, and blue—can be mixed in any proportion for an even greater control over the tonal interpretation of color than was ever possible by using colored filters when shooting. Whereas the range of effects were usually limited to a handful, including a darker sky from a red filter, increased atmospheric haze from a blue filter, and lighter vegetation and darker skin tones from a green filter, channel mixing in Photoshop and similar applications allows any hue to be rendered anywhere between black and white.

▲ TWO TREATMENTS

Two photographs, both taken of the same subject at about the same time. The color image, shot on transparency film, is natural and realistic, leading attention directly to the actions and attitude of the lioness and cub. The black-and-white version is a little different. Lacking color, the image is slightly more abstract, and the shape and line of the lioness become more important to the overall effect of the image.

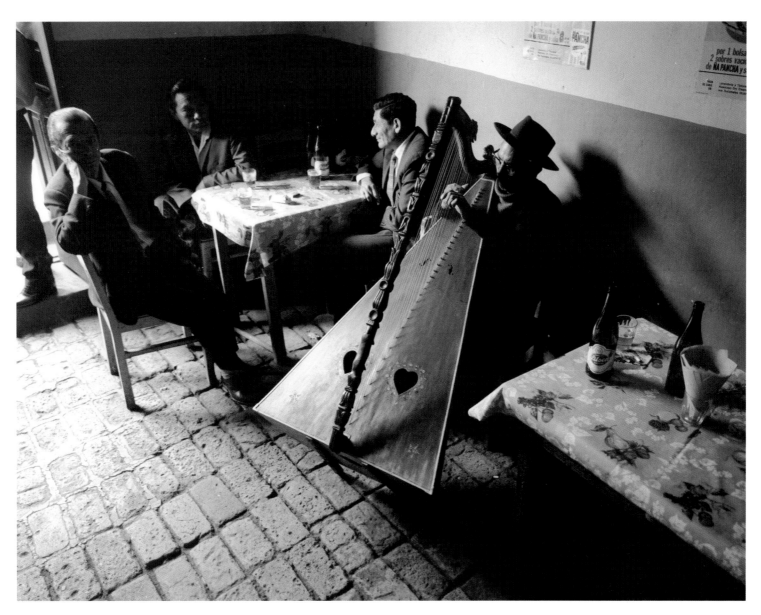

▲ TEXTURE AND FORM

Removing the quality of color from an image enhances its other qualities. With the modulation entirely in tone, the eye pays more attention to texture, line, and shape. The textural qualities of the surfaces play an important role in this print, and have been enhanced by using a hard paper grade to keep the background a rich, dark black.

CHAPTER 5:
INTENT

What gives composition a bad name is the suggestion that there are rules. We have certainly seen examples of how things work, how the principles and elements of design can have predictable effects on viewers, but these are very far from rules. To say that a small amount of yellow complements a large area of violet in a reasonably satisfying way is true, but to claim that you should always strive for this relationship between the two colors is silly. What determines composition is the purpose—the intent. As a simple example, is the purpose to please as many people as possible, or to be different and unexpected? Intent does not even have to be that specific; it may be an unspoken individual preference. Nevertheless, awareness of what you want should generally come before you make compositional decisions.

Most photography tends towards the pragmatic, simply because the camera is so well suited to recording and presenting visual information. In terms of quantity, photography is used more in mass communication than in fine art. The leading American graphic designer Milton Glaser wrote, "As society developed, the information and the art functions diverged, and distinctions were made between high art and communicating information to increasing numbers of people." That most photography falls on the mass communications side of this divide is because it is so easy to reproduce, and because it is so widely used non-professionally, both mitigating the evolution of clear individual style. Style in photography, with which we will conclude this chapter, is more elusive than in painting. It means, essentially, a certain graphic stamp on a body of work, but the elements and techniques that go together to make it are not always as distinctive as some people would like. Geoff Dyer, in *The Ongoing Moment*, is not the first commentator to note this. In his study of the photographers of the American Depression, he wrote, "Again and again we come up against [it] when studying photography: a subject strongly identified with one photographer—so much so that one identifies the photographer by the subject—turns out to be shared and replicated by several others."

In painting, the very process of making an image depends on the perception of the artist and the way in which the materials are applied. There is no such thing as a neutral, characterless image (even imitative techniques are based on some style). The reverse is true of photography. Photographs can be, and unfortunately often are, taken with little thought for the way they look. The camera can produce a photograph by itself, and to influence the composition and character of the image takes effort, as we have seen. To make an identifiable difference to the style of an image, the techniques used need to be definite rather than subtle. In most photographs it is the content that dominates, and most of the stylistic techniques that a photographer can use predictably are limited.

So far we have been concerned with the vocabulary and grammar of composition, but the process usually begins with purpose—a general or specific idea of what kind of image the photographer wants. However it is perfectly possible to start with no idea whatsoever, and simply react. This is actually one of the central problems in photography—overcoming the sheer mindless ease of taking a picture. The problem is compounded by the evidence that occasionally a strong image can result from no intention. The emphasis, though, is on "occasional," and even relying on instant reactions to the changing scene before you is a kind of plan. Previous shoots may lead you to expect that something promising may turn up as long as you take the camera and go off on a vague search. The key is to remain aware of what you are setting out to do, and what results are likely to satisfy you. It matters little that the intention may be only sketchy; knowing it will always help the design. The different kinds of intent fall naturally into contrasting pairs, and that is the way I will examine them in this chapter, beginning with the most basic, between conventional and challenging. It may also become more useful to see them as scales, because there are many positions that can be taken between the two extremes.

CONVENTIONAL OR CHALLENGING

One of the most important decisions in intent is how much you want to stay within the boundaries of what a viewer is expecting to see. Throughout the first five chapters we saw demonstrated time and again how certain compositional techniques and relationships deliver predictably satisfying results. For example, placement and division that more or less fit the proportions of the Golden Section (or, in a more rough-and-ready way, the rule of thirds) really are considered by most people to be appropriate and fitting. Similarly, complementary colors in the proportions shown on page 121 create a pleasing effect—again, for most people. What is important to remember, however, is that efficacy doesn't make a rule. Just because something suits the average taste does not make it better. Predictably efficient composition is perfect for some purposes, but not for others. It is not, of course, exciting and risky. This is where intent comes in.

For instance, if you need to show something as clearly as possible, or at its most attractive, then certain rules apply. The composition, lighting, and the treatment in general will be geared toward the conventional and toward the tried and tested. In a landscape, for example, this argues strongly for a viewpoint that has been used by other photographers many times before (because it is known to be attractive), and for the "golden light" of late afternoon or early morning in good weather. This would be the kind of shot that the publisher of a travel brochure would want—a good, workmanlike stock photograph, with good sales potential. On the other hand, the very fact that such an image is similar to many others already taken might be reason enough to avoid it, and in that case you might be actively looking for an original treatment—to surprise the viewer and perhaps show off imaginative skill.

The issue then becomes how far to go in unusual composition without the result looking forced or ridiculous. In fact, on this all-important scale between conventional and unconventional, all the difficult decisions are in the direction of the unconventional. Let me

work around this a little farther. If you need to be clear and acceptable, then the goal is precise and straightforward. More than this, the known techniques based on the psychology of perception are on your side. They are working for you in the same direction. However, if you want to move away from this and exercise more creative imagination, the definitions become fuzzy. Moving away from conventional images means moving away from what is known to work, and so ultimately into uncharted territory. What may work for you may not work for a viewer. There are two things to consider: how far to move towards the unconventional in composition, and for what exact reason. Move too far (such as placing the subject of the photograph right in one corner) and you would need a good reason to avoid it looking contrived or silly. As for "exact reason," there are many possible shades of purpose, and simply being different is the least convincing. Writing about the American photographer Garry Winogrand, whose most productive years were between the mid-'60s and the mid-'70s, and whose work was contentious due to its evident lack of skill or clear purpose, the then-director of photography at the Museum of Modern Art, John Szarkowski, who promoted this photographer, wrote, "Winogrand said that if he saw a familiar picture in his viewfinder he 'would do something to change it'—something that would give him an unsolved problem." This is weak purpose and weak reasoning. A more valid reason might be to choose a compositional style that more accurately reflects the way the photographer sees the subject—as Robert Frank did when he travelled across 1950s America on the Guggenheim grant that resulted in his seminal book *The Americans*.

In case all that sounded like unqualified praise for individuality and breaking the rules, I'd like to give the counter-argument in favor of convention. It is very easy to praise attempts at originality, with some implication that the conventional treatment is ordinary and less imaginative. In fact, this basic advice, to look

> **CANECUTTER**
In contrast to the Japanese scenic view, both technique and content here are not what most viewers would anticipate. The subject is a southern Sudanese canecutter on piecework, slashing away at the blackened cane stalks after the lot has been burned; as dawn and the end of his shift approaches, he works even harder to fill his quota. Experiment and luck went into the shooting: the conditions were choking and dark, and the only safe way to shoot from close with a wide-angle lens was to hold the camera at arm's length close to the ground. Capturing the headlamp and the pre-dawn light meant a time exposure added to rear-curtain flash, which made it highly unpredictable. There were many failures before this shot.

for the different, is in danger of becoming conventional itself. Photography—for the reasons we are exploring in this chapter but have already seen through the book—has a special tendency to encourage originality, but the obvious danger is in trying to be different simply for its own sake. Different is not necessarily better, and is a poor goal to aim for without good reason and some skill. Treatments become conventional because, in general, they work, and there are many more situations in photography that call for the workmanlike rather than for the unusual.

The search for originality, for a visual treatment that is different from what has been done before, has a special place in photography. More, I would argue, than in other visual arts, and we can see constant attempts at this. Why this should be so is due to two things: the sheer quantity of photographs that we are exposed to, and the recording process directly and optically, from scene through lens to sensor. The combination of these two makes it relatively difficult to escape from making similar images of similar scenes. Well-known scenes and subjects have inevitably been photographed endlessly, and as the ways of doing this are fairly limited (a few obvious viewpoints, a few commonsense ways of composing), most photographers naturally feel dissatisfaction at creating an image that may be

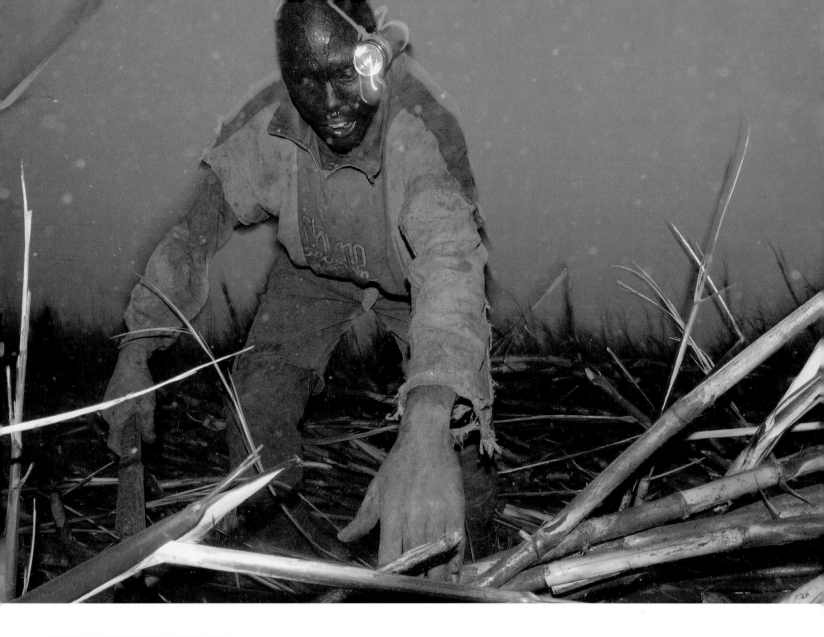

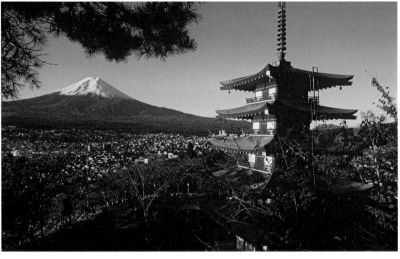

◄ MOUNT FUJI

This is a completely "safe" image in that it fulfils the expectations of a large audience—a view of Mount Fuji under good conditions of season (snow-capped), weather (clear with good visibility), and light (just after sunrise). Moreover, the viewpoint has been chosen with care and planning to include an icon of traditional Japan, and framed efficiently. In all, completely conventional with regard to subject matter and treatment.

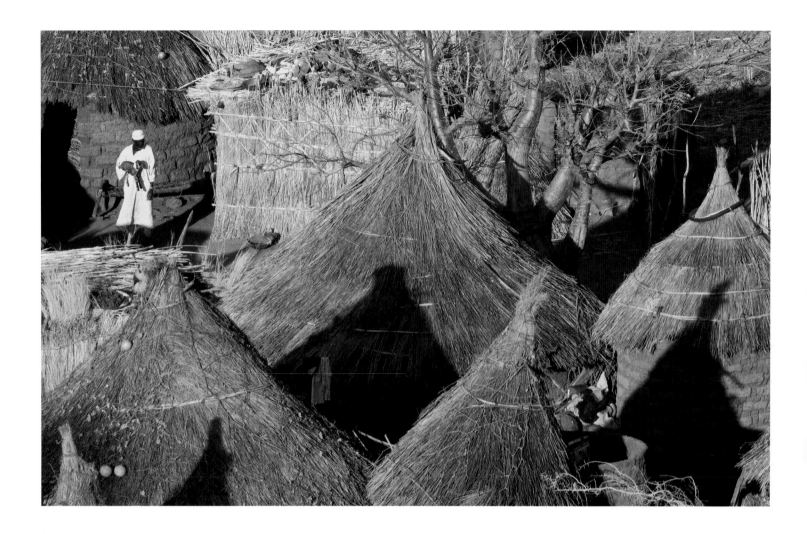

indistinguishable from many others. Except as a record of having been there, it may even seem rather pointless. It is not as if there is any choice in how the details or shapes are rendered, as there is in painting. The camera works impartially and without character. This is largely what motivates photographers to search for new ways of framing shots, because design is the route most accessible for individual interpretation.

This leads on to a more fundamental issue—that of the role of surprise in photography in general. Ultimately this is a philosophical concern, and indeed has attracted the attention of philosophers such as Roland Barthes. I want to touch on this here only in as much as it could be

useful to taking photographs, but it has its roots in the fact that all unmanipulated photographs show what was actually there, in place and time and in reality. Therefore, unless the subject or its treatment have something special about them, there is a constant risk of the image being ignored, being thought of as uninteresting. Jean-Paul Sartre wrote that "Newspaper photographs can very well 'say nothing to me' Moreover, cases occur where the photograph leaves me so indifferent that I do not even bother to see it 'as an image.' The photograph is vaguely constituted as an object..." This is ultimately why so many photographers want to break the ordinariness and surprise the viewer. Barthes identified a

▲ NUBA VILLAGE

The more eccentric the composition (as we saw on pages 24-25), the less conventional, but the more a good reason is required. In this view of a village at sunrise in the Nuba Mountains, the real reason for having the man and child in the far top left of the frame is that the best area of thatched roofs (in terms of pattern and consistency) was below him and to the right.

gamut of surprises (though none that he cared for much), and these included rarity of subject, capture of gesture normally missed by the eye, technical prowess, "contortions of technique," and the lucky find.

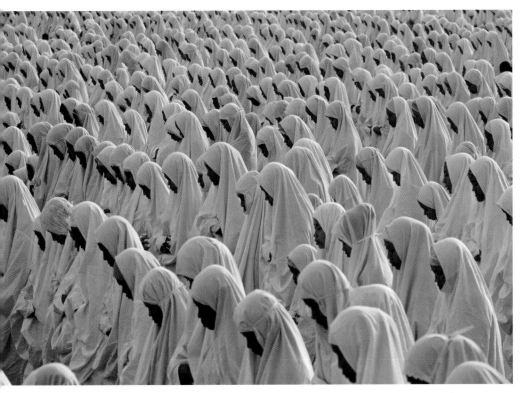

◄▼ MUSLIM WOMEN

In both images, shot within a number of minutes of each other, what appealed photographically was the mass of white-clad figures, and the approach taken was the obvious one of a slightly elevated viewpoint and a telephoto lens to compress the perspective (and so exclude extraneous surrounding details). The first shot is a variety of a "field" image (see pages 50-51) and straightforward. The second was the result of exploring different camera positions, and the chance appearance of the young girl, who stepped out of line because she was bored.

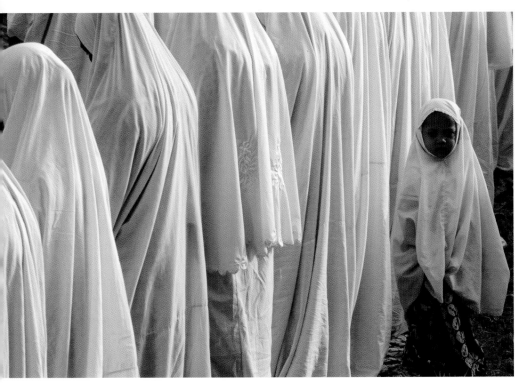

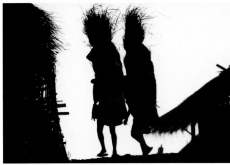

▲ ROOFING THATCH

Akha hill-tribe girls in northern Thailand were returning to the village at the end of the day, carrying on their backs large sheafs of grass for thatching. Having already photographed this in more conventional lighting, I was intrigued by the strange appearance they had in silhouette from the bottom of the slope, shot with a telephoto lens.

REACTIVE OR PLANNED

Another choice of intent is between shooting that relies on observational skills and speed of reaction to capture events as they unfold in front of the camera, and photography that is to some extent organised from the start. The issue is one of control, or at least attempted control, over the circumstances of the shoot. There is no question of legitimacy here, and a purely reactive reportage photograph does not have any claim to being truer than a still-life that has been carefully arranged over the course of a day. It is instead very much a matter of style, influenced by the nature of what is being photographed.

The usual view is that the amount of control exercised when shooting is determined by the subject. Thus, street photography is the most reactive because it has to be, and still-life the most planned because it can be. Largely this is true, as we explore in the next chapter, Process, but it is by no means inevitable. Just because most people tend to tackle a particular type of subject in a predictable way does not mean that other approaches are not possible. Personal style can override the obvious treatments. Take street photography, normally the hallowed ground of slice-of-life realism. The American photographer Philip-Lorca diCorcia approached the traditional subjects in a different way, by installing concealed flash lights that could be triggered by a radio signal, to add "a cinematic gloss to a commonplace event," in the photographer's words. An earlier, well-known example is *Kiss by the Hotel Ville*, taken by French photographer Robert Doisneau in 1950, a photograph that became a romantic icon and popular poster. Seemingly spontaneous, it was in fact posed. As Doisneau later said, "I would have never dared to photograph people like that. Lovers kissing in the street, those couples are rarely legitimate."

Equally, while the studio still-life image epitomizes control in photography, with some shoots taking days, from sourcing subjects and props, building the lighting and the set, to finally constructing the image, it is also possible to do the opposite—guerilla still-life photography taken handheld from real life. The role of the photographer's personality is crucial. Even Edward Weston, who famously took hours to make exposures in natural light and was extremely rigorous in composition, claimed to react rather than to pursue a worked-out plan: "My way of working—I start with no preconceived idea—discovery excites me to focus—then rediscovery through the lens—final form of presentation seen on ground glass, the finished print pre-visioned complete in every detail of texture, movement, proportion, before exposure—the shutter's release automatically and finally fixes my conception, allowing no other manipulation—the ultimate end, the print, is but a duplication of all that I saw and felt through my camera."

However closely a shot is planned and art-directed, as tends to happen in advertising, there are moments during the shoot when new ideas and possibilities occur. American photographer Ray Metzker commented, "As one is making images, there's this flow; there are certain images that one stumbles on. Sometimes it's with great delight and sometimes it's with puzzlement. But I can recognize that signal..." This is the subject of the next chapter, Process, but when photographers know from experience that this may happen, it becomes part of the intent. There are many shades of what we could call half-planned photography, in which the photographer goes part-way towards creating favorable conditions for shooting, and then allows reaction to play its part. Making a reconnaissance for a landscape shot to check possible viewpoints and the way the light falls, then returning when weather and lighting conditions seem favorable, is one example. Researching an event and then turning up on the day prepared for an anticipated set of possibilities is another.

▼ **DELHI STREET**
Spontaneous and reactive, this photograph of a homeless boy waking up next to a garbage can on a Delhi street was the result of nothing more planned than walking around the streets for a couple of hours from sunrise onward.

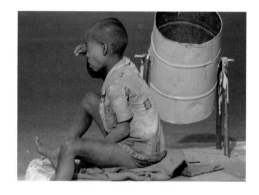

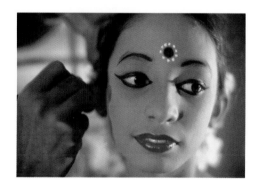

▲ **MAKE-UP FOR DANCING**
A half-planned photograph, in which the event—behind the scenes at a dance performance in Kerala, southern India—was known and permissions and attendance secured. What then remained was exploration within this localized situation.

➤ **THAI KITCHEN**
A set-piece interior, in which a traditional nineteenth century Thai kitchen was fitted out and put to work, with costumed model, owes most of its effect to planning and logistics, including the acquisition of props, timing for the natural light, and provision of photographic lighting.

➤ MOUNT POPA

One widely practised form of planning is anticipating natural lighting in an exterior view. With both landscape and architecture, experience and local knowledge (making use of sunrise and sunset tables, GPS, compass, and weather forecasts) make it possible to take an informed guess about how a scene will look at a later time. In this case, Mount Popa on the outskirts of Pagan, Burma, the recce was made earlier in the day, and this shot, taken shortly before sunrise, was more or less predicted.

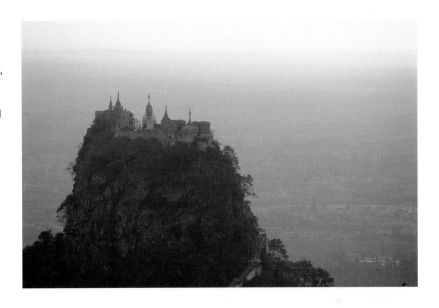

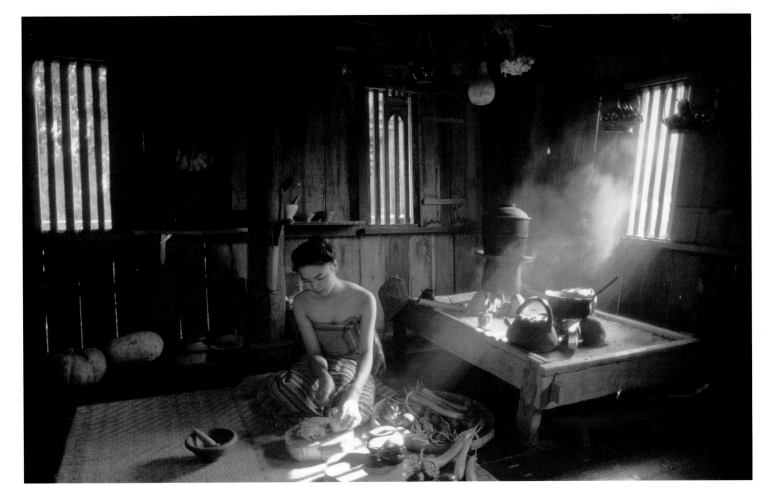

DOCUMENTARY OR EXPRESSIVE

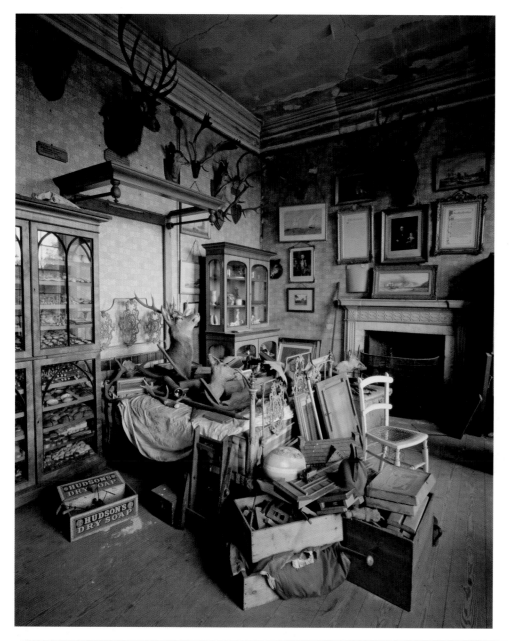

◄ **CALKE ABBEY**
Documentation was the main purpose of this project—the last week of an English country estate that had been untouched for more than a century, before it was handed over to the National Trust, who were about to make an inventory and then restore the property before opening it, much later, to the public. This bedroom alone was a time capsule. In camera position, lighting and angle of view, the approach is artless—the purpose is to show in as neutral a fashion as possible how the room looked upon entering.

The first of these, exploring the world (the manifesto of *Life* magazine, launched in 1936, was "to see life; to see the world; to eye-witness great events; to watch the faces of the poor and the gestures of the proud..."), seems initially to be the more practical, but it is a little more complicated than that. Shorn of creative or artistic pretensions, this could be called documentary photography, and indeed, the original definition stressed the relative absence of the photographer's own ego. Authenticity, even truth, were considered to be attainable ideals, as in the Farm Security Administration (FSA) photographic program in the United States during the Depression. Archetypal documentary photographers include Walker Evans, Eugene Atget, and August Sander, among others. Walker Evans' biographer Belinda Rathbone, commenting on Evans' description of the wealth of detail in one of his pictures, wrote that, "This eclectic mix of information, delivered in even, unspectacular description, exemplified to Evans those photographs that were 'quiet and true.'"

At the other pole is the desire to do something untried and unique photographically, whatever the subject. That the subject might already have been endlessly photographed by others may even be an advantage—a challenge to one's own creativity. Garry Winogrand, in a frequently quoted declaration of intent, said, "I photograph to find out what something will look like when

One way of dividing the multitude of reasons why people take photographs attempts to draw a line between the content and the interpretation (or content and form, if you like). Exploration has always been central to photography, and it's perfectly possible to look at all the ways of placing subjects, dividing frames, juxtaposing colors, and so on, as exploring the visual possibilities of a frame. But when it comes to intent—the self-assigned purpose of photographers—there is a bipolar difference between exploring the world and exploring one's own imagination. At one end we have the desire to go out and discover what people, things, and places look like, and on the other the impulse to see what we ourselves can do with them through the camera.

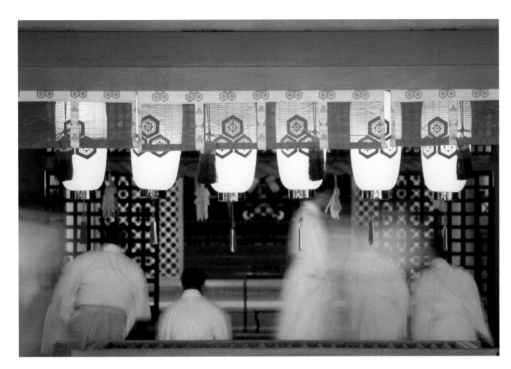

◄ SHINTO SHRINE
At the Shinto shrine of Itsukushima on Miyajima Island, Japan, document was less important than an evocation of the movement of the priests, and a sub-plot of permanence-impermanence. A time exposure, with its attendant uncertainty, was the chosen method.

▲ TEAPOT
A clean and precise product shot of a traditional iron Japanese teapot, with the background dropped out in post-production, makes a documentary still-life record.

photographed." This is just one interpretation, and is a kind of loose, open-to-everything approach. There are others, including the deliberate application of an already worked-out style—perhaps strong angles with a wide-angle lens, or deliberate blur of one kind or another, or strange manipulations of color.

The complication is that neither document nor expression are pure ideals. Interpretation is involved in making a record, and expressive photography needs content to work on. The bias of intent is usually in one direction or the other, but photographers themselves may not always be able to separate one from the other—or even need to, to be honest. A completely deadpan view, as in a police crime-scene photograph or a catalogue of coins, is by definition not particularly interesting other than as a data source, and the photographer's eye usually intrudes. To quote Walker Evans again, "It's as though there's a wonderful secret in a certain place and I can capture it. Only I, at this moment, can capture it, and only this moment and only me."

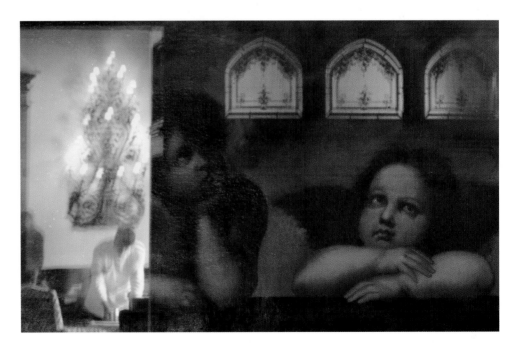

▲ BADRUTTS PALACE
On an assignment to make an anniversary book for the oldest hotel in St Moritz, Switzerland, the art director's brief stressed images that were oblique and ambiguous, deliberately to avoid the normal, precise, and organised hotel-brochure style. This shot makes use of the vague and slightly distorted reflections in the glass covering an old painting in the lobby.

SIMPLE OR COMPLEX

Simplicity and reduction to essentials have been so much a part of modern art and design that the advice to "simplify" often passes without question. It became one strand of Modernism, particularly in Constructivism, which laid the foundations for Minimalism and its central tenet "Less is more." Its application to photography is particularly intriguing, because the natural messiness of uncomposed real-life scenes seems to call out for a solution like this. One very convincing argument for holding simplicity as a principle in composing photographs is that it is a natural extension of creating order out of chaos—which is, of course, one definition of composition itself.

For this reason, simplification almost always works, at least to the extent that it helps make an effective, workmanlike image, but to make a rule out of it would just be restrictive. It may well be that photography itself helps to keep simplicity alive as a regular goal, because without care and attention most scenes from real life tend to record rather messily and untidily. Bringing some kind of graphic organization to a photograph is easiest to do by reducing the mess, cutting out the unnecessary (such as by cropping or changing viewpoint) and imposing a structure which is then simpler. The ability to bring order from chaos has become one of the skills most admired in photography.

Nevertheless, there are arguments in favor of a more complex arrangement, in which the structure is dense and rich, offering more for the eye to explore and examine. Handling several interlocking components in an image rather than a minimalist one or two takes considerable skill if the result is still to have some kind of order. As we saw in Chapters 2 and 3, adding (or finding) more points of interest in the frame increases complexity and is demanding, but after a certain number the points of interest merge into a "field" image, and as such become simple once again—from a single person to a group to a crowd.

One of the more interesting developments of simplification is abstraction. In art, to abstract involves an extreme translation away from the

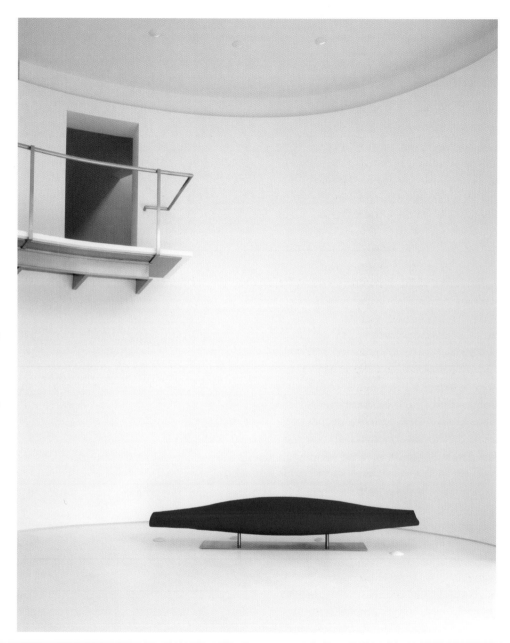

representational and towards more purely graphic forms. In the case of Picasso and Cubism, one motive certainly was the desire to represent things in simple forms that retained depth. In painting and sculpture, the starting point can be real objects (as in the Cubist paintings of Picasso and Braque, and in Constantin Brancusi's sculptures), but it does not need to be. The painter Paul Klee,

among others, was more interested in playing with forms. Photography, on the other hand, is more or less compelled to begin with raw material from real life, which makes abstraction much more of a challenge, and more difficult to pull off. Moreover, the question of whether or not an image is abstract, or is to a degree abstract, can be a matter of opinion. What may be abstract to

RED SOFA

A minimalist interior in which the white finish to wall, ceiling, and floor, together with the balcony, serve to emphasize the dominant red of the modern sofa.

one viewer may be a perfectly recognizable and not so interesting representation to another. The American photographer Paul Strand was known for his abstract compositions that often destroyed perspective, but he saw it somewhat differently: "I [...] made *The White Fence* and I have never made a purely abstract photograph since! I have always tried to apply all that I learn to all that I do. All good art is abstract in its structure." Ansel Adams, too, was suspicious of the term when applied to photography: "I prefer the term extract over abstract, since I cannot change the optical realities, but only manage them in relation to themselves and the format."

Abstract composition, if we can call it that, tends to be rigorous in its organization, with an emphasis on excluding clues to realism. An appropriate choice of subject matter helps, and angular, manmade structures are among the most adaptable to this kind of composition. Closing in on details that would normally be beyond the normal range of the eye is another approach, aided by cropping that takes the view out of context. Patterns respond to abstraction also. One general problem, however, is that the real basis of the abstracted photograph tends to encourage a viewer response of "what-is-it?", as if it were a kind of test or puzzle (as indeed, it often has been in newspapers and magazines).

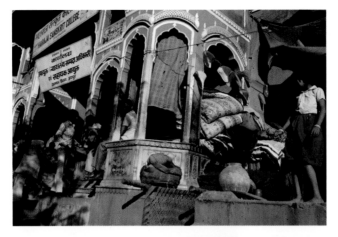

JAIPUR

In this complex image of a street scene in Jaipur, India, the high-contrast sunlight and many physical elements create an interlocking composition on several levels. The principal ones are shown schematically below.

▲ CHIAROSCURO

▲ COLOR ACCENTS

▲ LINES

▲ PEOPLE

FILM

This photograph of various types of film achieves extreme simplicity through a carefully planned geometric construction, featuring corners and edges in exact alignments. The images on the films were selected to be ambiguous so as to give prominence to the rebates.

CLEAR OR AMBIGUOUS

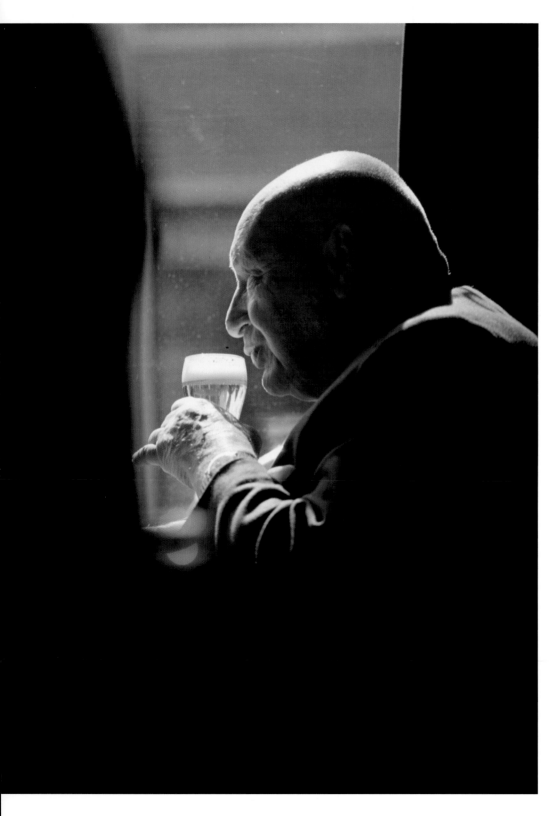

How obvious should an image be? This is an interesting problem for a photographer, because in photojournalism in particular, the search is usually for the single powerful image that encapsulates the issue. When it becomes powerfully obvious and striking to you, the photographer, it becomes the same for the picture editor and the reader. The great single shot that says it all was very much part of the ethos of *Life* magazine, which was hugely influential on at least two generations of photographers. Partly it was the way I was taught, by editors such as *Life*'s Ed Thompson. Great value is attached to images that say it all, and say it instantly, but such photographs tend not to ask too much of the viewer. As Roland Barthes put it, writing about a *Paris-Match* cover photograph, the picture "is already complete." The dilemma, then, is that clarity packs a punch and so is a goal of photojournalism, but more ambiguous images that are slower to read are likely to absorb more attention—and last longer, in other words.

It boils down essentially to the matter of ambiguity, and this, declared Ernst Gombrich, the influential art historian, "is clearly the key to the whole problem of image reading." The less obvious the point of the photograph, the more it involves the viewer in reading it and thinking about it. This is what Gombrich called the "beholder's share"—the involvement of the viewer, the viewer's experience and expectations,

◄ MAN IN BAR
There is nothing ambiguous in either content or treatment about this image of a man taking his first sip of beer in an Amsterdam bar. The moment is caught, and the lighting attractive and appropriate for a glass of beer, but there is nothing to ponder. The image communicates quickly and efficiently.

► APPLE STORE
The newly opened Apple Store on New York's Fifth Avenue. The glass spiral staircase descending to below ground level offered a very different view from what would be expected from a store—the shadowy sequence of feet.

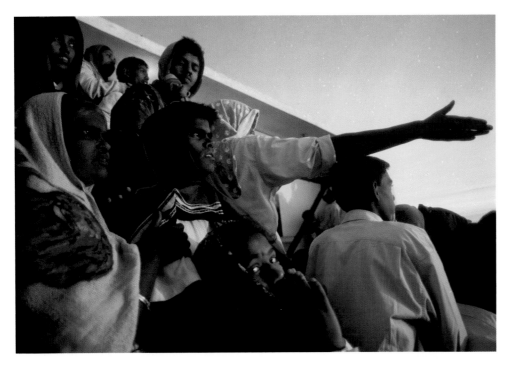

◄ADAM'S PEAK
Reference to things outside the frame almost always creates ambiguity and uncertainty. Without a caption, the full story here is impossible to guess. This is the summit of Adam's Peak, a sacred site in Sri Lanka, where hundreds of people gather each night to await the sunrise. Of course, this still leaves the question of why these people are so awed by a daily event.

▼BURMESE GIRLS
Ambiguity can be more subtle than the example above. Here it resides in the expression on this Burmese girl's face, perhaps enhanced by the tanaka bark powder that she has applied to her cheeks and forehead. It is not a happy expression, but whether she is simply lost in thought or brooding over something is impossible to tell.

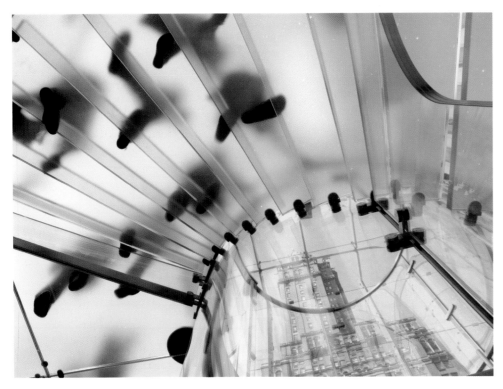

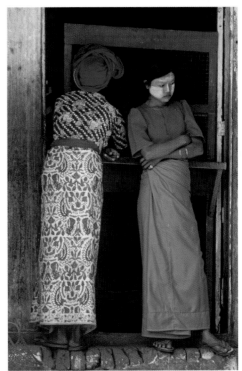

in enjoying and completing the experience of looking at a work of art. This works just as well in photography as in painting. In particular, there is a kind of flattery involved when the photograph is not so obvious at first glance, yet the viewer with a little effort finally does "get" it. This has been known in art for centuries, and the 17th century French art theorist Roger de Piles put it well when he wrote in favor of "employment for the spectator's imagination, which pleases itself in discovering and finishing things which it ascribes to the artist though in fact they proceed only from itself." In a sense, it is like hearing a clever joke—just understanding the point is rewarding.

Ambiguity comes in many forms, from content to the composition. We'll come to the role of composition on pages 144-145, but we have already seen (on pages 130-139) something of the role of content—in particular the contrast between times when the content is so strong that it can carry poor composition, and times when the actual subject is much less important to the image than the way it is put together by the photographer. Here, let's take the role of content farther. When it is blindingly obvious and straightforward, as in the picture on page 140, the viewer sees, understands, and moves on. But when it is not at all clear what is going on, or why, then so long as the viewer can be persuaded to go on looking for some time more, he or she will begin to make interpretations.

Sometimes, of course, these interpretations are wrongly made, in what Gombrich calls "traffic accidents on the way between artist and beholder." This may matter not at all, but it does suggest giving some thought to captions, if only as a means of holding the viewer's attention for long enough. Almost without exception, when photographs are

➤ **SHIP PAINTER**
The smaller image to the right (the first I took) is completely straightforward—a man painting a ship—but the angle of the sun casting a clear shadow on the side of the vessel suggested a less obvious, and so potentially more interesting, way of framing the shot. The shadow communicates what is happening well enough on its own.

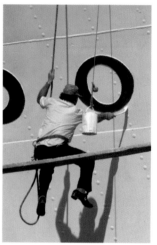

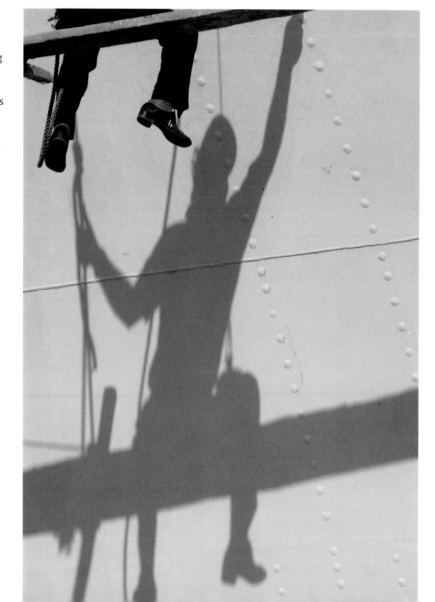

formally displayed, whether on a gallery wall, in a magazine or book, or on a website, they acquire a caption. This creates a new relationship between the image and its content, and between the image, the creator, and the viewer. This is a fertile ground for analysis, but also likely to stray far from the main purpose of this book, and so I'll limit my comments to the strictly relevant. I say "acquire" advisedly, because few photographers to my knowledge take pictures with a label in mind. It is at the point when the image becomes a useful object that people want to identify it. At its simplest, this is because of the basic human need to classify and

order (not so far, perhaps, from the photographer's need to bring order to a scene when shooting).

The conventions vary according to the display. For a gallery, the minimum is a title and date, with a subtitle describing the medium (such as "archival digital pigment print") and anything unusual about the process (such as "pinhole camera exposed for four hours"). For a magazine or book, more is usually required, but how detailed a description is very much up to individual preference and the style of the publication. Where this becomes relevant to composition and process is in the extra direction,

or misdirection, that it gives the viewer. The way someone will read a photograph will definitely be influenced by the caption, and the most basic influence is what the photographer (or caption writer) declares the subject of the picture to be. For instance, a landscape taken at the site of a battle or a disaster acquires a different significance if we know this fact. And, needless to say, the stronger the content of the image, the more viewers will want to know the story behind it. Too little information can be intriguing, but it can also be frustrating and annoying, depending on your point of view.

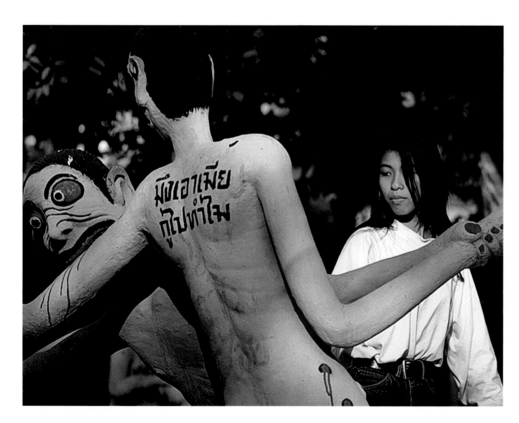

∧ THE IMPORTANCE OF CAPTIONS
This image, shot during an assignment on Buddhist sculpture gardens, begs for more information. The original caption reads: "At the sculpture garden of Wat Phai Rong Wua, a girl pauses to look at the punishment being meted out to an adulterer. As a demon devours his arm, the words on the man's back read plaintively, 'Why did you take my wife away from me?'".

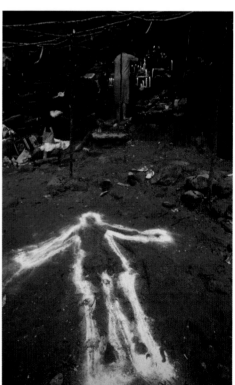

∧ TRACES AND ABSENCE
Just as events out of frame can be intriguing (see page 141), so can the traces of things that have already happened be mysterious. This outline of a man looks more ominous than it is—powder sprinkled on a devotee of a Venezuelan cult called Maria Lionza.

DELAY

The compositional route to being less obvious and promoting ambiguity in an image depends ultimately on delay. Specifically, while inviting the viewer to look at the image, a key element is embedded in the composition in such a way that it reveals itself only slowly, or after a pause. Instead of rapid communication, the photographer aims for the equivalent of a punchline delivered after the viewer has already entered the image. Doing this at the time of shooting means essentially stepping or pulling back instead of the more natural reaction of closing in on a subject of interest. It also often means seeing and treating the subject in context.

Perhaps the most common class of delaying tactic is spatial reorganisation, in which the critical subject or key is made smaller or less central in the composition. This automatically places the first attention on the surroundings, and the jump from this background context to the discovery of the key subject relies on a relationship between the two, often with some surprise. The figure in a landscape is probably the best known of this kind of composition, and has a long history in painting preceding that in photography. Notable examples are *The Martyrdom of Saint Catherine* by Matthys Cock and *The Sermon on the Mount* by Claude Lorrain. In these paintings the landscape dominates human affairs, for a variety of reasons, and often it is only on the second look that the key human element becomes obvious. The small figure serves not just to enhance the scale of the landscape and to comment on human events in the scheme of things, but in the reading of the image creates a small event for the viewer. It prolongs the experience of looking at the picture and encourages a re-examination. Within this class, ways of temporarily "hiding" the subject include not just making it small, but placing it eccentrically away from the center, and misleading the eye by using geometry and organization to direct attention elsewhere first. Also, reversing any of the several techniques discussed earlier that emphasize a subject (such as differential focus and lighting) can help to "hide" a subject.

There are other delaying tactics that are not so readily classifiable. One is to refer or "point" to a subject that is outside the frame, for instance by showing just its shadow, or by showing the reaction of someone to this unseen element. Another, shown opposite, is the surprise of unexpected phenomena, when something is not what it first appears to be—in this case a line of men who are not standing, but caught in mid-air. In all this, it's important to be aware of the risk of there being insufficient clues, to the point at which the viewer gives up before recognizing the point being made.

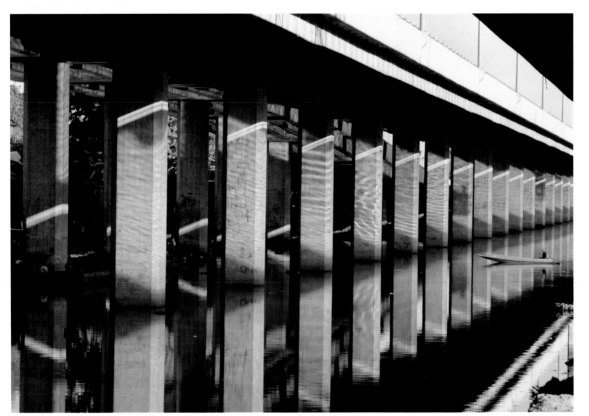

◄ BANGKOK KLONG
The interest in this photograph is not really the boat on a klong (canal) in Bangkok, but the fact that it is still there after a massive motorway has been built right over it. The concrete pillars make a landscape which one would not normally associate with a traditional way of life. Hence, a close view of the boat would not have served the purpose. However, simply a long shot, with the boat very small, might just lose it from view. Instead, this viewpoint, and placing the boat at the far right of the frame, helps to point it out through the convergence of the motorway pillars.

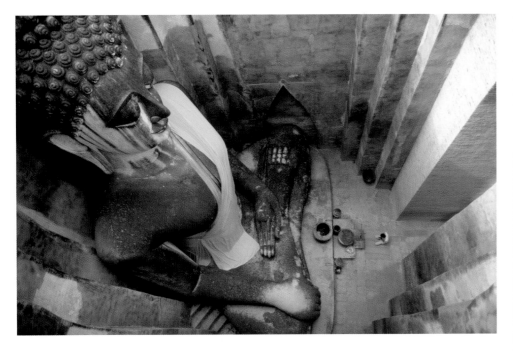

◄ BUDDHA

Two things contribute to the time lag in seeing the kneeling figure of a man praying—which is essential to appreciating the scale of the Buddha. One is the dramatic and unexpectedly high angle of view, the other is the great difference in scale between the two figures.

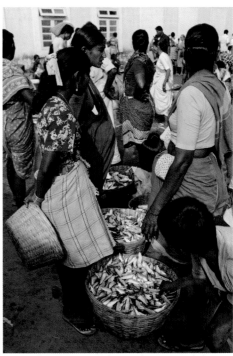

▾ SUFI SECT

Adherents of a Sufi sect in Omdurman, Sudan, practice a form of meditative jumping in unison. Catching them at the peak of the jump was an obvious choice, but the pattern of the matting makes the mid-air suspension less obvious at first glance, and this enhances the surprise when, after a few seconds, it is seen.

▲ FISH MARKET, GOA

This is a chance photograph, for which there was very little warning. The framing is right for giving some humor to the situation; by making sure that the boy stealing the fish appears just at the bottom of the frame, there is a small delay before he is noticed. The viewer first sees the women in a conventional marketplace shot and then notices the petty thieving going on below. This, of course, is how the fisherwomen themselves saw the event.

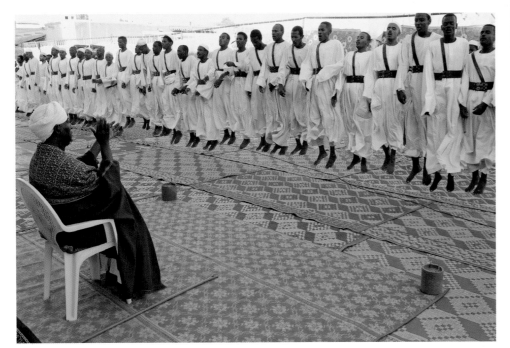

STYLE AND FASHION

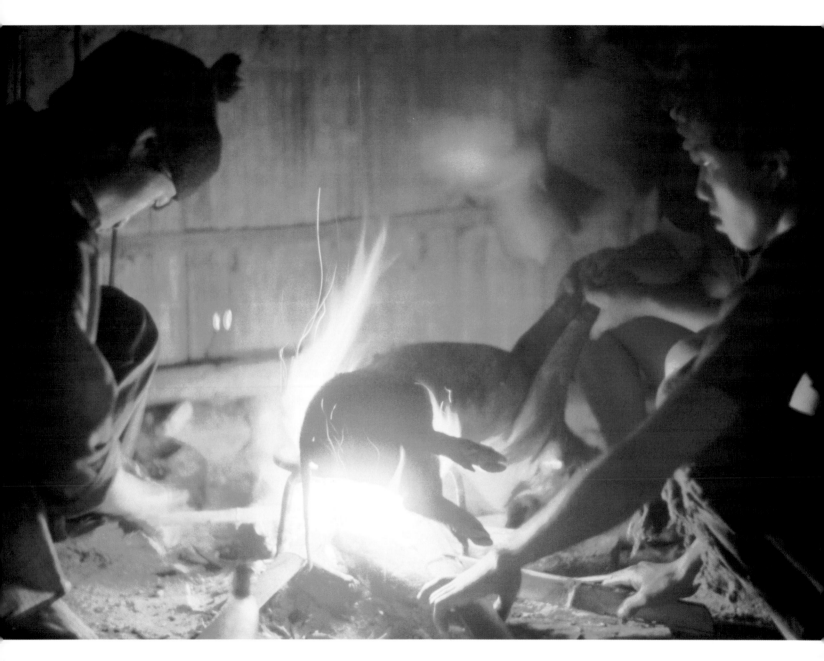

Despite the inherent vagueness of the idea of style in photography, it can and does influence the way in which some people work. There is some distinction between an individual photographer's style and the more general style subscribed to at any one time by a number of photographers. The difficulty lies in agreeing on what legitimately constitutes a style rather than a trick or straightforward technique, and opinions vary greatly. When a style can be easily defined—for instance, in lighting, two from the past that come to mind are "painting with light" using customized light "hoses," and ringflash that gives a shadowless, hard effect from a special tube that surrounds the front of the lens—it might be better called a mannerism. On the other hand,

when critics struggle hard for the definition of something they feel ought to be there, it may be that the style is at best tenuous.

Whether we like or approve of them, there have been a number of photographic styles that are generally acknowledged. Because style is intimately connected with current fashion, most of these have already had their day—although, in the manner of fashion, they are always available for revival. Roughly in date order, they include Pictorialism, the Linked Ring, Photo-Secession, Neue Sachlichkeit (New Objectivity), Straight photography, Modernism, Constructivist, Minimalism, Color Formalism, and post-modern new realism.

Also, surrealism in its time and beyond has had a powerful influence on photography, with Man Ray its best-known practitioner. But while most people would probably think of surrealist photography nowadays as being versions of the themes of René Magritte and Salvador Dali (endlessly reworked), it had a more fundamental effect. Peter Galassi, in his book, *Henri Cartier-Bresson, The Early Work*, wrote, "The Surrealists approached photography in the same way that Aragon and Breton ... approached the street: with a voracious appetite for the usual and unusual ... The Surrealists recognized in plain photographic fact an essential quality that had been excluded from prior theories of photographic realism. They saw that ordinary photographs, especially when uprooted from their practical functions, contain a wealth of unintended, unpredictable meanings." Cartier-Bresson himself wrote, "The only aspect of the phenomenon of photography that fascinates me and will always interest me, is the intuitive capture through the camera of what is seen. This is exactly how [André] Breton defined objective chance (*le hasard objectif*) in his *Entretiens*."

A tendency of photographers who work consciously to a style is to take the whole thing very seriously. For example, when Ansel Adams, Edward Weston, and others set up their "f64" group to promote "straight," "pure" photography, they railed against the sins of pictorialism. "In the early '30s," Adams wrote, "the salon syndrome was in full flower and the Pictorialists were riding high. For anyone trained in music or the visual arts, the shallow sentimentalism of the 'fuzzy-wuzzies' (as Edward Weston called them) was anathema, especially when they boasted of their importance in 'Art' ... We felt the need for a stern manifesto!"

As an antidote to this, I like the dry comment of M. F. Agha, who became art director of *Vogue* in 1928, on the then-current modernist style in photography: "Modernistic photography is easily recognized by its subject matter. Eggs (any style). Twenty shoes, standing in a row. A skyscraper, taken from a modernistic angle. Ten teacups standing in a row. A factory chimney seen through the ironwork of a railroad bridge (modernistic angle). The eye of a fly enlarged 2000 times. The eye of an elephant (same size). The interior of a watch. Three different heads of one lady superimposed. The interior of a garbage can. More eggs ...". All conscious styles start to pall after a while.

The concept of beauty is not far removed from style, and receives less rigorous attention than perhaps it should; indeed, it largely goes unquestioned. But if we understand how it comes to be agreed at any one time and in any one place, we can tighten the composition of images by using or rejecting it. Although beauty is an elusive concept, we all nevertheless employ it in judgment, and generally assume that everyone else knows what we are talking about. It is certainly true that some scenes and some faces, for example, will be considered beautiful by most people. Yet we don't know why, and as soon as we try to explain the reason for a general consensus that shafts of evening sunlight breaking through a clearing storm over Yosemite or the English Lake District make a beautiful scene, it quickly unravels. The point is that there is a consensus, and it shifts with time and fashion—and of course, from culture to culture. That beauty is in the eye of the beholder is only partly true at best.

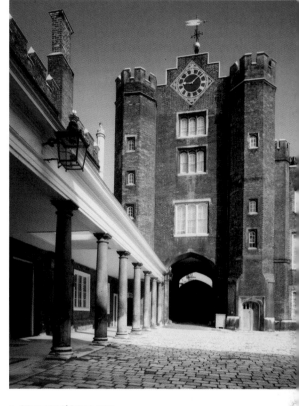

▲ ST JAMES'S PALACE
This "straight" photograph of St James's Palace in London displays several of the characteristics of formalism. The composition is considered, the essential architectural features are included, the verticals are correct, the detail is as sharp as only a large-format camera can make it, and the exposure and printing have been managed carefully to retain both shadows and highlights.

Fashion is an extension of beauty, with more edge added. It is what is considered good, a little challenging (not too much), elitist, and above all now. Fashion, in photography as much as in clothing and make-up, is a way of challenging the existing order of appreciation—trying out something a little different (not usually radical) to see if other people will take it up. It is, therefore, slightly experimental, very much geared to being adopted, and of course highly competitive.

➤ PERFUME BOTTLE BLANKS
The approach here, assembling a collection of resin models for perfume bottles, could be called constructivist. Most of the shapes are abstract in any case, and by including one recognizable bottle shape close to the center, the opportunity was left open simply to play with the geometry, using diagonals as a general theme.

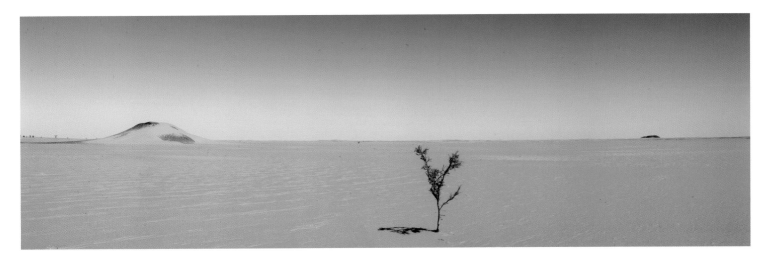

▲ BAYUD DESERT

Another minimal approach in a different context uses frame shape, frame division, and the isolation of one small, pathetic bush to convey the emptiness of this bleak desert in northern Sudan. Including the small bush close to the camera enhances rather than diminishes the emptiness, and considerable thought was put into exactly where in the frame to place it—very slightly off center helps create a balance with the low sand hill behind.

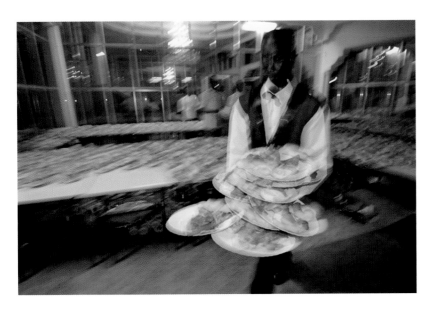

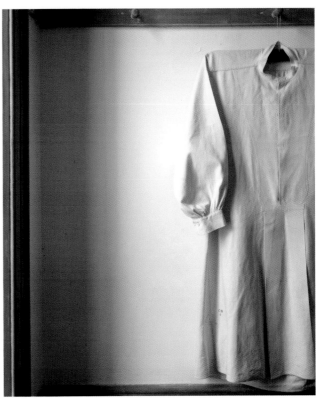

▲ SUDANESE WEDDING

Rear-curtain flash, of which this is a typical example, has generated a relatively new kind of photograph that could almost be considered a style, even though it is in a sense a technical artifact. With an SLR, the flash can be triggered at the end of a time exposure rather than more normally at the beginning. Depending on the relative exposure of ambient lighting with inevitable motion blur and flash lighting, which effectively "closes" the movement, the mixture of blur and sharp detail is distinctive.

▲ SMOCK

Employing techniques of minimalism, the essence of this nineteenth-century linen shirt hanging in a Shaker meeting house in Kentucky has been conveyed with the least detail and fewest colors. All necessary information of texture and shape is available from little more than half of the garment, and the tight crop at left and top frames the scene. Bare simplicity characterizes this style of photography.

CHAPTER 6:
PROCESS

In art criticism of all kinds, but possibly more so in photography, process has been given less attention than it deserves. Perhaps it is because the viewer, or critic, has to extrapolate backwards from the image to guess the situation and what went through the photographer's mind. This can be done, but it needs thorough practical knowledge. Here, photography becomes arguably more difficult to analyze than painting because the process is much shorter—often too short for the photographer to be completely aware of the steps at the time of shooting.

This tends to confound art critics with limited personal experience. MoMA's John Szarkowski, writing about a well-known reportage shot by Mario Giacomelli, said: "Analysis was surely useless to Giacomelli during the thin slice of a second during which this picture was possible, before the black shapes slid into an irretrievably altered relationship with each other, and with the ground and frame. It seems in fact most improbable that a photographer's visual intelligence might be acute enough to recognize in such a brief and plastic instant..." and so on. He concludes by invoking luck as a hidden ingredient, closing with the curious "...whether good or bad, luck is the attentive photographer's best teacher, for it defines what might be anticipated next time." It does not, of course. Good or bad, luck is simply a reminder that you are shooting in a world that does not bend to your control. Szarkowski's own photography, I should note, is of the deliberate, non-reactive kind.

Many photographers simply say each shot derives from "intuition." Without denying the power of intuition, this chapter will investigate its foundation. André Kertész has declared that from the start of his photography (in 1912, at age 20), "From the point of view of composition, I was ready. The very earliest thing I did was absolutely perfectly composed. Balance and line and everything were good, instinctively. This is not to my merit. I was born this way." Logically this would suggest that Kertesz did not refine or evolve his composition, but this is not true. He, like so many others, was simply not interested in examining his own process. Fortunately, some photographers of historical importance, including Cartier-Bresson, Ansel Adams, Walker Evans, Edward Weston, and Joel Meyerowitz did, and their analyses are useful—and used here.

The term "photography" seems on the face of it to bring consistency to a wide range of subjects and ways of making images, but as an umbrella description it suggests more similarities in process than there actually are. The technology of camera and software may be common to the many different ways in which people shoot, but it does not go much farther. Between the extremes of reactive shooting in unpredictable situations, and the total control of a purpose-built studio, there is a huge difference in how photographers go about creating and composing images. The goal of a well-designed image may be the same, but the process is not. Reaction, as in street and news photography, tends to rely on intuition and experience (and because of the latter, generally gets better with time). In any case, the process has to be very fast, often allowing no time for thinking things through in a step-by-step, logical way. Deliberation, which is at the opposite end of the spectrum, and applies strongly in still-life and architectural photography, is slower and calls on powers of reflection and constant questioning. It is by no means less creative for being measured, but the creative energy is called up and used in a different way.

In this chapter, I'll begin by looking at reactive photography; those occasions when anticipation and skill are put to the test. But what may be even more important is knowing in advance the kind of image you could make from a situation. When the scene does not impose itself, the photographer makes it fit into what I will call a "repertoire." This is a sort of mental image bank of what the photographer knows can be done and likes as a treatment. For me, it includes images that I made in the past and found satisfying. I now know that they work for me, and I keep them mentally in reserve—not to be copied slavishly, but as a kind of design template to adapt to any new situation.

THE SEARCH FOR ORDER

All the visual arts depend heavily on ordering the various elements according to the artist's preference, with the assumption that the visual impressions presented by the world are disordered and often chaotic. Photography is no exception. In fact, it requires more effort in organizing the image than do other arts, for the reason that the camera records everything in front of it. A painter selects from the view, but a photographer has to subdue, diminish, or hide the elements that are unwanted. Photographers' writings on this stress this time and again. Edward Weston, early in his career, in 1922, wrote that for photography, landscape was too "chaotic... too crude and lacking in arrangement," and it took him several years of work to meet the challenge. Ansel Adams wrote, "For photographic compositions I think in terms of creating configurations out of chaos, rather than following any conventional rules of composition." Cartier-Bresson called it "a rigorous organization of the interplay of surfaces, lines, and values. It is in this organization alone that our conceptions and emotions become concrete and communicable." The mountaineer-photographer Galen Rowell, writing specifically about a composition in Death Valley, begins with, "At first the scene appeared very jumbled to me...." He is about to leave, when he thinks again and returns: "The zones that had first seemed so jumbled now converged in strong diagonals that I was able to compose by moving my camera position back and forth."

In Chapters 1 through 5 we have examined the tools available for imposing order on an image, and doing this would seem to be so basic that the questions of interest are to do with how and in what style. But what do we make of photography that appears to deny the organization of image components? We need to address this because a significant proportion of art photography from the 1960s onward does challenge these norms. It began with photographers such as Garry Winogrand and Lee Friedlander in America, and the identification of what art critics began to call the "snapshot aesthetic" (a term Winogrand, for one, hated). The critical argument for "informal" composition was that when used by non-photographers, the camera occasionally delivered "happy accidents," in which what would normally be seen as tilted camera angles and bad framing created interesting, unexpected juxtapositions and geometry. Sometimes artifacts like camera shake and flare would contribute, again "happily." In the hands of an expert, and made deliberately, vernacular composition could have artistic value.

The critic Sally Eauclaire, writing on the Color Formalist photographer William Eggleston, typifies the view at the time: "In the careless cropping, negligent alignments, and imprecise exposures of amateur snapshots, Eggleston recognized potent effects that under his direction could produce mesmerizing contrasts and shifts of conventional emphases." More recently, Graham Clarke, on Lee Friedlander's composition in the image *Albuquerque* (1972), writes, "At first glance it appears as a bland and nondescript image, but then begins to resonate with a rich and profuse meaning... It resists any single focal point, so that our eye moves over and over the image without any point of rest, any settled or final sense of unity (and unitary sense and meaning)." Tellingly, he uses the very absence of apparent skill to justify the artistic value of the image. "Resonate" and "profuse meaning" are, of course, tell-tale signs that the art critic is avoiding analysis and invoking mysterious insight on the part of a viewing elite, in which the reader is invited somehow to participate.

This is the argument, though of dubious logic. As we saw on pages 94-97, artifacts in photographs can work very well, but they do so by trading on what we know an accurately taken image should look like. In other words, to be successful and accepted, they can only be occasional. Willful disregard for the principles of composition and design can only be justified conceptually—by saying, in effect, "this is not a normal photograph." This, in fact, is how the snapshot aesthetic has developed in recent years,

CLUTTER INTO STRUCTURE

The aim here was to show a kindergarten with children using it, and to cram as much information as possible into the image. In other words, a recipe for a busy scene—perhaps too busy. The most obvious variable was expression and action from the children. This was what you would normally expect to make the difference between a good and an ordinary shot, and was the first priority. A member of staff was briefed to organize the children and encourage them into different activities; it was then a matter of observation and waiting.

As usual, however, design can add an extra layer of improvement, as the sequence shows, in time order. The two final shots both successfully include all the necessary information (table, activities, playhouse, children, teacher) but in a graphically coherent way, precisely because they have structure. The major difference between the two is in the attitude—and so visual importance—of the boy closest to the camera.

1. The initial shot, from a standing position, simply aims to take in the three major elements: children with teacher, table, and a chalet-style playhouse behind. The result is clear enough, acceptable, and a starting point for improvement.

2. A first step towards looking for the strongest viewpoint and composition is to walk around the table. The painted mural is an alternative feature of interest to the playhouse, and one of the children has chosen to sit at the opposite side of the table. But the shot doesn't work, on more than one level. There are too many backs of heads; framing the boy between the heads means including the distractingly bare wooden wall at left; and not enough of the painting activity is visible.

3. The next step was to try something more coherent on the opposite side of the table, using a closer view of the mural. Not obvious from the previous shot was the colorful rainbow pattern on this side. What is wrong here, however, is that even with a wide-angle lens, the other group of children is out of frame.

5

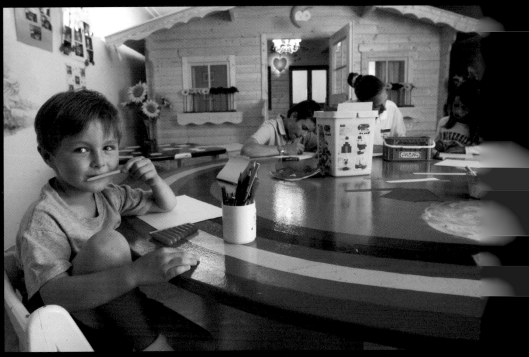

6

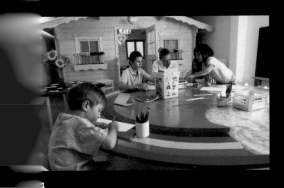

4. This viewpoint made more sense. There is a good sense of depth from the boy in the foreground to the other children, and on to the chalet behind, and this gives the eye something to do—looking across the frame from one to the other. But can it be improved?

5. A lower camera position does improve the shot, for two reasons. First, it puts us at the children's level, which is more involving. Second, it makes more of the rainbow pattern and, with the same wide-angle lens as used throughout, gives a more dynamic composition.

6. The boy looked up and then swivelled round in his seat. The expression is good and holds the viewer's eye. In fact, both of these last two images are fine; the

eye contact just makes this a different kind of picture. If we analyze this image, we can see that the eye-line straight out from the boy to the viewer makes it the strongest focus of attention. Faces always carry a strong visual weight, so that despite the various strong colors, the three other foci of attention are indeed the three faces on the opposite side of the table. The dynamics of the picture are strongly controlled by the curve of the table, emphasized by the rainbow colors and by the distorting effect of the 24mm efl lens, while the faces, yellow box, and blue window act as stops along the way. Then, once the viewer's eye has been led around the frame by this structure, it roams the picture to examine the various details, but always returns to the face of the boy.

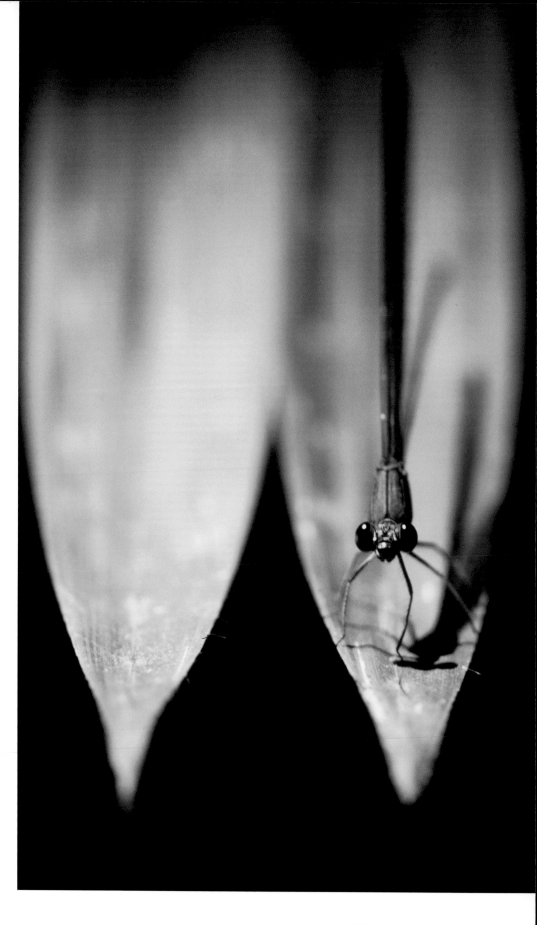

as self-referential questioning. Notably, many of those who work in this way identify themselves as artists who happen to use a camera, not as photographers. This is photography as conceptual art, and concept is being substituted for skill. Understanding this makes it easier to fit "artless composition" into the scheme of things, even though most traditional photographers dislike it. It is valid as art, but I would argue that it falls outside the canon of photography.

It's important to note at this point that art photography increasingly has its own paradigm and its own rhetoric, not to mention lexicon. To a growing extent its aims and ideals are diverging from those of photography practised for professional or amateur reasons. This is not a criticism, but an observation that affects the way these two purposes of photography have to deal with each other. In this light, certain commentaries of art critics become less confusing. So, when Graham Clarke, in the Oxford History of Art's *The Photograph*, written in 1997, states that "The problem with Bresson is that his images confound the critical eye" and "Winogrand has the ability to freeze rather than make still a moment", both of which verge on the ridiculous to a photographer, the problem is solved when we realize that he is writing with the rhetoric of art criticism and most certainly not for photographers. Cartier-Bresson's images do not confound the photographer's eye; rather we admire his consummate skill.

➤ DRAGONFLY

Insects in situ rarely present neatly organised images, but when the opportunity does arise, as with this dragonfly perched on the edge of a pointed leaf, framing and camera position can create order. First, the position was chosen for an exact head-on view; second, the shot was framed a little unusually to include the second, identical leaf.

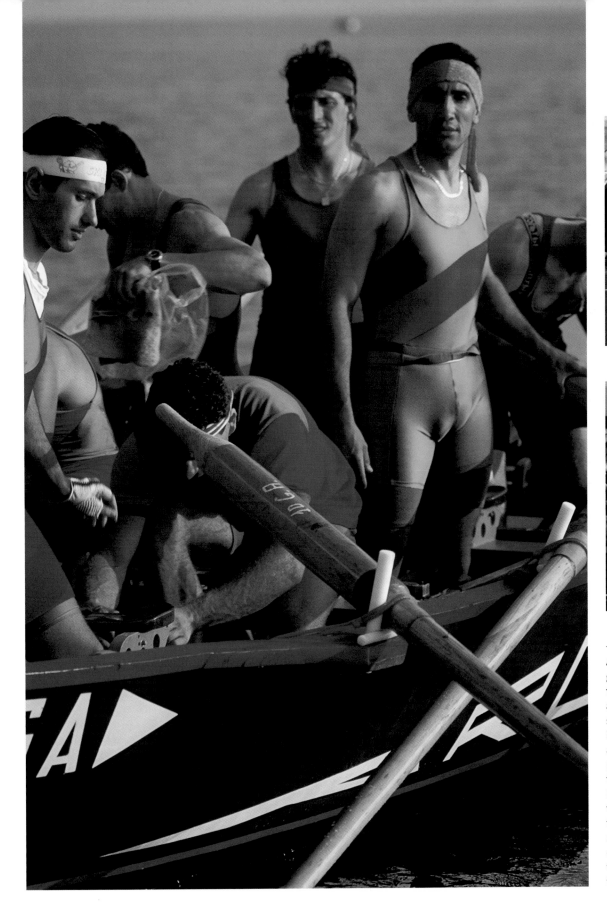

◄▲ ROWING CREW

A medium telephoto view of a group of Italian rowers preparing to take part in a regatta. Color and machismo dominate the scene, and the longer focal length is good for compressing and concentrating on these. The problem again is structural, and for a while nothing presented itself as a real shot (top). As the men prepared, however, the crossed oars hanging loose showed potential for bringing order (above) and by moving to the right this helped finally to pull the final image (left) together.

HUNTING

Fundamental to mainstream photography is the process of finding situations which can be resolved into meaningful images. Some images, in controlled situations, can of course be constructed, first in the imagination, then by assembling, removing, and making other physical changes. But when the situation is outside the photographer's control—as with street life in a city—images are potential, unknown, waiting to be put together by that special interaction between observer and reality that makes photography unique in the visual arts.

Essential to an understanding of this process is the psychology of perception itself, and while there are different theories even today, the dominant ones derive largely from Hermann von Helmholtz (1821-1894). As explained by R. L. Gregory, they hold that the brain actively seeks to interpret the sensory input from the eye, and throws up hypotheses as to what is being represented. Now, photography takes perception a large step further—to the creation of a permanent image. The photographer not only has to perceive accurately, but to try and make the perceptions "fit" a coherent image that he or she knows (or believes) will work.

As a photographer, you are essentially "hunting" for a photograph that meets your own creative needs yet is drawn from a fluid, evolving set of events. This is the essence of reportage, or photojournalism, and I want to begin with this, the most elusive and difficult area of photography, because to my mind it is one of the purest and most basic forms. Within much of professional photography it is highly admired precisely because it is so difficult to perform well. Some would argue that it is the ultimate in creative, expressive photography because it is a wonderful combination of the actuality of the world and the photographer's eye.

There is frequently nothing to begin with as a likely image. This is not Monument Valley from a known vantage point, more likely a messy set of streets in a city somewhere. There is no guarantee that anything will come of the time you spend walking around—but anything that does will be entirely due to your own choosing. A great deal of self-determination is involved, because not only is this a "hunt", but it is one in which the prey—the final image—is determined only by you. It, the subject of the successful image, does not know that it is photogenic.

This unplanned, reactive shooting of situations involving people's normal lives—this street photography, if you like—completely engages the photographer with the uncertainties and surprises of everyday life. This is the basis on which you can claim the purity of this form of photography, although this is clearly a sweeping and challenging statement. The way the argument runs is that the essence of photography is its direct optical relationship with the real world. However the camera is used, it takes from what is actually happening in front of it. There is no replay, no going back, and with any normal shutter speed, what is captured is from a moment in time and a single place. As Cartier-Bresson wrote, "...for photographers, what has gone has gone forever. From that stem the anxieties and strengths of our profession." Given this, the crux comes when the photographer has to react to whatever happens with no possibility of improving the odds by directing events or setting things up. It is in this sense that street photography has a purity.

Those few reportage photographers who have articulated their working method tend to use real hunting analogies. Here is Cartier-Bresson again, the master of this genre: "I prowled the streets all day, feeling very strung-up and ready to pounce, determined to "trap" life—to preserve life in the act of living. Above all, I craved to seize, in the confines of one single photograph, the whole essence of some situation that was in the process of unrolling itself before my eyes." And Joel Meyerowitz, who began as a street photographer in New York: "It's all out there. Every day I would look out of my office at the action on the street, some thirty stories below, and I would wish I were out there. So, when I got my first camera, it seemed natural to go straight to the street. That was the stream. That's where the fish were."

Not surprisingly, there is a physical accompaniment to this. Reportage photography is a very physical activity, and the process of hunting for images often involves a kind of "dance." Meyerowitz watched both Cartier-Bresson and Robert Frank at work on different occasions. About the former he wrote, "It was astonishing. We stood back a few paces, and we watched him. He was a thrilling, balletic figure, moving in and out of the crowd, thrusting himself forward, pulling back, turning away. He was so full of a kind of a mime quality. We learned instantaneously that it's possible to efface yourself in the crowd, that you could turn over your shoulder like a bullfighter doing a *paso doble*." And about Frank: " I think what moved me more than anything else was the fact that he was in motion while he was making still photographs. It seemed to me some kind of irony that you could flow and dance and keep alive, and at the same time chip things away and just cut them off. I liked the physicality of that." Robert Doisneau even made apologies for it: "I'm a little ashamed of my illogical steps, my gesticulations. I take three steps to this side, four to that side, I come back, I leave again, I think, I come back, then all of a sudden I get the hell out of the place, then I come back."

➤**MODEL FOR THE PROCESS OF "HUNTING" FOR A PHOTOGRAPH**
Based on R. L. Gregory's scheme for perception, in which conceptual and perceptual knowledge work actively at solving the problem of what the visual signals received by the eye represent. Perception is a constantly changing hypothesis as the mind tries to organize the signals into meaning. It is the result of top-down interpolation on bottom-up signal processing, with certain rules to organize acting from the side. In this model, the resulting photographic image can be thought of as "creative perception"—in other words, perception with an photographic end result.

REPERTOIRE

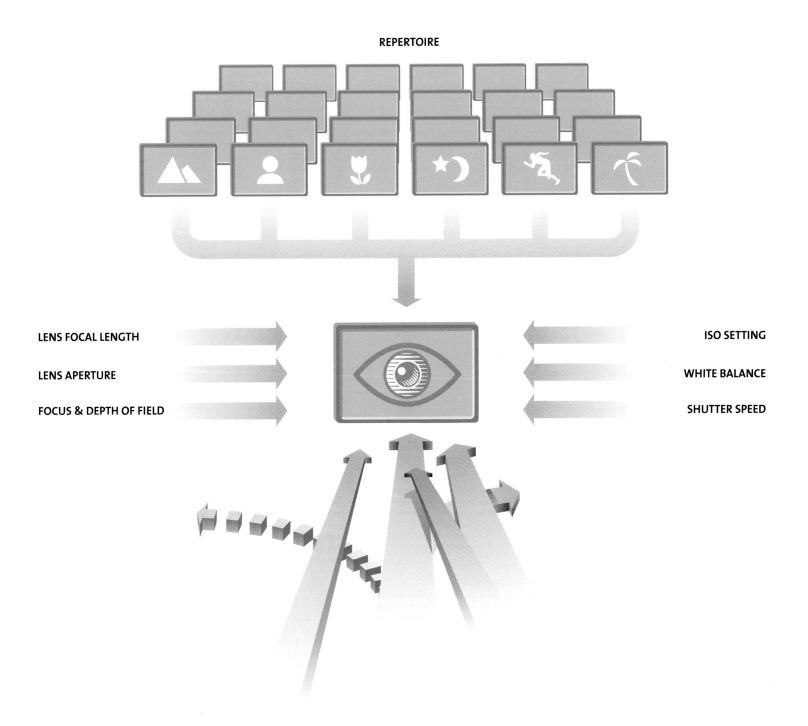

LENS FOCAL LENGTH

LENS APERTURE

FOCUS & DEPTH OF FIELD

ISO SETTING

WHITE BALANCE

SHUTTER SPEED

SCENE OPPORTUNITIES PRESENTING THEMSELVES

➤ MOSQUE

The subject here is the Sudanese religious and political leader Sadiq al-Mahdi, and the occasion his attendance at a mosque for Friday prayers. At this point, Sadiq is leaving the mosque, surrounded by supporters—an opportunity, if all works well, to catch gestures and expressions that may show the respect in which he is held. In the first shot (1), he is preceded by others, and this is a kind of ranging shot to prepare. I readjust my position closer to the exit (off-camera right), which I hope may give me a few seconds more for shooting. Exactly one minute goes by before the second shot (2), in this new position, again with other personalities. I zoom in very slightly from 17mm to 20mm to crop tightly just above the heads. I note the silhouette of the supporter at far right against the open door — this makes a useful compositional stop on the right side of the frame. Now I'm ready.

Rather less than a minute goes by before Sadiq emerges and I start shooting (3), concerned most of all that I get a clear shot of his face, not obstructed (as is very likely) by anyone approaching him from the left, across my field of view. I open back up to 17mm for safety of coverage. The fourth shot (4) is one second after this, me panning to the right—not so good, as Sadiq has his hand raised for a handshake, covering his face, and the foreground figure at left looks somehow disconnected from the event. The last shot (5) is more than lucky—one second later, I'm continuing to pan, stopping at the silhouetted man on the right side (I'm expecting this) and by good fortune all the figures are in place. The man on the right has his hands raised in a praying position, the one behind has his hand to his heart, and on the left is Sadiq's son, anchoring the left of the frame.

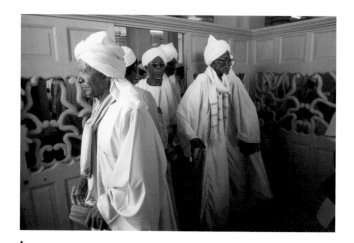

1

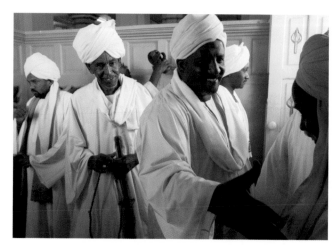

2

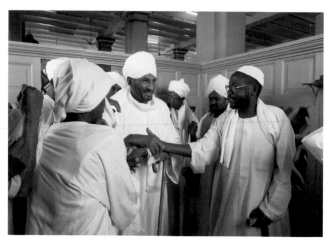

3

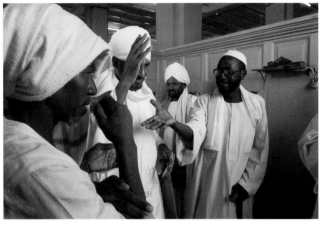

4

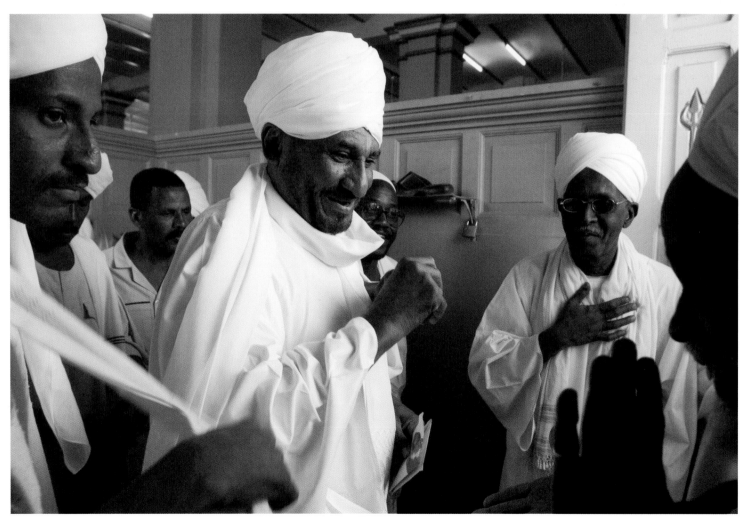

5

CASE STUDY: JAPANESE MONK

This particular example is useful because it is relatively straightforward, focusing on one isolated subject, and with a successful outcome. Obviously shooting began only once the viewpoint had been found, but there were no on-the-spot deletions (which I sometimes do to avoid clogging up the memory card with useless images), so a reasonable record remains and the EXIF data gives the precise timing and changes to settings. The subject was a Japanese mendicant monk collecting at the entrance to a busy Tokyo station, spotted as I was leaving it. My interest was piqued because I once worked on a film, *Baraka*, that featured a similar monk, but I had never seen one in real life before. The interest was clearly going to be in the area of juxtaposing old and new, as such monks are now a rarity in modern Japan and represent cultural values at odds with those of Tokyo metropolitan street life. The initial rapid reaction and assessment went something like this, although not in sequence:

- Rare, exotic species in contrasting environment
- Need to find camera position that delivers a clear image because the dress and general appearance is unfamiliar; must avoid any confusion. Maybe a profile will do this best.
- Will he move soon? How long do I have to get in position with the right focal length?
- Outline will be key, perhaps almost a silhouette; backlit advertising panels may do this.
- Two arguments for a longer focal length: if juxtaposition is the way to go, longer focal lengths usually work better than short, and as I may have to wait in order to get a juxtaposition, shooting from a distance will be more polite than from close.
- The advertising displays may be sufficient for the juxtaposition of Zen tradition and modern consumerism, but I may get luckier and find a passerby who makes a stronger contrast.
- Auto white balance will be OK (since I'm shooting

in Raw, it can be altered later with ease).
- The lens will need to be changed quickly (currently a wide-angle zoom is fitted), making sure vibration reduction is ON.
- No need to dial up the ISO from 100, as the light leve allows 1/160 sec to 1/00 sec shutter speed at f5.6.

All of these thoughts occur on top of each other, and within a few seconds I've already begun to take the first important steps of moving to a position for a clea view from one side, then change the lens and check the settings. This is a busy concourse, so there will be frequent obstructions from passersby, but I can cope with that. The next question is framing. The feet seem important, suggesting a full-figure shot, but that migh make the composition more untidy by including the ground. I need to fine-tune my position to juxtapose the head of the monk with the display panel behind; this takes a few seconds. Start shooting.

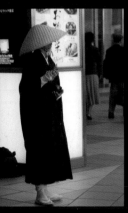

00:00

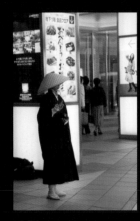

00:27

00 min 00 sec – 00 min 27
Start with frame-filling vertical, using 24-120 mm zoom lens at 100 mm. Try pulling back to 75 mm.

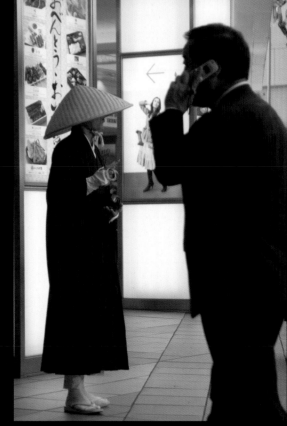

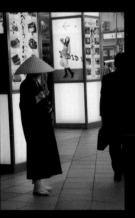

00:38

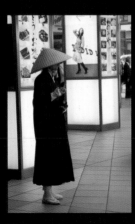

00:41

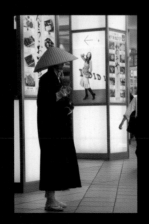

00:52

00:57

00 min 38 sec – 00 min 41 sec
See fashion advertizing on panel to right; might make more telling juxtaposition. Step to left and slightly forward, and reframe.

00 min 52 sec – 00 min 57 sec
A lower position will reduce the ground area appearing in shot; I crouch on my heels. At 57 seconds int the shoot, a man walks quickly into frame from right, holding cellphone and in silhouette. No chance to prepare for this, just shoot and hope the two figures (monk and man) remain separated in the frame.

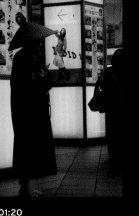 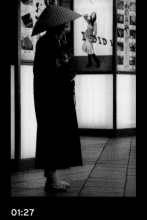 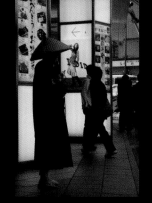 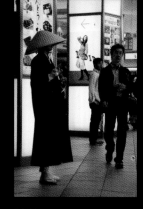 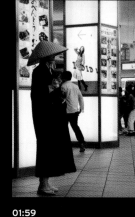

01:20 01:27 01:39 01:54 01:59

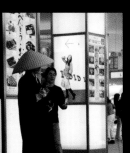 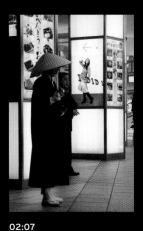 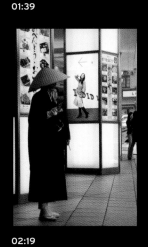 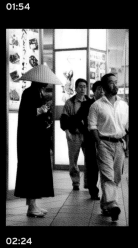 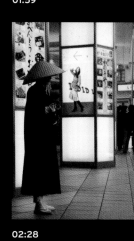

02:03 02:07 02:19 02:24 02:28

01 min 20 sec – 02 min 28 sec

The previous shot makes me think more about the traffic—and mobile phones as the hook for a juxtaposition. People coming toward camera right and in front of monk; I can get a second or two's warning for each person, and maybe I will get someone interesting, whatever that means. People from left and right across the foreground much more unpredictable, and make silhouettes, as I just discovered. Definitely don't want anyone looking at me, but there's nothing I can do about this, given the position I've chosen; fortunately, Japanese in public places tend not to make eye contact. But in the event, nothing much of interest passes through the area of the frame at right, in front of the monk, that I've left waiting for this. No exotic-

looking people. At 2 minutes 24 seconds into shooting I get three figures in a line walking in a determined kind of way straight past the monk, ignoring him (as does everyone else). This might work, but a small uncertainty remains about whether one man looked straight to camera. No chance to check this immediately. I have another appointment, and start to think that I'll have to go with what I already have. Ansel Adams wrote, "… I have always been mindful of Edward Weston's remark, 'If I wait for something here I may lose something better over there.'" So, one more "clean" shot, then check the previous one at magnification to see if the man made eye contact with me. Fortunately not. When I look up, the monk has gone.

The result is that I have a choice of three shots: one "clean" without passersby, one with the silhouetted man talking on a cellphone, and the third of the three men walking in line. Over the next few weeks I come to prefer the one with the silhouetted man. So does the art director on my next book, but to my initial dismay she argues that she has to crop the shot severely in order to make it fit the page. This is always the next area for discussion and argument in photography that is taken for print publishing—book and magazine layouts have their own graphic dynamics. Pity that the feet got lost, but the main point of the image still gets across. In the final analysis, therefore, I had the shot that we ultimately chose quite quickly and only partly planned. The rest of the time was spent working towards an improvement which did not happen. This is perfectly usual.

REPERTOIRE

The model for searching for an image, described on the previous pages, has real practical importance in that the "repertoire" can be analyzed. Even if the visual processes involved in shooting are too rapid to be deliberated at the time, what you can do when not shooting is to review this mental library.

My argument, based on the "active" theories of perceptual psychology, conversations with other photographers, and analyzing my own experiences, is that most photographers bring to a shooting situation a mental set of image types that they like. The illustrations here are an attempt to show a partial example of this, although I'm fully aware of the dangers of being too specific. The repertoire does not actually present itself (at least, not to me) as a stack of images, but more as a set of compositional possibilities—templates or schemas, if you like. In all probability, this is not one hundred percent conscious, and so these illustrations are too exact and specific. Nevertheless, with this in mind, they show the principle of bringing possibilities to the situation—basically, to see what fits.

Needless to say, these are drawn from my own repertoire, and happened to be the first two dozen that I could think of in the abstract. The schemas are a kind of shorthand, and the accompanying photographs are examples from actual shoots. As you can see, images like that of the two Burmese monks on page 180 fit two possibilities at least. Most images, I suspect, fit a number of possibilities, and you can make an exercise of this by playing a kind of domino game—one schema fits one image, which in turn suggests another schema, and so on.

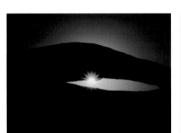

EDGE-CUT SUN

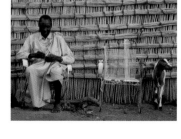
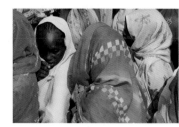

FIGURE AND BACKGROUND

BIG SKY

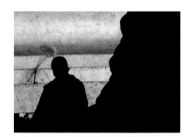

SEPARATE SHAPES

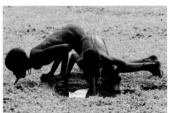

FRAME FIT

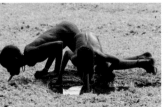

OFF-CENTER

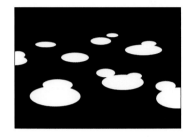
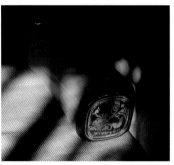

CHIAROSCURO

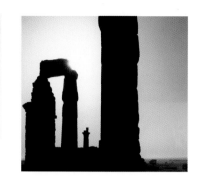

DELAY

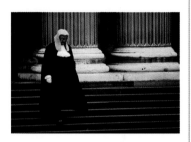

WALKING INTO

REFLECTION

FIGURE IN A LANDSCAPE

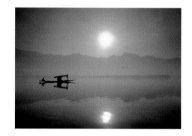
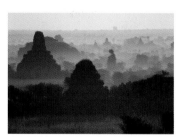

STACKED PLANES

SHADOWSCAPE

REACTION

The repertoire of "images that are known to work" is the key to a high success rate when shooting quickly, but bringing it into play calls on a number of techniques that range from the practical to the observational. I even hesitate to call them techniques, because the word suggests a well-defined procedure, yet some of them are elusive. Here we are looking at tactics for rapid-reaction, unpredictable situations—how to prepare and how to exploit chance. Back again to Cartier-Bresson: "Photography is not like painting," he said in 1957. "There is a creative fraction of a second when you are taking a picture. Your eye must see a composition or an expression that life itself offers you, and you must know with intuition when to click the camera." He added that once missed, the opportunity was gone forever, a salutary reminder.

I can think of four different areas of preparation: camera handling, observation, familiarity with compositional techniques, and state of mind. Probably the most straightforward part of the preparation is in dexterity at handling the camera so that it becomes, as more than one photographer has described it, an extension of the body, like any familiar tool. In the model for hunting for images on page 157, this means practice at the "sideways" input so that the controls can be applied faster and faster. The second type of preparation is in developing more acute observation of people and events— "situational awareness" (originally an aviation term) in other words—by constant attention and alertness. This can be practiced all the time, without a camera. The third, compositional skills, means trying out all the options described in the bulk of this book and deciding which suit you best. Finally, state of mind, probably the most difficult and elusive of the four, is highly personal, and requires finding ways of helping yourself to be alert and connected for a shoot.

There are more esoteric methods of preparation, and one that perhaps deserves attention is Zen. Cartier-Bresson professed a Buddhist influence on his way of working: "In whatever one does, there must be a relationship between the eye and the heart. One must come to one's subject in a pure spirit." He also emphasized the goal, when photographing people, of revealing their inner look. In particular, he referred to the short but highly influential work *Zen in the Art of Archery*, written by Eugen Herrigel. The author, a German, describes how he sought a closer understanding of Zen by studying archery under a Master, Awa Kenzo. The argument was that archery, with its intense focus of skill and concentration on a single instant of release in order to achieve a precise hit, could promote spiritual focus and "the ability to see true nature." The parallels between archery and fast-reaction photography are clear enough, both in what is trying to be achieved and in the concentration of focus. Zen training teaches a way through that leaps over the obstacles of deliberation and conceptualization.

That said, a true practitioner of Zen would see it as an abuse and extremely trivial to use Zen in order to improve photography. Nevertheless, a significant number of photographers have expressed an almost spiritual communion between their consciousness and the reality around them while shooting, and this surely is not far from the spirit of Zen. Robert Frank spoke of identifying with the subject: "I watch a man whose face and manner of walking interest me. I am him. I wonder what's going to happen." For Ray Metzker, "As one is making images, there's this flow."

Daisetz Suzuki, a famous Zen scholar of the twentieth century who provided the introduction to Herrigel's book, wrote, "If one really wishes to be master of an art, technical knowledge of it is not enough. One has to transcend technique so that the art becomes an 'artless art' growing out of the Unconscious." When we consider the role of instinct and intuition in finding and framing a shot, this rings true in photography. One of the goals of Zen is to expect the unexpected and adapt oneself to it, and this certainly has relevance to photography.

An important concept here is a "letting go," an emptying of the mind that *follows* acquiring and honing the skills. From archery, a key text in an old archery manual, *Yoshida Toyokazu tosho*, lists the techniques and then says that they are not needed, but continues: "Not being needed does not mean that they are unnecessary from the beginning. At the beginning when one knows nothing, if the beginner does not first completely learn..." and so on. Herrigel, toward the end of his book, concludes that the student must develop "a new sense, or, more accurately, a new alertness of all his senses," which will allow him to react without thinking. "He no longer needs to watch with undivided attention ... Rather, he sees and feels what is going to happen ... This, then, is what counts: a lightning reaction which has no further need of conscious observation." All this has direct application to reactive photography, and in particular can be a solution to a fairly common problem—that of missing shots by trying to think at the time of all the compositional and technical issues.

The training involves two kinds of practice. The first is at learning and using the techniques, including all those in Chapters 1 through 5. The second is practice at maintaining a direct connection with the situation and subject, while clearing the mind of the much slower deliberations such as, "Where should I place this in the frame?" or "How closely should I align this edge to the side of the frame?" In summary, the procedure is "learn, empty, react," or at least "learn, put aside, react." In *Zen in the Art of Archery*, the Master exclaims, "Don't think of what you have to do, don't consider how to carry it out!" Herrigel learned, having acquired the technical skills through endless repetition, to detach himself, and wrote: "Before [the task] the artist summons forth this presence of mind and makes sure of it through practice."

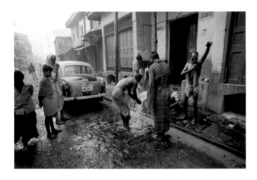

ᴧ CALCUTTA STREET

For street photography, India is notable not only for the wealth of events and animation, but for the extreme alertness of people in the streets. If the aim is to shoot without having anyone in frame looking at the camera, almost the only way is to frame the shot in the mind's eye and then raise the camera and shoot all in one motion.

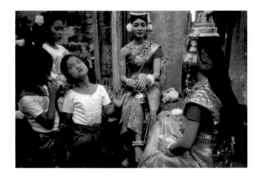

ᴧ KHMER DANCERS

A troupe of classical Khmer dancers were preparing themselves for a performance in an Angkor temple. The situation allowed time to explore with the camera, and because the usual make-up and dressing was fairly predictable, I was looking exactly for odd and clearly unposed moments like this.

➤ GIRL WITH BROOMS

The timeframe available for making this shot, of a Thai woman carrying traditional brooms, was so short that I had little idea if it would be well framed. While I was concentrating on something else, I saw her moving quickly behind me out of the corner of my eye, and had time only to swing right round and shoot without thinking.

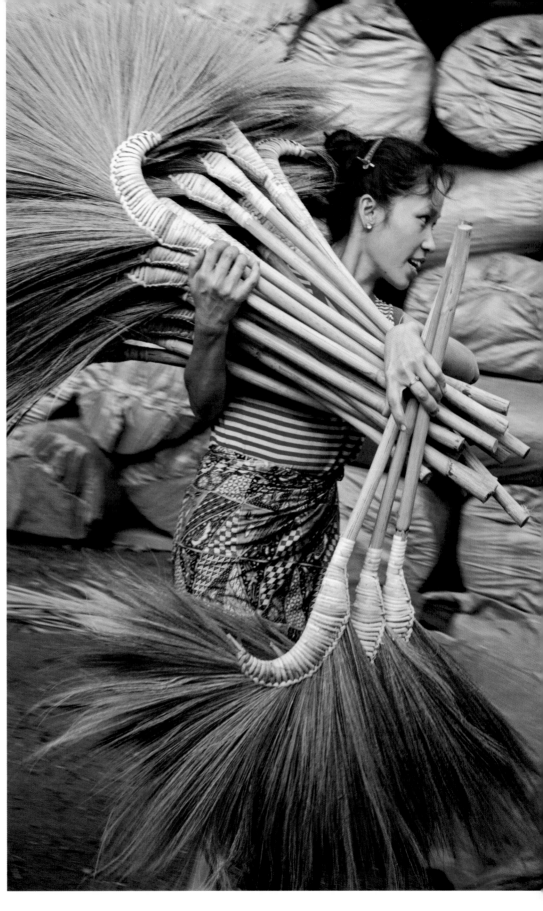

ANTICIPATION

The less control you have over a shooting situation, the more valuable it is to have an idea of what may happen next. Though largely irrelevant in studio work and other kinds of constructed photography, it is hugely important in reportage. Anticipation is a skill that goes much deeper than photography, and draws mainly on observation and a knowledge of behavior. Using it for photography gives it a particular edge, because the aim is not just to work out how a situation might unfold and how a person may react, but how the results will work graphically. The example opposite, from a cattle camp in southern Sudan, shows this combination. The aim is always to translate the event into an organized image. As Henri Cartier-Bresson put it, "To take photographs means to recognize—simultaneously and within a fraction of a second—both the fact itself and the rigorous organization of visually perceived forms that give it meaning."

Therefore, there are two strands to anticipation. One is concerned with behavior and action, and also the way in which things move across the field of view and the light changes. This can be honed by staying focused and attentive, and by practice. The other strand is graphic, predicting how shapes, lines, and all the other elements that we saw in Chapters 3 through 5 will shift and come together in the frame, and the way to improve this is to keep in mind as many types of successful image composition as possible—the repertoire on pages 162-163, in other words.

On the behavioral front, the number of situations is infinite, but there are some identifiable types. There is a general situation in one location, of the kind described particularly well by the French reportage photographer Robert Doisneau: "Often, you find a scene, a scene that is already evoking something—either stupidity, or pretentiousness, or, perhaps, charm. So you have a little theatre. Well, all you have to do is wait there in front of this little theatre for the actors to present themselves. I often operate in this way. Here I have my setting and I wait. What I'm waiting for, I don't know exactly. I can stay half a day in the same place." There is a specific type in which the shot as framed is good provided that some element, such as a person, moves into a particular position. Another type is focused on a subject that you have already identified but which is not yet graphically a picture—imagine that, in wildlife photography, you have found the animal but the shot depends on it moving into a particular view. When photographing people, expression and gesture form yet another class.

➤ CATTLE CAMP

This example involved seeing a potential subject, knowing what was going on, and spotting a possible juxtaposition—with just enough time to move into position and shoot. This was a Mandari cattle camp, where young men and boys live with the cattle for part of the year, at a distance from the village. Cattle play an important social and cultural role, as well as an economic one, in this ethnic group in southern Sudan. The animals have names, and a fine pair of horns is particularly prized. The location was ripe with image possibilities and I already had a number of successful shots.

◄ THE PASSERBY

A common class of situation in photography, particularly street photography, is when you can see a potential picture that has a strong setting, but which will be lifted a notch higher by a person, or people, walking into the frame. This view of a traditional narrowboat moored on a canal in the heart of Birmingham, England, had most of the elements needed, and the footbridge above added interest. Visually, however, the weight of the boat needed ideally to be balanced by a group of people above. How long you are prepared to wait for passersby in the hope that you will get just the right ones is another matter.

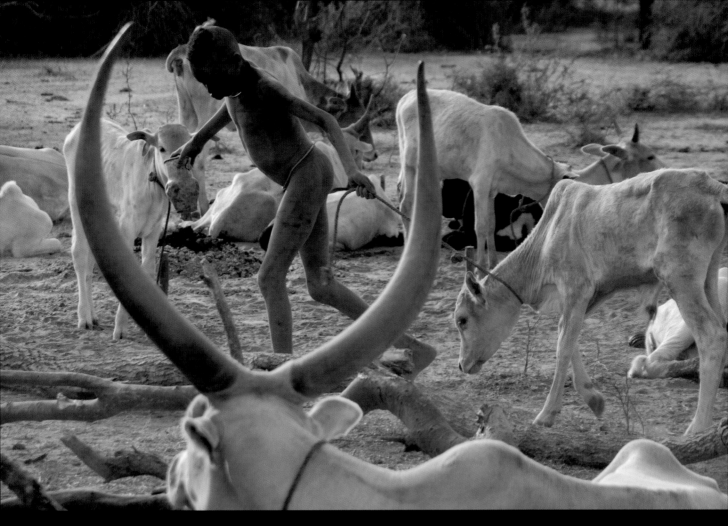

1. I spotted the boy pulling the calf along–a potential picture, depending on what he was going to do and where he would pass.

2. Looking ahead of him, to the left, I guessed that he was taking the calf to the mother for suckling, but as my eye travelled to this cow, I saw that there was a very good pair of horns on the way. Would the boy pass in such a way that I could frame him? If so, the shot would have the added value of making a point about the importance of cattle.

3. I quickly realized two things. One was that I needed to step forward and to the right to get the horns large in the frame (and adjust the zoom focal length to suit). The other was that the bull with the horns might turn his head to the right as the boy passed. I moved into position, and fortunately the bull did move its head.

EXPLORATION

Exploration becomes possible when we expand the timescale a notch up from a pure reaction situation. While you could justifiably argue that reactive photography is a kind of fast exploration, when there is more time, as in these examples, more coherent thought is possible.

There are different types of exploration. One is when the subject is a clearly defined physical object and there is time enough to move around it, or move it around, looking for different angles, lighting, and so on. This commonly happens in still-life photography, but also, as in the example opposite, with any kind of discrete physical object such as a building, or a person. Another is when the general subject is a place and the photographer travels around it, and the area can range greatly in size—from, say, a garden to a national park. A third is when a localized situation occurs over a period of time—a prolonged event, in other words—and this could be, for example, a football game, a street demonstration, or a ceremony of some kind. We could categorize these if we wished, into physical, spatial, and temporal, although there is plenty of opportunity for overlap; in the case of the windmill, partly physical, partly spatial.

The means for exploring range even more widely, and potentially draw on all the compositional methods that we have already examined. The viewfinder, or in the case of many digital cameras, the LCD screen, is the primary tool, and one of the most common, and useful, ways of exploring with a camera is to move around while looking through the viewfinder to see the continual changes of framing and geometry—active framing, in other words. With a static subject (rather than an event), the basic way of exploring is spatial. Changing the viewpoint is the one action that alters the real perspective in a photograph. That is, it alters the actual relationship between the different parts of a scene. Its effectiveness, therefore, depends on how much of the scene you can see as you move, and this naturally favors wide-angle lenses —and only a small change of viewpoint is needed

with a wide-angle lens for a substantial change to the image. The juxtaposition effects that make telephotos so valuable are controlled by viewpoint, but with a long lens you need to move farther to see the relationship change. Zoom lenses offer an extra permutation, to the extent that moving around a scene while also altering the focal length of the zoom can often be too complicated—that is, offers too many levels of change to deal with comfortably.

With a single object, viewpoint determines its shape and its appearance. Moving closer alters the proportions of its different parts, as the sequence of the windmill demonstrates. Its circular base is hardly noticeable in the distant pictures, but in the closest shot it makes up a good third of the building and is an important contrasting shape to the diagonal sails. Moving around a subject gives even greater variety: the front, sides, back, and top.

The viewpoint controls the relationship between an object and background, or two or more objects, in two ways: position and size. Simply the action of bringing two things together in one frame suggests that there is a relationship between them; this is a major design tool. Relationships depend on who chooses to see them, and what one photographer may see as significant, another may ignore or not even notice. The sequence of the Acropolis on pages 170-171 is a case in point. Isolating it with a telephoto lens at sunrise places it deliberately out of context; all relationships have been deliberately avoided to give a timeless a view as possible: the historical version. The last view, by contrast, makes a point of juxtaposition; a decidedly unromantic relationship between the Acropolis and a modern city.

Even when a photographer feels disinclined to make more effort, there is often a sense of duty to cover all the bases. Cartier-Bresson wrote that even when the photographer has the feeling that he or she has caught the strongest shot, "nevertheless, you find yourself compulsively shooting, because you cannot be sure in advance

exactly how the situation, the scene, is going to unfold." On top of that, of course, you cannot afford to leave any gaps because the situation will never be repeated.

Ultimately, exploration has to be limited, which means that the photographer has to choose when to stop. This is by no means always an easy conclusion, as it not only involves deciding when you have exhausted the possibilities (like many activities, photography can be subject to the law of diminishing returns, with fewer and fewer benefits from more and more time spent), but also whether time will be better spent moving on and finding another subject.

CHANGING VIEWPOINT WITH
A WIDE-ANGLE LENS

The example here is a windmill in a rural setting, and the lens 20mm efl, one of the shortest focal lengths, with a pronounced wide-angle effect.

1. We begin with a medium-distance view, from a little less than 300 feet (90 meters) away. The whiteness of the windmill is particularly striking, and in an attempt to keep the graphic elements simple, this first shot is framed to exclude the surroundings, to make a high-contrast, blue-and-white image. The sky is a particularly deep blue, which should, and does, make a powerful contrast with the windmill. It also seems possible to make something out of the whiteness that is shared by the clouds and the windmill. In the event, the picture is only a partial success. They symmetry of the windmill encouraged a central placement in the frame, but it does not balance the two areas of cloud as well as it might. Also, placing the windmill low in the frame, to avoid seeing the surroundings, gives too much sky.

2. The second shot has more normal proportions and more careful organization. The intention is the same as in the first photograph, but works better. The viewpoint is closer, so that the windmill fills more of the frame and is off-centered to give a better balance, and has been moved to the right, so that the windmill just occupies the space between the clouds.

3. The potential of a symmetrical image remains. To make the most of this, the viewpoint is changed so that it is exactly facing the front of the windmill. Moving closer to remove the clouds from view reveals an interesting distortion of the base; its curve makes a pleasant contrast of shape with the triangular structures above, and still contributes to the symmetry.

4. From this, the camera position is changed radically, to as distant a view as possible, while maintaining the windmill as the focus of attention. This is the classic depth-enhancing use of a wide-angle lens, showing as much of the foreground as the depth of field allows. To this end, the camera position is low, and the windmill placed high towards one corner.

5. In the same position as the previous shot, the camera is tilted so that the horizon is much lower in the frame, revealing the sky and tree cover.

6. The last photograph in the sequence is basically the same type of shot, but with an improvement in the location. A new viewpoint has been chosen which shows more distinctive detail in the foreground, to make this part of the picture more prominent.

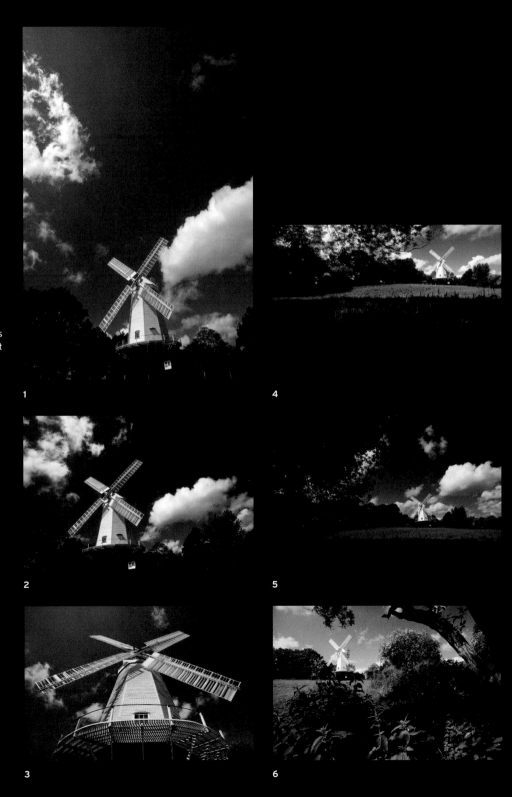

1

2

3

4

5

6

VARYING VIEWPOINT AND LENS

In this example, over the course of several days, the Acropolis in Athens, and specifically the Parthenon, the central building, was photographed from every useful viewpoint, and the lens focal length chosen to suit each view. In order to be able to make full use of the extremes of focal length, it is important to find a subject that is visible from a distance.

1. The first shot is with a wide-angle lens (20mm efl) from close, and makes a deliberately pronounced graphic arrangement—triangular, using the typical exaggeration of converging verticals from a wide-angle lens.

2. The second photograph is from the ideal middle-distance camera position—a helicopter, flying in the early morning. This, naturally, took a great deal of trouble to arrange, and this shot is just one of many from different heights and angles.

3. Then, from a distance. Whereas the close view experimented with shape and line, and the medium view is more documentary, the third photograph deliberately sets out to give a romantic, atmospheric impression of the Acropolis, isolated from its modern surroundings. To this end, a telephoto lens gives a selective view, and the dawn lighting conceals unnecessary modern details in a silhouette. With a longer focal length from the same viewpoint, the graphic possibilities are explored: these are chiefly blocks of tones and horizontal and vertical lines.

4. From exactly the same position during the afternoon, a different approach was tried, using a wide-angle lens to set the Acropolis in the context of the surrounding landscape, with plenty of sky. Although it appears tiny in the frame, the brilliant white of the stone helped it to stand out. With this treatment, making use of the foreground, even the city is diminished in relationship to the overall setting.

5. Finally, to make a distinct contrast with modern Athens, a viewpoint was chosen to show the very ordinary, drab streets that surround the Acropolis, and the composition gives them prominence. A standard lens was used to give the feeling that this is a normal view, such as a passerby might glimpse while walking along.

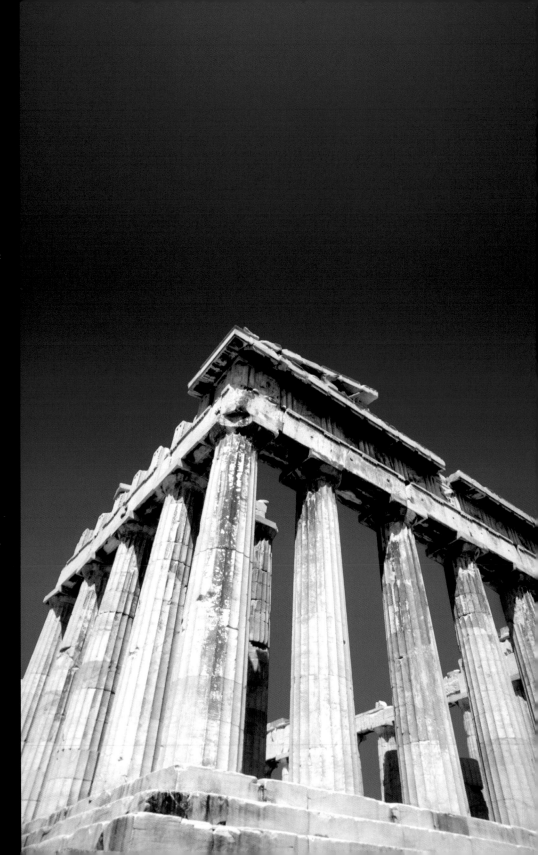

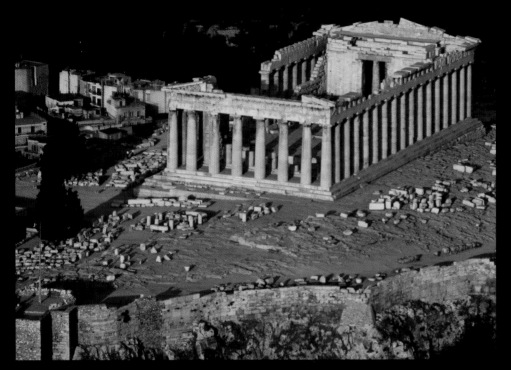

2

3

4

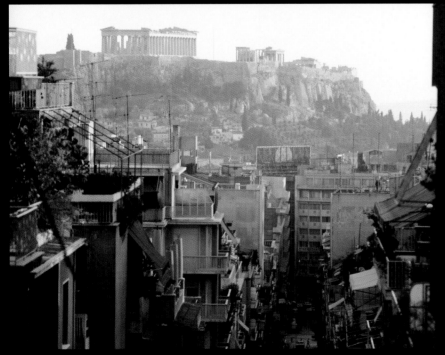

5

RETURN

Another kind of exploration is over an extended period of time. Ansel Adams wrote, in relation to his chosen field, landscapes, "Repeated returns may be more rewarding than prolonged waiting for something to happen at a given spot." This clearly makes more sense in the photography of place than most other subjects, but it brings with it a new set of issues and expectations. With a landscape, what the photographer expects to have changed is the lighting in the short term, and perhaps seasonal variations over a few months. But the unexpected becomes more likely as time goes by and as more of the hand of man is evident. The exploration of one subject over a period of time takes on a very different form from the single-session exploration that we began with. In addition to unpredictable changes that might include demolition and new construction in the manmade landscape, we should also factor in our own changing attitudes. What appeals to a photographer at one point in time might at a later date seem boring.

There is considerable risk in actually relying on a return to deliver an improvement, not least because the combination of things that first attracted a photographer's attention with the possibility of making an image can be quite a subtle mix, and may simply not be there at another time. This is especially true when unpredictable lighting is involved. Actually relying on a return visit to produce results is out of the question, which is why most photographers in these situations quickly learn to shoot what they can at the time. The two examples here illustrate how idiosyncratic any return experience can be.

ANGKOR

My first visit to the Bayon—an important temple of more than 50 face-towers in Angkor, Cambodia—was in August, the rainy season. At no time in the week's shooting was there any interesting light for this kind of overall view, and while close-ups of the face-towers were effective, the temple from this distance tends to appear as a jumble of masonry, and really needs the help of a low sun (1 and 2). The only reason why these first two shots were taken at all was because there was no alternative. I returned four months later to face a different lighting issue. Even in clear weather, the surrounding trees cut off direct sunlight until almost mid-morning from the east, and at least an hour before sunset from the west (3). Unsatisfactory, with a dark mass at the bottom and a boring sky. On another return, some years later, I was finally able to get the help of clouds, and had decided that black and white, with its focus on texture and modeling, was a better idea (4).

1

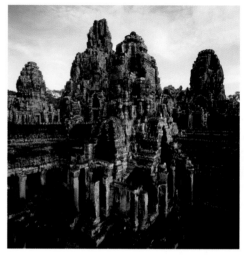

2

3

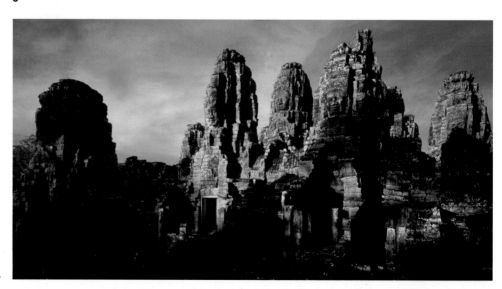

4

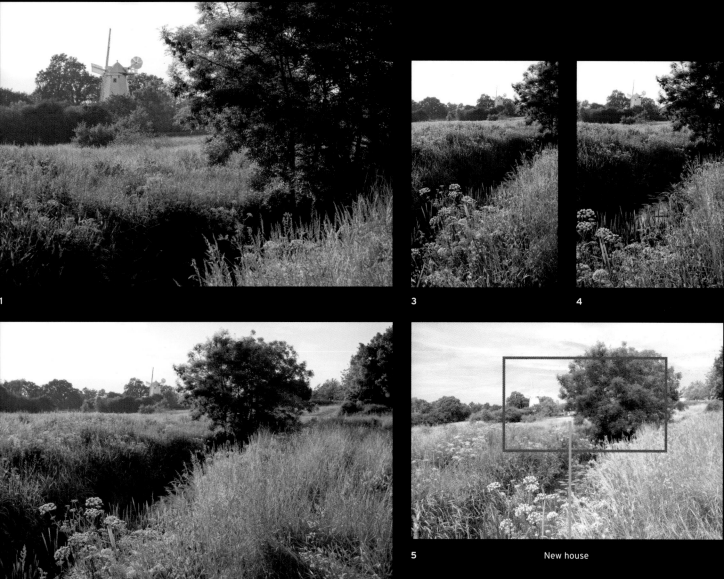

1

3

4

5

New house

2

WINDMILL

Purely for this book, and without any particular
expectations, I returned to the site of the windmill
shown on page 169, 27 years later to the month (June).
In 1979 the weather and lighting had been so specific—
unusually clear, bright and contrasty, with a passage
of fair-weather cumulus—that they had completely
created the opportunity. At the same time of year, the
weather now was more typical of an English summer,
and less special. The softer light and whiter sky, and

the fact that the sails had been turned in another
direction invalidated the same viewpoints, and I made
an extended recce of the area for a different view. The
only possibility was from the area to the east, farther
away, with a stream running through a field. Nearby
turned out to be a chosen spot for local painting
groups. An additional issue was a new house that did
nothing for the scene and yet was highly visible from
this direction. This limited the viewpoints to those from

where it would be concealed by vegetation—notably
a small tree. With this kind of weather, I fell back on
traditional lighting—low sun—and this meant an into-
the-light shot in the evening. The recce was at midday;
I returned at 1900 hours. The back-lighting placed more
of the interest on the texture of the surroundings and
less on the windmill, which suggested a wide-angle shot
that made use of the foreground. The day highlighted
how special had been the original circumstances.

CONSTRUCTION

At the far end of the scale from fast-reaction street photography is the deliberate, time-consuming process of shooting static subjects with the camera on a tripod. Still-life and architecture are the two subject areas that most embody this kind of composition, in which the image is constructed, either through selecting and positioning the subjects themselves (as in still-life) or by carefully exploring the camera viewpoints in relation to lens focal length. Or both.

Having the time and facility to work on image composition like this does not necessarily make it easier than reportage. Rather, the skills are different, and require prolonged attention and a rigorous and thoughtful approach. Stephen Shore, describing his large-format pictures of American urban settings, compared the process with fly-fishing and the unwavering attention needed to feel the end of the line. "Without constant pressure the timing falters, and so does the fly line, leaving the caster with a disconnected, where-did-it-go feeling. Of course, it's very possible to take pictures without constantly paying attention to every decision that needs to be made, but my experience was that when my attention wandered and I started making decisions automatically, there was something missing in the pictures and I was left with that where-did-it-go feeling."

This is an instructive passage because it expresses very accurately the complexity of organizing a detailed image with many interlocking components. To viewers accustomed to more spontaneous kinds of photography, the painstakingly ordered still-life or architectural view may at first appear cold and overcalculated. In actuality, there is a constant stream of intricate and intuitive decisions to be made, most of which spring up during the process with a domino-like effect on other parts of the image. What Shore describes is the need for total concentration, and the need for absolute rigor.

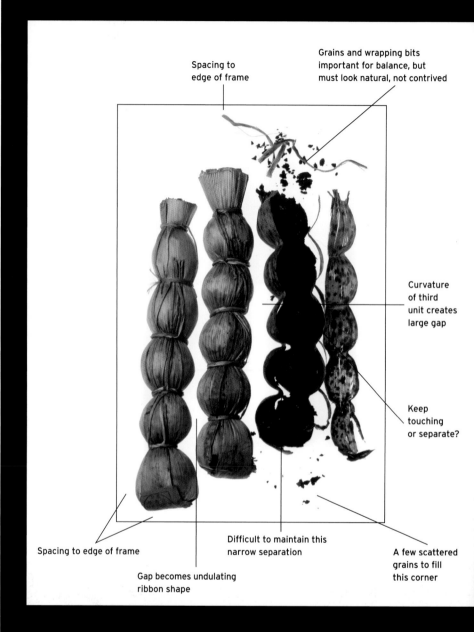

Spacing to edge of frame

Grains and wrapping bits important for balance, but must look natural, not contrived

Curvature of third unit creates large gap

Keep touching or separate?

Spacing to edge of frame

Difficult to maintain this narrow separation

A few scattered grains to fill this corner

Gap becomes undulating ribbon shape

▲ CHINESE TEA

The parameters for this still-life are almost ludicrously simple—an expository shot of traditionally wrapped Chinese tea, bound in dry leaves, on a plain white background with no props. Yet, even with such a minimal intention, many interlocking compositional decisions accumulate, not all of them possible to resolve completely. The main decisions were:

- To have several rather than one, with one opened to show contents.
- The undulating rhythm of bound segments is worth exploiting, but avoiding symmetry.
- There is a need to find an informal arrangement that occupies the frame and has some dynamic interest.
- Opening one reveals even more interesting undulations and repeated wave-like patterns.
- I decided to contrast neatness of wrapped units with crumbling disorder of the open one.

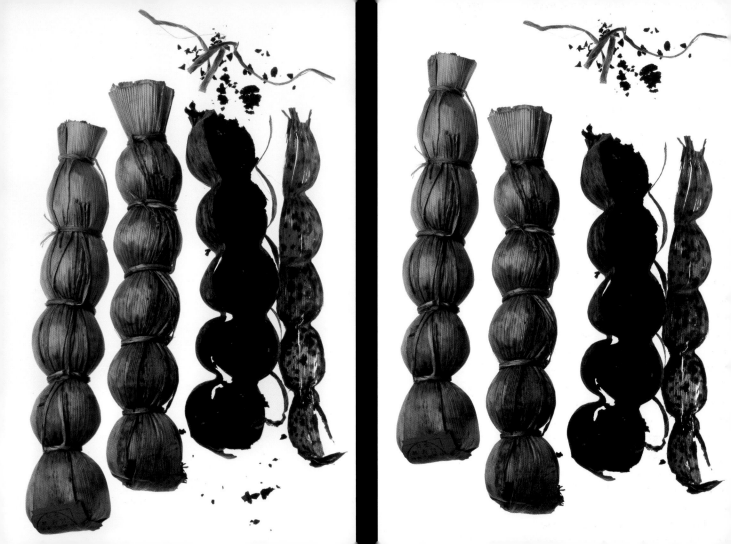

▶ FINE POINTS OF PLACEMENT

As an exercise, it's worth looking at possible variations in positioning of a key element in this still-life, which shows work in progress on an illuminated manuscript. The dried salamander is a specimen being used in an illustration, and the intention was to place it in the upper part of the image. In reality, framing and the arrangement of the different sheets of paper and manuscript would be adjusted at the same time, but these alternatives for the salamander show some of the detailed decisions that need to be made. For example, should the creature and its shadow (the long shadow is integral) fit neatly within a blank area, as in 3, or does this seem annoyingly contrived? Yet the composition is necessarily contrived in any case. Breaking lines, as in 4, might seem more natural, with less artifice. Intent, in other words, plays a role even in the minutiae of refinements in composition.

1

2

3

4

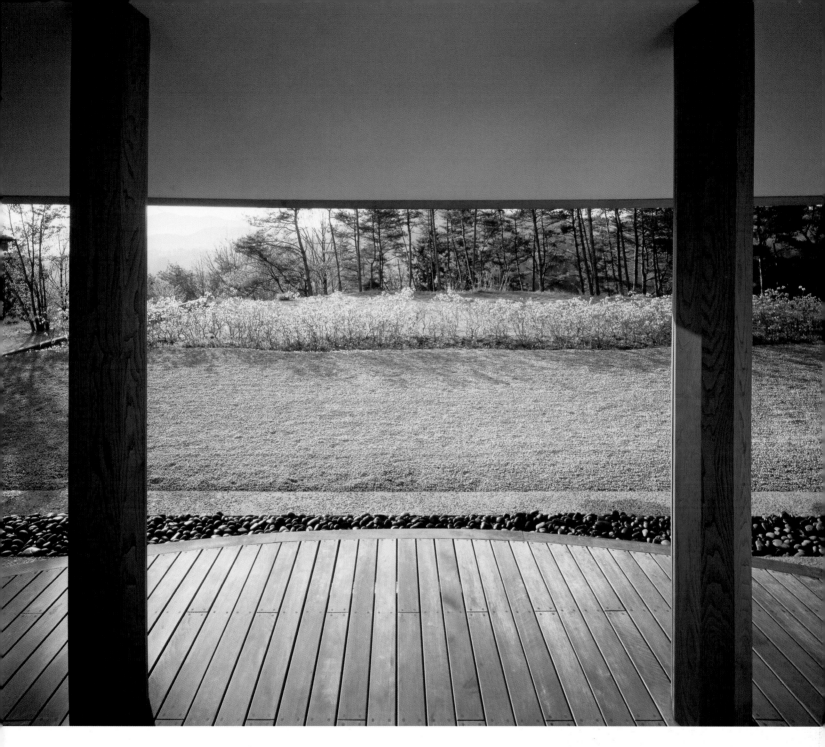

▲ ORGANIZING STRUCTURES ON A LARGE SCALE

Buildings, street scenes, and landscapes often make heavy demands on finding the exact camera position, with several compromises needed and a final position measured in inches. For this photograph of a new Japanese villa in the hills above Hiroshima, with its minimally designed garden, the decision to go for a symmetrical view made the work even harder—precision became integral to the image.

JUXTAPOSITION

Photography relies hugely on the simple compositional device of bringing two or more subjects together in the frame. I say hugely because of our innate tendency to assume a relationship between things seen side by side. At the very least, juxtaposition brings two things to our attention at the same time, and as soon as the viewer starts to wonder why the photographer chose that viewpoint, and if the juxtaposition was intentional, this sets off a train of thought.

There are two sources for juxtaposition, although one inevitably triggers effects on the other, and these are the content and the graphics. Perhaps "motives" might be a better term than "sources," because in the first case the initiative comes from subject, and in the second the inspiration more often comes from chance appearances (as in, for example, the reflection of one thing in a window through which can also be seen a second subject). The two, content and graphics, are never completely separated.

The amount of deliberation can vary enormously, from a planned expedition to find a way of juxtaposing two subjects, to spur-of-the-moment coincidences, and if the final image is the only thing that a viewer sees, in itself it is not at all a reliable indicator. The examples here, described in more detail, cover this range. The reflection shot of the mountains was planned days in advance, while the cellphone advertisement was seen and shot within seconds.

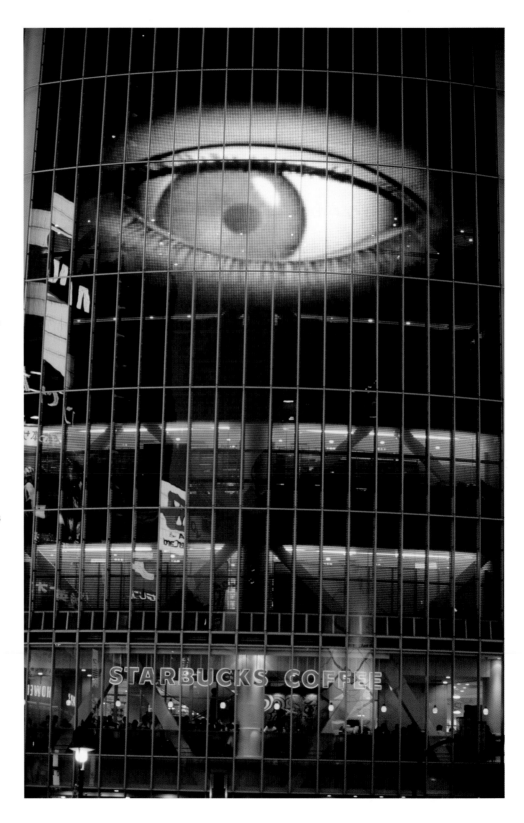

> **SHIBUYA CROSSING**
At Shibuya crossing in central Tokyo, the entire façade of this building is a digital display. At one point in the sequence, a giant eye appears, with the obvious Big Brother inference. Framing the image like this, with the eye at the top and a Starbucks coffee shop below, exploits this possibility.

◄ ALPINE REFLECTION

Content came first in this shot of a snow-covered ridge reflected in the silverwork of a Rolls-Royce. The distinctive emblem is that of a hotel in St Moritz, Badrutts Palace, and the aim was to combine it with the mountains. Simple in concept, this was more difficult in execution, demanding a particular alignment. Several positions for the car were tried around the area before settling on this, and even then the car had to be moved around several times. The exact combination of lens focal length and camera position took time to find, and this needed to be done well in advance of sunset. Minimum aperture ensured maximum depth of field.

▲ CELLPHONE NETWORK ADVERTISEMENT

In northern Sudan, the poster seemed quite out of place for the raggedy street market, though not worth photographing just for this reason. However, the position and lighting of the contrasting second face—that of the merchant—made the shot. It depended on tight cropping to exclude anything else and, of course, on speed. I was highly visible, and within a second or two the man would look directly at me, at which point the shot would lose almost all its value as far as I was concerned.

◄ JIE GIRL

In a Jie village in southeastern Sudan, arms are common because of rivalry with other ethnic groups. As a teenage girl grinds sorghum, a Kalashnikov assault rifle lies casually propped nearby. Juxtaposition here involved simply moving close to the rifle and using a wide-angle lens, adding depth to the content.

PHOTOGRAPHS TOGETHER

Images behave differently in groups, juxtaposed, than when displayed individually. In a sense, a new kind of image is created—one in which the frame is a gallery wall or a two-page spread in a magazine or book, and the few or several images themselves become picture elements. The arrangement can be time-based or spatial, or a mixture of the two, and according to the medium the viewer has more, or less, choice in the order of seeing the photographs. A slideshow is inflexible and highly controlled, while a magazine or book allows the reader to flick backward and forward.

One of the classic uses of photographs in an assembly is the picture story, and some of the best examples come from the heyday of large-format, general-interest illustrated magazines, from the early days of the *Münchner Illustrierte Presse* and *Ilustrated Weekly* in London, to *Life*, *Picture Post* and *Paris-Match*. Well executed, the picture story is a complex entity, involving not just the talents of the photographer, but of the editor, picture editor, and designer. The individual visual unit is the "spread" (a double-page layout), and it is the sequencing of spreads that gives the picture story both its narrative and dynamic flow.

From the point of view of shooting, the knowledge that the end product will be a grouping of images introduces new demands, but perhaps eases the pressure on getting one single all-encompassing shot. Only very occasionally do all the important elements in a complex situation come together in a single composition, and when they do, this is often noteworthy enough for the photographer to breathe a sigh of relief. Dorothea Lange wrote about one of her iconic images of the Depression that it was one of those occasions when "you have an inner sense that you have encompassed the thing generally." The alternative, if the aim is telling a story, is to shoot different aspects of it as a set of images. Cartier-Bresson likened a typical situation to a "core" with sparks being struck off it; the sparks are elusive, but can be captured individually.

There are technical matters such as knowing that the "gutter" between two facing pages can

⌃ COINCIDENCES ON A GALLERY WALL

There are as many ways of hanging groups of prints in a gallery show as there are curators, and this is just one incidental example. Once the images have been decided upon, and framed, what remain are the permutations of grouping. Here, consideration was given to a coincidence of color and form—two red-robed Burmese novice monks over the vertical red reflection of the sun in the Mekong River, both images from a show on Asia. The lower picture is used differently in the layout on page 182.

AMPHIBIOUS LIVING IN A REMOTE ARCHIPELAGO

Among the denizens of the Sulu archipelago in the southernmost Philippines are many who are more at home on the sea than on land. The Samal, an Islamic race of farmers and seafarers, colonize the shallows round the islands' shores with villages built on stilts. The watery expanses surrounding their homes afford some protection against intruders in an area notorious for lawlessness.

Scattered among the Samal, the autonomous Bajau Laut have taken amphibious existence a stage further; some of them pass their entire lives afloat, roaming the coasts in little houseboats. The boat-dwellers depend for their livelihood on fishing and a modicum of trade with the Samal. For generations these sea-gypsies have been the poorest of the archipelago's peoples; their water-borne homes are picturesque but primitive, providing cramped and uncomfortable living quarters. Traditionally disdained by their neighbours, many Bajau Laut have of recent years taken to self-building, seeing a settled home as the key to a better status.

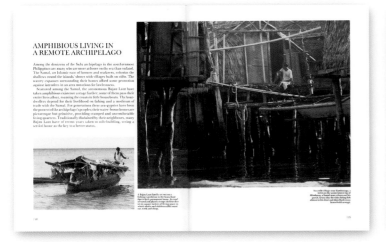

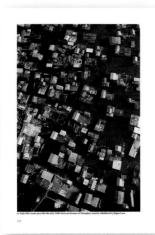

A Bajau Laut family set out on a fishing expedition in the houseboat that is their permanent home. Its roof of wood and plastic scraps shelters the six square metres of living space in which adults and children alike must eat, work and sleep.

In a stilt village near Zamboanga, a town on the westernmost tip of Mindanao, a Samal man relaxes on his porch. Every day the tides bring fish almost to his door and thus flush away household sewage.

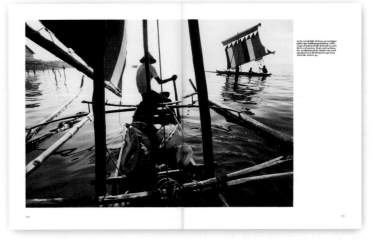

A settlement near Sitangkai at the archipelago's southern tip provides shelter and mooring space for a community of Bajau Laut. The houses perch on stilts above a submerged coral reef ten kilometres offshore.

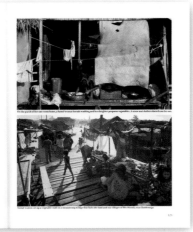

At high tide, boats pass idle the only little houses between houses in Sitangkai, mainly inhabited by Bajau Laut.

On the porch of her one-room home, a Samal woman kneads washing and her daughter prepares vegetables. A straw mat shelters them from the sun.

Samal women set up a vegetable stall on a meandering bridge that links the land and sea villages of Rio Hondo, near Zamboanga.

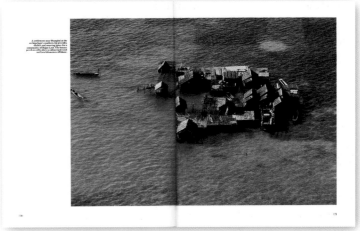

In the mystal light of dawn, an outrigger glides into Zamboanga harbour with a cargo of kelong shells destined to catch the lay of tourists. Boats such as these, the workhorses of the Samal, can reach speeds of over 20 kilometres per hour when the wind is up.

Smiling figures and miniature craft mark Bajau Laut graves on the island of Great Bassi Sitai near Zamboanga, used as a cemetery by the boat-dwellers. Excluding visits to market, the Bajau Laut are only brought ashore by death.

◄ ▲ Á LA TIME-LIFE

An example of a picture story in book form constructed by editors at Time-Life Books: five double-page spreads on a theme of the life of the seafaring inhabitants of the remote Sulu archipelago in the southern Philippines. The book was a 160-page volume on Southeast Asia in the series Library of Nations, in which the construction was six chapters, one for each country or group, interleaved with picture essays like this. Each essay is a glimpse in detail at one specific aspect of what had been covered in the preceding chapter, and this one was chosen, unplanned, on the strength of what emerged during the long shoot. In all, eight images were selected from a total take of around 400 useful frames.

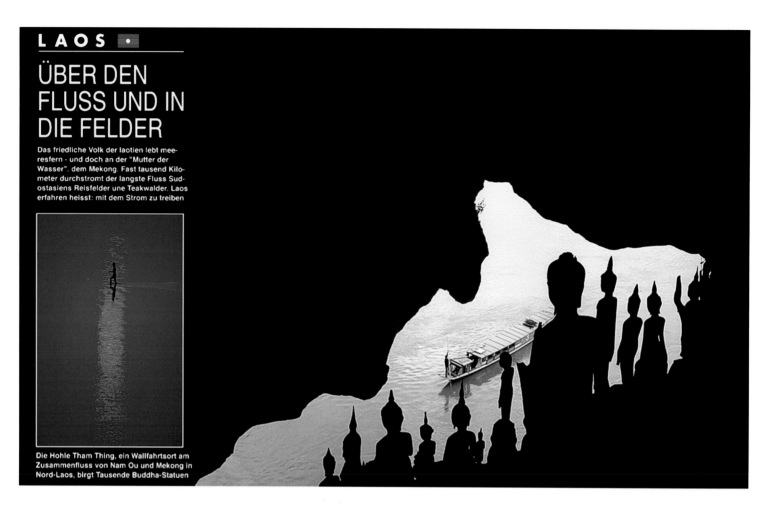

LAOS ◖▪

ÜBER DEN FLUSS UND IN DIE FELDER

Das friedliche Volk der laotien lebt mee-resfern - und doch an der "Mutter der Wasser". dem Mekong. Fast tausend Kilo-meter durchstromt der langste Fluss Sud-ostasiens Reisfelder une Teakwalder. Laos erfahren heisst: mit dem Strom zu treiben

Die Hohle Tham Thing, ein Wallfahrtsort am Zusammenfluss von Nam Ou und Mekong in Nord-Laos, birgt Tausende Buddha-Statuen

ruin a centrally composed image, and editorial ones such as the need for graphic variety, and the need for vertical images to fill full pages. We can extend this use of assembled images to illustrated books, where there is greater variety of style than in magazines and more pages to expand a story. The spread remains the visual unit, but in the case of a highly illustrated book (that is, mainly images with little text), the large number of pages introduces more of a time sequence. In other words, there is likely to be more of a sense of seeing images one after another rather than side by side. The dynamics of sequencing are subtly different from the spatial relationship on one spread left open. An extra component is the captions, and these need to work together, typically long enough to provide

a kind of interleaved text narrative. Caption writing is an editorial skill in its own right, but again, the importance for us is in how it changes the viewer's perception of the image by directing attention to one element or another, as we saw on pages 140-143.

The classic picture story is just one of the ways in which photographs achieve a new life when combined. The other important one is a gallery show; pictures framed and hung on a wall. Time-based collections of images are sequences such as slide shows, whether shown as an event or offered online. In all of these, the graphic relationships tend to impact more than relationships of content (first-glance syndrome), and this places a special importance on color, which if strong registers very rapidly on the

eye. The color relationships between the several images impose their own structure. Sequence is always involved in whatever form they are displayed, because the eye travels from one to another. Because the units of color are entire images, the juxtaposition of photographs tends to favor those with a dominant color.

▲ OPENING SPREADS

Of the endless ways of combining images on a page, one that art directors seem to like to use when the circumstances permit is embedding one in the relatively featureless area of another.

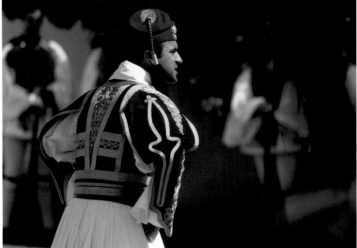

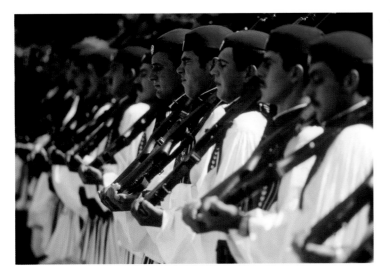

▲ ➤ CREATIVE ART DIRECTION
Both of these photographs, of Greek Evzones (palace guards) on parade were shot from the same position with the same 400mm lens, several seconds apart. A greater distance separated the officer from the soldiers than appears here, as the art director allowed the gutter to reduce the separation visually.

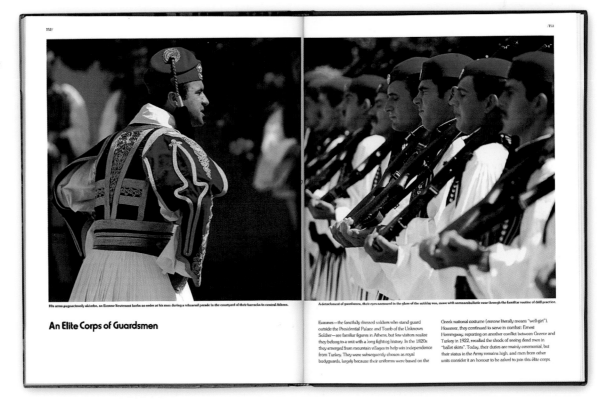

His arms pugnaciously akimbo, an Evzone lieutenant barks an order at his men during a rehearsal parade in the courtyard of their barracks in central Athens.

A detachment of guardsmen, their eyes narrowed in the glare of the midday sun, move with somnambulistic ease through the familiar routine of drill practice.

An Elite Corps of Guardsmen

Evzones—the fancifully dressed soldiers who stand guard outside the Presidential Palace and Tomb of the Unknown Soldier—are familiar figures in Athens, but few visitors realize they belong to a unit with a long fighting history. In the 1820s they emerged from mountain villages to help win independence from Turkey. They were subsequently chosen as royal bodyguards, largely because their uniforms were based on the Greek national costume (*evzone* literally means "well-girt"). However, they continued to serve in combat: Ernest Hemingway, reporting on another conflict between Greece and Turkey in 1922, recalled the shock of seeing dead men in "ballet skirts". Today, their duties are mainly ceremonial, but their status in the Army remains high, and men from other units consider it an honour to be asked to join this élite corps.

POST-PRODUCTION

Digital photography has created, more than anything else, a culture of post-production. To those brought up to respect the purity of the moment as captured and the frame as the sacred boundary of the image (printing the rebates—the frame edges—in the final image is the clearest expression of this cult), this may seem anathema. But the argument to counter this reaction is that digital post-production returns the photographer to the days of black and white as the only medium, with the darkroom as the place where images were made special. Of course, post-production is open to abuse, but another way of looking at this is that it throws photographers back on their sense of what is right and what is wrong. To my mind this is no bad thing at all—it's a way of saying "take full responsibility."

The range of post-production activities is potentially huge, and this is not the place to list them, but what is useful is to attempt a subdivision into the kinds of procedure that photographs are put through in the computer. The minimum is optimization, and the maximum is total manipulation to the extent that the image no longer resembles the original. These may seem like clear definitions, but in practice they conceal many shades of decision, purpose, and effect.

A general definition of optimization is "the procedures to make a system or design as effective or functional as possible." Translated into photography, this means preparing the image as

shot to the best of its technical potential. Typically, the procedures include setting black and white points to present the dynamic range to its best advantage, adjusting contrast, color temperature, hue, brightness, and saturation, and removing artifacts such as noise and dust specks. Even this, however, raises such questions of interpretation as how bright, how colorful, how contrasty? Moving on to greater changes calls for reassessment, which may include questioning the nature of photography itself, certainly when out-and-out special effects are involved. All of this, from optimization up to rearranging the content of the image, falls on what I call a "scale of intervention," and how far along that scale a photographer is prepared to go is an important decision.

Ethical issues are now in sharper focus than ever before, because all constraints have been removed. Manipulating images, whether openly for special effects, as in advertising, or clandestinely to fool the viewer, has always gone on, but demanded great effort. Now, Photoshop and other software allow anything to be changed in an image, and the only limitation is the visual judgement of the computer user. In the early days of digital photography, a number of critics bemoaned the whole idea, as if the only thing holding photographers in check from cheating constantly was technical difficulty. In reality, trust in the inherent truthfulness of the medium was simple-minded, as meaningless as believing that

words are truthful in themselves. Quite apart from early feats of retouching that included printing other skies onto landscape scenes and removing purged Communist Party officials from propaganda photographs, there was also falsification of the subject and event. The debate continues around one famous image, by Robert Capa, of a Republican soldier in the Spanish Civil War falling, apparently at the moment of being shot in battle. There are strong arguments that this was in fact posed during training.

One of the major effects of post-production on process is the ways in which it can affect the shooting. Knowing what can later be done to an image inevitably affects the decisions made at the time of capture. At the very least, for example, faced with an unknown color temperature or a difficult exposure situation, most digital photographers would opt to shoot in Raw format, confident that this will give more choice in recovering a technically satisfactory image. Or imagine another case, in which the subject is a view intermittently interrupted by passing people, when what the photographer wants is an image with no-one in sight. A traditional solution would be to return at a time when the site was empty, but a digital solution would be to shoot several frames with the passers-by in different positions, then in post-production make a layer stack of these and selectively delete the people. In ways like this, digital photography can change the way we shoot.

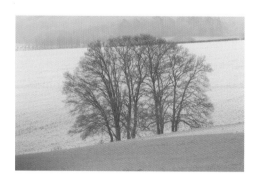
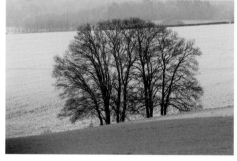
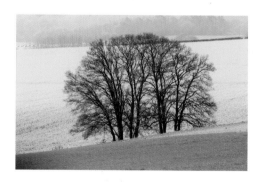

➤ TIME-LAPSE

An invasive style of post-production, but still arguably within the bounds of honesty and realism, is demonstrated by a series of frames of a Roman ruin at Ephesus, Turkey, shot as a solution to the horde of (unwanted) tourists. In this post technique, several frames are layered in register, then selectively erased to remove the people. This method is intrinsically more acceptable than cloning in that the patches brought to the front were actually captured.

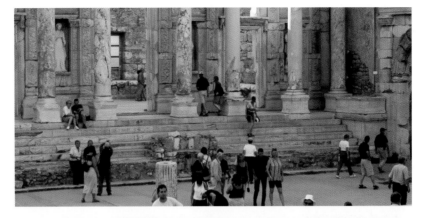

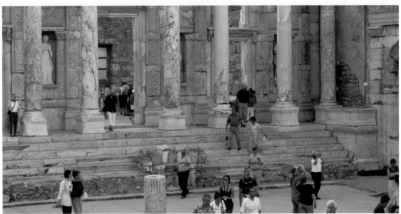

◀ INTERPRETING RAW

Raw format preserves the original data as captured and permits a higher dynamic range to be recorded (depending on the sensor), making it the file format of choice for post-production. Color temperature, hue shifts, contrast, and several other settings can be assigned later, rather than at the time of shooting. As this example illustrates, images can be optimized in a variety of ways to suit individual taste. The original settings, as opened in the Raw editor, have low contrast and an exposure that loses neither highlights nor shadows. Shown next are the automatic conversion, and then a version that aims for extreme saturation to emphasize the bands of color. These are two of many possible translations.

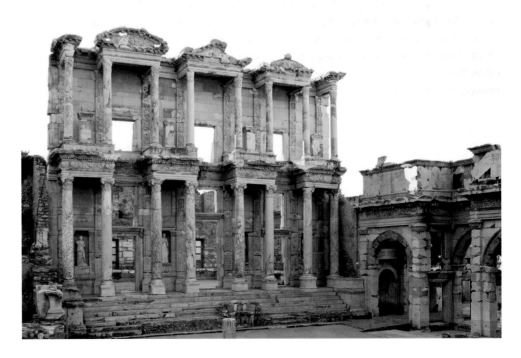

SYNTAX

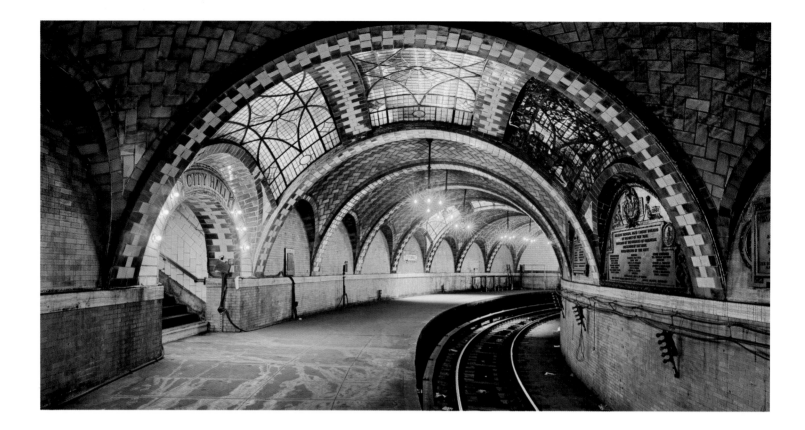

Syntax, as normally defined, is the study of the rules governing the way words are put together to form sentences. In photography we need something similar, particularly in the digital era, to account for the changes in the general visual character of photographs. If we compare a late nineteenth-century landscape from a wet plate, a Tri-X 35mm black and white, a 35mm Kodachrome, and a modern digital night scene shot on Raw and using HDRI (high dynamic range imaging), there are some obvious differences in how the images look, and in how they were and are perceived by audiences.

To take the first example, the dead-white sky of early photography was due to the inefficient response of emulsions, which were blue-sensitive. When the exposure was good for the ground, in the print a clear sky appeared white and most clouds were invisible. While some photographers responded with artifice, using another negative

to print in another sky, those who remained true to the medium learned to compose around the limitation. Timothy O'Sullivan, for example, treated the white sky as a shape, exploiting the figure-ground relationship. This approach, in turn, came to be accepted by its audience as the natural way that a photograph should look. Syntax in linguistics explains what makes an admissible sentence. Syntax in photography explains how a photograph ought to look.

The invention of 35 mm created a different syntax for photography, with the camera used off the tripod, handheld. The smaller film frame revealed the grain in an enlargement onto a print, so photographers learned to live with the texture. Kodak's Tri-X in particular had a tight, distinct grain structure, and this was enjoyed by some photographers, and eventually by viewers. The invention of Kodachrome, with its rich, deeply saturated colors (the more so when under-

▲ HDRI
A good example of the new style of High Dynamic Range Imaging, in which the entire dynamic range of this New York subway scene is captured with full color saturation, from the darkest shadows to the individual bare lamps. No additional lighting was used (for comparison a low dynamic range single frame is shown below). This kind of image was inconceivable until the 21st century, but its full presentation of all the information in a scene may take some getting used to.

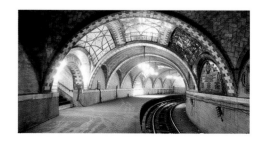

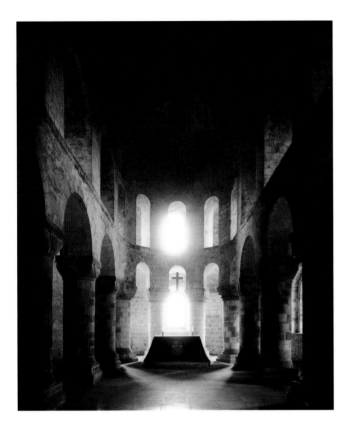

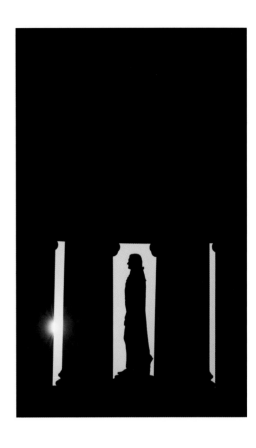

◄ EVOCATIVE FLARE
Shot on black-and-white film, deliberately without added lighting, this morning view of St. John's Chapel in the Tower of London attempts to capture the flood of light as the sun streams down on the altar, and to do this makes full use of the flare characteristic of well-exposed high-contrast images.

► SILHOUETTE
Typical of Kodachrome images exposed for the highlights—in this case the sun rising behind the Jefferson Memorial in Washington DC—this photograph treats its subject as a silhouette, relying on viewpoint and a recognizable profile outline. The multi-spiked flare star around the sun is typical from a lens at small aperture with underexposure.

exposed), led to another way of working. Even in the handful of labs that could process it, there was almost no latitude for correcting mistakes by altering the processing. The transparency went straight to the repro house, so Kodachrome photographers learned to put all their effort into getting the exposure and framing right—more than at any time previously. Remember that with black and white, photographers shot in the knowledge of what they, or a skilled printer, could later achieve. W. Eugene Smith's darkroom marathons became legend, but they were also the epitome of printing as a second, essential stage in the process. This disappeared with Kodachrome for reproduction in magazines and books. This film, which dominated professional color photography during the 1960s and 1970s, also created the practice of deliberate underexposure. Photographers exposed to hold the highlights, which when overexposed on Kodachrome looked

terrible, in the knowledge that a repro house could "open up" the shadows.

Color Formalism, born in 1970s America, and the later love affair that many fashion and advertising photographers have had with color negative film processed and printed idiosyncratically, were in part a reaction to the Kodachrome generation, as we saw in Chapter 5, but the greatest change of all in the rules of what makes an acceptable photographic image are happening right now. Post-production is possibly the major change wrought by digital photography, certainly from the point of view of process. Particularly interesting is how post-production can change the syntax of photography by eliminating or altering the graphic elements special to cameras, lenses, and film.

Digital possibilities include the ability to make everything technically "correct." Consider those two components of photographic syntax

unquestioned until now—flare and silhouettes. Flare is actually inefficient, an artifact in digital terminology, but has that made it wrong? Of course not. Photographers have had decades to make it work and be attractive and evocative. Audiences have had the same time to learn it and enjoy it. Flare brings the impression of flooding light and the view out. The same with silhouettes, which I would argue are an invention of photography (I'm excluding cameos). With digital photography, neither flare nor silhouettes are inevitable. HDRI can remove them. Is this good? Is it acceptable or desirable? These are questions still to be answered, not only by photographers but by the audience, too. There is now the possibility of making photographs that are closer to the way we see, but whether or not this is something that photography should aim for is open for discussion. As always with photography, nothing is agreed, and all is still in flux.

INDEX

I would like to thank my publisher, Alastair Campbell, an old friend, for his encouragement and many suggestions; my editor, Adam Juniper, for finding ways to make many of the ideas here work in published form; another old friend, Robert Adkinson, who many years ago commissioned my earlier book on this subject, *The Image*; and special thanks to Tom Campbell, whose suggestions initiated the writing of this book.

SELECT BIBLIOGRAPHY

Adams, Ansel. *Examples: The Making of 40 Photographs.* New York: Little, Brown; 1983.

Albers, Josef. *Interaction of Color.* New Haven: Yale University Press; 1975.

Barthes, Roland. *Camera Lucida.* London: Vintage; 2000.

Berger, John. *About Looking.* London: Writers & Readers; 1980.

Berger, John. *Ways of Seeing.* London: BBC/Penguin; 1972.

Cartier-Bresson, Henri. *The Decisive Moment.* New York: Simon & Schuster.

Cartier-Bresson, Henri. *The Mind's Eye.*

Clarke, Graham. *The Photograph (Oxford History of Art).* Oxford: Oxford University Press; 1997.

Diamonstein, Barbaralee. *Visions and Images: American Photographers on Photography.* New York: Rizzoli; 1982.

Dyer, Geoff. *The Ongoing Moment.* London: Little, Brown; 2005.

Eauclaire, Sally. *The New Color Photography.* New York: Abbeville; 1981.

Fletcher, Alan; Forbes, Colin; Gill, Bob. *Graphic Design: Visual Comparisons.* London: Studio Books; 1963.

Freeman, Michael. *The Image (Collins Photography Workshop).* London: Collins; 1988.

Freeman, Michael. *Achieving Photographic Style.* London: Macdonald; 1984.

Gernsheim, Helmut and Alison. *A Concise History of Photography.* London: Thames & Hudson; 1965.

Gombrich, E. H. *Art and Illusion.* London: Phaidon; 2002.

Gombrich, E. H. *The Image and The Eye.* London: Oxford; 1982.

Gombrich, E. H., Hochberg, Julian and Black, Max. Art, *Perception and Reality.* Baltimore: Johns Hopkins University Press; 1972.

Graves, Maitland. *The Art of Color and Design.* New York: McGraw-Hill; 1951.

Gregory, Richard L. *Eye and Brain: The Psychology of Seeing.* Oxford: Oxford University Press; 1998.

Herrigel, Eugen. *Zen in the Art of Archery.* New York: Vintage Books; 1989.

Hill, Paul. *Approaching Photography.* Lewes: Photographers' Institute Press; 2004.

Hill, Paul and Cooper Thomas. *Dialogue with Photography.* Stockport: Dewi Lewis; 2005.

Itten, Johannes. *Design and Form: The Basic Course at the Bauhaus.* London: Thames & Hudson; 1983.

Itten, Johannes. *The Elements of Color.* New York: Van Nostrand Reinhold; 1970.

Mante, Harald. *Photo Design: Picture Composition for Black and White Photography.* New York: Van Nostrand Reinhold; 1971.

Mante, Harald. *Color Design in Photography.* Boston: Focal Press; 1972.

McLuhan, Marshall. *Understanding Media: The Extensions of Man.* Cambridge, Mass. and London: MIT Press; 1994.

Newhall, Beaumont. *The History of Photography from 1839 to the Present Day.* New York: MoMA/Doubleday; 1964.

Newhall, Nancy. *Edward Weston: The Flame of Recognition.* New York: Aperture; 1965.

Rathbone, Belinda. *Walker Evans: A Biography.* Boston, New York: Houghton Mifflin; 1995.

Rowell, Galen. *Mountain Light.* San Francisco: Sierra Club Books; 1986.

de Sausmarez, Maurice. *Basic Design: the Dynamics of Visual Form.* London: Studio Vista; 1964.

Smith, Bill. *Designing a Photograph.* New York: Amphoto; 1985.

Sontag, Susan. *On Looking.* New York: Farrar, Straus & Giroux; 1973.

Szarkowski, John. *Looking At Photographs.* New York: Museum of Modern Art; 1973.

Torrans, Clare. *Gestalt and Instructional Design.* Available at http://chd.gmu.edu/immersion/knowledgebase/strategies/cognitivism/gestalt/gestalt.htm 1999.

Winogrand, Garry. *Winogrand: Figments From The Real World.* Boston: New York Graphic Society/Little, Brown; 1988.

Wobbe, Harve B. *A New Approach to Pictorial Composition.* Orange, N. J.: Arvelen; 1941.

Zakia, Richard D. *Perception and Imaging.* Boston: Focal Press; 2000.

THE PHOTOGRAPHER'S EYE